MOORCROFT
POTTERY

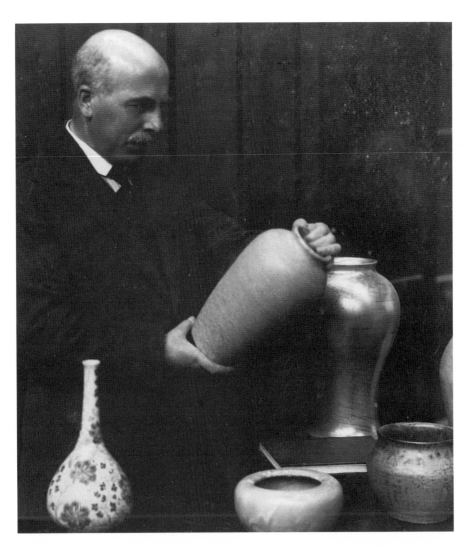

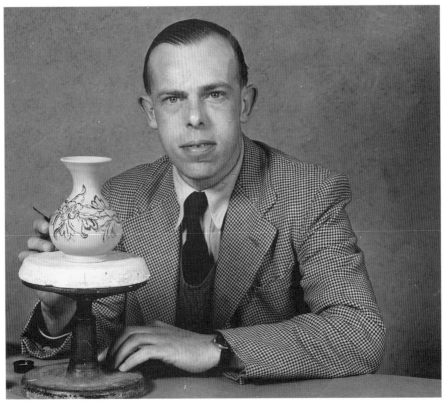

William Moorcroft and Walter Moorcroft

MOORCROFT POTTERY

A Guide to the Pottery of William and Walter Moorcroft, 1897-1986

Paul Atterbury

Additional material by Beatrice Moorcroft

Published by Richard Dennis and Hugh Edwards
144 Kensington Church Street, London W8

Acknowledgements

If love drives on the collector of Moorcroft Pottery, then the collector's goodwill lies at the heart of publication of this book. A special debt of gratitude is owed to W. Moorcroft Limited and members of the Moorcroft Family for the loan of splendid pieces, for their acceptance of our many raids on family archives and the total invasion of their privacy following hijacks of their houses as photographic studios. To Walter, the Master Potter, and his wife Elisabeth, Managing Director John and his wife Gill, Mrs Hazel Moorcroft, widow of William and Beatrice, custodian of family records, we extend our warmest thanks. Of the many collectors who entrusted us with their pieces, a very special debt of gratitude is due to Mr and Mrs T.J. Archer, Maureen and Terry Batkin, Drs A. and M. Belton, Michael Bruce, Cannonhall Museum, Barnsley, Rita and Robert Edgar-Dimmack, Mrs V. H. Edwards, Mr G. B. Habib (dish plate 2 page 62, bowl and tall vase plate 4 page 65, goblet plate 3 page 84, oval dish plate 1 page 86, charger plate 4 page 95), Ray Heath, Mr and Mrs J. R. Johnson, Haydn and Christine Miles, Mrs M. Munn, the Newstead family, Peter Rose, Mr and Mrs Clive Saych, Ian and Rita Smythe and above all, Barbara Tobias and Mr and Mrs Albert Wade. For performing miracles with her travelling Studio we thank Pru Cuming, our photographer. Grateful thanks also go to City of London solicitors Richards Bulter for their advice given throughout publication and the loan of one their partners to co-ordinate material, check out the script and secure copyright.

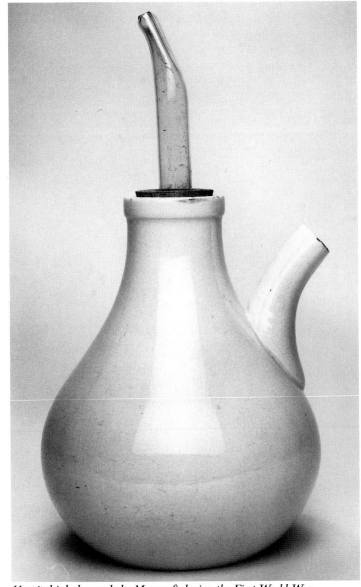

Hospital inhaler made by Moorcroft during the First World War.

Photography: Prudence Cuming Associates, O's Gallery Tokyo, Gate Studios, Phillips, Sotheby's
Design and Production: Trevor Gardiner
Editorial and production assistance: Jill Rumsey, Melanie Wood
Typesetting: Sunset Studios
Printed and bound in Japan

© Paul Atterbury, Richard Dennis and Hugh Edwards

Published in 1987 by Richard Dennis and Hugh Edwards,
144 Kensington Church Street, London W 8

ISBN 0 903685 18 3

Illustrated on the front cover: The Moorcroft Pottery at Cobridge, Burslem, built by William Moorcroft in 1913.
Photograph: John Moorcroft
Illustrated on the back cover: Vase, decorated with a rare version of the landscape design, c1928.
Photograph: Prudence Cuming Associates

The Moorcroft pottery is located at Cobridge, on the Sandbach Road, Burslem, Stoke-on-Trent ST6 2DQ. Telephone Stoke-on-Trent (0782) 24323

Contents

Mug decorated with a moulded design of a bottle oven, 1986.

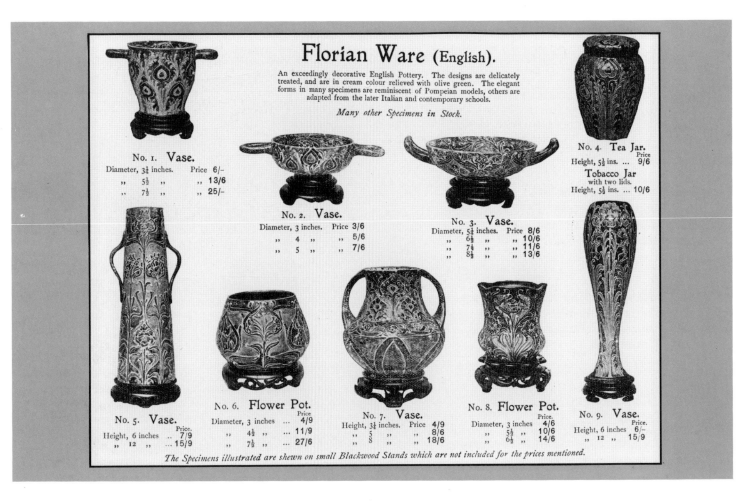

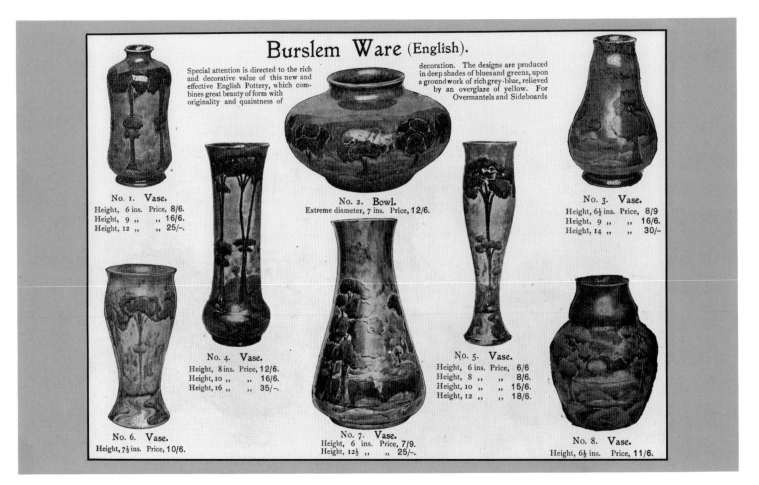

1 Advertisement for Florian Ware from Liberty's Yule-Tide Gifts catalogue of 1901

2 Advertisement for Burslem Ware from Liberty's Yule-Tide Gifts catalogue of 1902

Chapter One
William Moorcroft, 1872-1945

William Moorcroft was born in Burslem in 1872 into a family well established in the Potteries. His father, Thomas, after training at Hanley and Burslem Schools of Art from 1863, had developed a considerable reputation as a designer and china painter, working at the Hill Pottery with E.J.D. Bodley. Unfortunately his career was cut short by his death in 1886 at the age of 36. His first wife, Theresa Edge, had also died young, in 1881, and so Thomas's young children were brought up by their stepmother. However, these family difficulties do not seem to have hindered William Moorcroft. He was educated at Longport Hall School, an establishment set up in 1870 to provide a 'modern education for middle class boys,' and then subsequently became a student at Burslem School of Art, situated since 1869 in the new Wedgwood Institute. In 1895 his considerable abilities earned Moorcroft a place at the National Art Training School, which became the Royal College of Art in 1896. He not only attended the usual lectures and classes but embarked on an intensive study of ancient and modern pottery and porcelain at the British Museum and the South Kensington Museum, a course of study he later pursued further in Paris. By 1897 he had obtained his Art Master's Certificate, the ultimate goal of every student of the government schools of art. This would have enabled him to earn his living by teaching, but he had set his heart on a career as a potter. His opportunity to realise his ambition arose when he was offered a job as a designer by the china and earthenware manufacturers, James Macintyre & Company of the Washington Works, Burslem.

Macintyre's, a large and influential firm in Burslem for over half a century, produced a wide variety of commercial wares, ranging from artist's pallettes to elaborately decorated door furniture. Their wares were largely utilitarian, but their standards were high. They had been commended by Llewellyn Jewitt for their technical achievements, including the development of decorative clay bodies, such as agates, malachites, and imitation ivory, and for glazes that included the first examples of the black jet, a glaze which, by the end of the century, was used throughout the Potteries by manufacturers of inexpensive teapots. By the 1880s they were producing tableware in earthenware and china, the former dipped in coloured slip to produce plain colours, the latter decorated with underglaze printing supplemented by enamels and gilding, In 1889 they began to experiment with electrical porcelain insulators and switchgear for the new electricity industry, pioneer work that was to produce results on which the firm's future was later to depend. In 1893, the directors decided to expand their production by developing ornamental art pottery. Art pottery had by this time become a vogue, a direct legacy of William Morris and the Aesthetic Movement. Companies, large and small, were busily introducing new art ranges, and advertisements which emphasised 'art' in the crudest terms littered the pages of magazines such as the *Pottery Gazette*. In 1899, the editor of the *Magazine of Art* felt compelled to comment: 'There has been of late years such a large production of so called "art pottery" that (it) has almost become a term of reproach, whether regarded from the point of view of design or decoration . . .'

Undeterred by such competition, Macintyre's determined to excel in the field, and began to search for a designer capable of developing the new ware. Between 1893 and 1895 they appear to have engaged a succession of artists and modellers whose careers at the factory were short. Several were engaged on a trial basis, among them a Mr Scaife, of whose work little is known and Mr Rowley who specialised in lustre ware. In 1894 the firm was able to participate in the *Exhibition of Decorative and Artistic Pottery* held in London at the Imperial Institute and to show examples of their ware alongside that of Doulton, Minton, Ault,

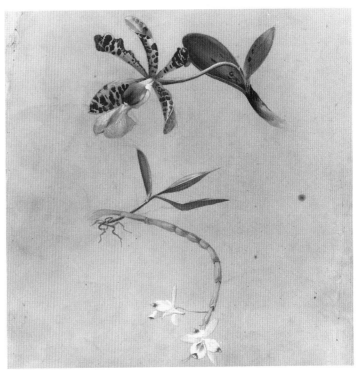

3 Watercolour drawings of orchids, Cattleya Achlandia and Dendrolium, by Thomas Moorcroft, May 1879. A number of plant studies, presumably drawn while Thomas was working at the Hill Pottery, were used as design sources

4 During his brief stay at the Washington Works, Harry Barnard produced a large number of shape designs, most of which never went into production. Those illustrated here show his interest in classical, Middle Eastern and Far Eastern forms, sources that were subsequently developed further by Moorcroft

5 The Washington Works of James Macintyre & Co, shown shortly before its demolition

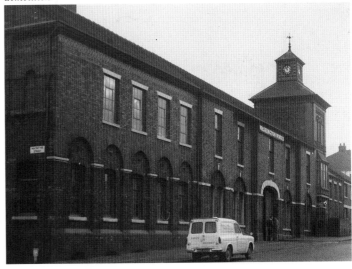

Sir Edmond Elton and other well established manufacturers of art pottery. Their exhibits included tableware designed by Richard Lunn and two types of decorative slipware known as Taluf Ware and Washington Faience. Of these, the former displayed a type of slip decoration with patterns cut through layers of coloured slip on a lathe or by hand, while the latter was a kind of sprigged ware, with relief ornament by Mr Wildig, 'gold medallist of South Kensington'. Wildig was a local artist and modeller, who had studied in the Potteries before going to South Kensington. He was a successful artist craftsman who had gained a number of medals, including the rare and much coveted gold medal in the National Competitions held annually by the Department of Science and Art. He was employed by Macintyre's for several years but finally left to set up his own studio in Hanley.

Macintyre's had been among the more generous supporters of the Burslem School of Art and had shown a preference for local talent, but in 1894 they looked further afield and invited Harry Barnard to leave London to take over the design and production of an entirely new art pottery, that was to be decorated in 'plastic clay'. Barnard had been trained as a modeller at Fulham and had worked at Doulton's Lambeth studio, initially as an assistant to Mark V. Marshall, and later in his own right. For Macintyre's he undertook to develop a form of *pâte sur pâte*, the decoration of which was to be built up in layers of slip in low relief, a technique resembling that of gesso work. Painting in coloured slip was a recognised process, known in France as *barbotine* and practised in England by many companies, including Minton, Doulton and Wedgwood. Barnard's designs were to be emphasised in high relief, and so Macintyre's called their new art pottery Gesso Faience. Barnard was given his own workshops and a staff of decorators to develop his technique. An elaborate backstamp was prepared to mark the ware and, having set up the new department the firm awaited results. At first the decoration in 'plastic clay' appeared promising but the new art pottery was not a commercial success. By the end of 1896 the future of Barnard's department was already uncertain. His salary was reduced and the directors decided to look for a second designer who would develop the other wares made in the factory. Barnard was not responsible for these, but he did design a wide range of shapes for ornamental and tablewares, some of which may have been produced. They reverted to their search for local talent and in March 1897 appointed William Moorcroft, who had been born and trained in Burslem.

Young, ambitious, with firm ideas about design and decoration inspired by William Morris, and armed with the latest principles of design as taught at the Royal College of Art, Moorcroft had much to commend him as a designer. Unlike the majority of the art students trained in the government schools of art, he had also studied ceramic chemistry and had acquired experience of ceramic processes, qualifications that would enable him to execute his own designs or supervise their execution by others. During the first nine months that followed his appointment he introduced a new and original style of decoration for Macintyre's printed and enamelled ware, and designed new shapes and decoration for their plain coloured tablewares. For the printed and enamelled ware he designed shapes for both vases and domestic ware and decorated them with patterns consisting of highly conventionalised floral motifs, frets and diapers, in a fashion that owed more to the decorative traditions of Morris and the English designers than to continental Art Nouveau, with which his decoration has been compared. The new ware was given the name Aurelian and three of the designs were registered in February 1898. Having begun the development of Aurelian Ware, produced in Macintyre's main decorating room, Moorcroft turned his attention to the slipware. Macintyre's had been producing the plain tableware that they called 'Tinted Faience' for some time, but Moorcroft introduced new shapes and colours that prepared the way for Dura Ware, for which he later became responsible. The plain surface invited decoration

and Macintyre's had already introduced a range of tableware on which patterns were outlined in white slip by the process of slip trailing, or tube lining, a method of decoration used throughout the Potteries for the decoration of tiles. It is not certain whether Barnard was responsible for this development or not, but in any case this ware bore the Gesso Faience backstamp. Moorcroft was quick to appreciate the possibilities of slip trailing and explored its potential to develop a new range. By the end of 1897, he had introduced a number of designs for tableware and the first ornamental pieces in what was to develop into his characteristic and highly individual style.

While Moorcroft was making rapid progress, Harry Barnard was in difficulties. His department was still proving unprofitable and in September 1897 he left the company to take up a more successful and lifelong career with Wedgwood. Macintyre's had to decide whether to close his department and abandon the art pottery or to make a fresh start. They decided on the latter course and by the beginning of 1898 had promoted Moorcroft and invited him to develop a new type of slip ware, using the techniques of slip trailing and underglaze colour that he had already begun to explore. With the title of Manager of the Ornamental Ware, he was installed in the workroom and office that Barnard had vacated and provided with a staff of decorators and the services of a thrower and turner who would work for him exclusively. Unlike the ill-fated Gesso Faience the new art pottery was commercially successful. It was called Florian Ware, a name indicative of the floral motifs which provided the basis of most of Moorcroft's designs. A new backstamp was prepared, but the Gesso Faience mark outlived the ware for which it had been intended and continued in casual and occasional use on Florian Ware and Dura tableware for several years. This has confused subsequent generations of collectors, and explains why pieces have been recorded carrying both the Gesso Faience mark and Moorcroft's signature.

Moorcroft quickly developed his own designs and working methods. Given sole responsibility for the development of Florian Ware, the training and supervision of his staff, and access to the firm's laboratories, clayrooms, dipping house and commercial kilns in which the ware was fired, he was able to control the design and manufacture of his ware from clay to kiln, and experiment freely with colour, glaze and decorating techniques. He established a design philosophy that was to stay with him for the rest of his life. His early diaries reveal his interest in organic form; from plants he developed the principle that ornament should be used to emphasise form, and never for its own sake. In this he had more in common with Christopher Dresser than with many contemporary potters, such as William de Morgan, for whom decoration was of paramount importance. Like many English designers in the Arts and Crafts movement, who followed William Morris, Moorcroft disliked continental Art Nouveau, and described the more extreme characteristics of the style as 'a disease'. His concern for form gave him an uneasy relationship with the style, and his determination to link shape and decoration put him apart from the more extravagent aspects of Art Nouveau. In his use of slip trailing and a sinuous flowing style of decoration based on nature, Moorcroft can be included among the avant garde designers who introduced modern European styles into England.

Moorcroft's interest in form also lay behind his method of working. Whenever possible, all pieces were thrown on the wheel, to allow the pot to develop organically. He used a fine white porcelaneous body, developed by Macintyre's for industrial use and thus capable of withstanding high temperatures. Working in the round, Moorcroft drew the designs himself, adapting the patterns to fit every size and shape of pot. Assistants then outlined the designs with a fine extrusion of slip. This outline, drawn heavily on the early pieces, and gradually becoming almost imperceptible later, formed a cloisonnist pattern that created a relief effect. At the same time it served to separate the colours. These, derived from metallic oxides, were

6 A display of Moorcroft ware photographed at an exhibition in Liverpool in 1918.

7 The Moorcroft stand at the British Industries Fair, 1926

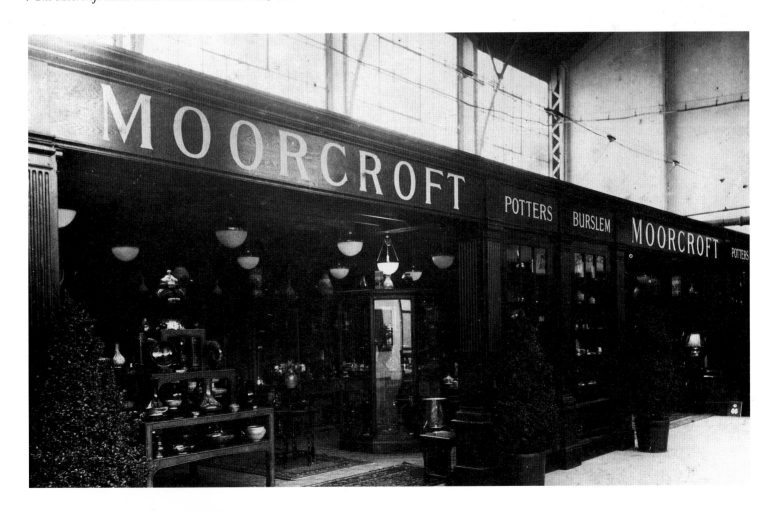

painted on underglaze and then each piece was fired at least twice to 1100 degress centigrade or more. The final clear glaze was highly vitrified, emphasising the depth and richness of the colours. When Florian Ware was launched the colour range was restricted to blues, greens, pinks and yellow, but later Moorcroft was able to develop new underglaze colours capable of withstanding the high temperatures.

Moorcroft controlled the design of every shape and every pattern executed in his department, including both ornamental and useful ware. The thrower, turner and decorators who worked with him used their skills entirely under his direction. As a result, both the Florian Ware and the later ranges were the creation of one mind. Moorcroft's insistence upon retaining the responsibility for the design of every piece separates his work from that of the majority of English art potters with whom group, or studio, methods were commonplace. This method of working was seen by many as one of the particular qualities of Florian Ware and enabled Moorcroft to sign his work as his own, by signing his name or initials with a brush, laden with colour, or a wooden point, on the bottom of each piece. Contemporary magazines commented on the ware soon after its introduction, the *Studio* calling it 'the most interesting work in pottery executed entirely on the clay.' The *Magazine of Art* went further: 'One interesting feature of this ware is that it bears indelibly the mark of the artist and skilled craftsman. All the designs are the work of Mr W. Moorcroft; every piece is examined by him at each stage, and is revised and corrected as much as is necessary before being passed into the oven. The decorative work is executed by students – who have to go through a course of training at the Burslem Art Schools – and while the design of Mr Moorcroft is as closely followed as possible, any individual touches of the operators are seldom interfered with if they tend to improvement. It thus happens that no two pieces are individually alike….this ware deserves a large share of popularity. Messrs. Macintyre are to be congratulated on their success in placing before the public a ware that really exhibits evidence of thoughtful art and skilful craftmanship.' Moorcroft was also responsible for the shapes and these reflect his wide ranging interests. Forms drawn from Middle Eastern, Far Eastern and contemporary Art Nouveau styles are all present, but particularly notable is the influence of Roman ceramics excavated at Pompeii and Paestum. This influence, noted by the *Magazine of Art* in 1899, can particularly be seen in the handles.

When Florian Ware had been launched, many of the designs and some of the shapes were registered, maintaining a tradition established by Macintyre long before Moorcroft joined the firm. The first Florian designs were registered in September and October 1898, and others followed at regular intervals until April 1905. Florian Ware established Moorcroft's characteristic style. Formalised flower and plant forms predominated, although peacock feathers, fish and the first landscape designs were included in the range. The designs cover the surface, reflecting the influence of William Morris and the Arts and Crafts Movement. The grounds were usually pale, with patterns often drawn in darker shades of the same colour, blue on blue, green on green, in a flowing curvilinear style. The flowers were English, poppies, bluebells, cornflowers, tulips, lilac, daisies, narcissi, honesty, roses and forget-me-nots. For Moorcroft, Florian was a specific range, and he began to move on to other things from 1904 but Macintyre's used the name Florian as a generic term for the art pottery made in his department. For this reason it was accepted as such by the British press: the *Pottery Gazette* was still referring to Moorcroft's pottery as Florian Ware in 1913, whereas in the United States and Canada it was known by Moorcroft's name much earlier.

The Florian designs were repeated for a number of years, and the backstamp was used until about 1906, when it was replaced by the ordinary Macintyre trademark. The ware was nevertheless sold under other names, most of which were chosen by the retailers who distributed it, exceptions being the shortlived

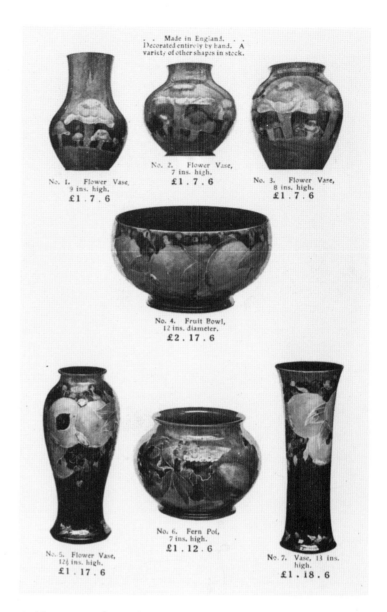

8 *Advertisement from Liberty's Yule-Tide Gifts catalogue, 1919, showing Claremont and pomegranate*

Butterfly Ware, and the Flamminian Ware of 1905. Butterfly Ware, introduced in 1899, was the name chosen for wares decorated with Florian-like butterflies in gold on a very dark ground and distinguished by an elaborate backstamp. The name, like that of the later Flamminian Ware, was chosen either by Moorcroft himself, or by Macintyre's but other names used during the Macintyre period were given to the pottery by Liberty and were accepted for general use. These included Burslem Ware, used to refer to a number of designs; Hazledene, applied to the green tree design; Claremont, for the toadstool design; Bara and Tudor Rose. A number of retailers elected to have their ware marked with their own names. Marks such as Made for Liberty & Co were printed on the ware. Osler's sold the ware as Hesperian and their backstamp, like that of Liberty and other retailers, was substituted for the Macintyre marks.

Moorcroft devoted almost as much of his time to the design and making of tableware as to his ornamental pieces. Some carried Florian patterns and was designed, decorated and signed in exactly the same way as the vases made in his department. However, he was also responsible for the Dura and Aurelian tablewares that were advertised regularly in the *Pottery Gazette*. Dura Ware, although not signed, was produced in his department, and designed and decorated in the same way as the Florian Ware. The Aurelian tableware, with its printed and enamelled decoration, although designed by Moorcroft, was produced in another part of the factory, together with the Aurelian vases that continued in production after he took over the art pottery departments. The original Tinted Faience and the

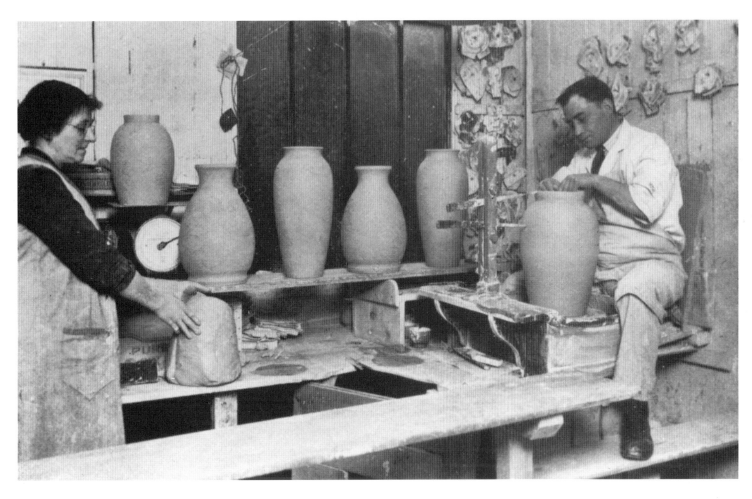

9 *Thrower Harry Bailey with his assistant Mrs Farrington, photographed in 1930*

10 *The Moorcroft decorating shop in 1933, from the Pottery Gazette*

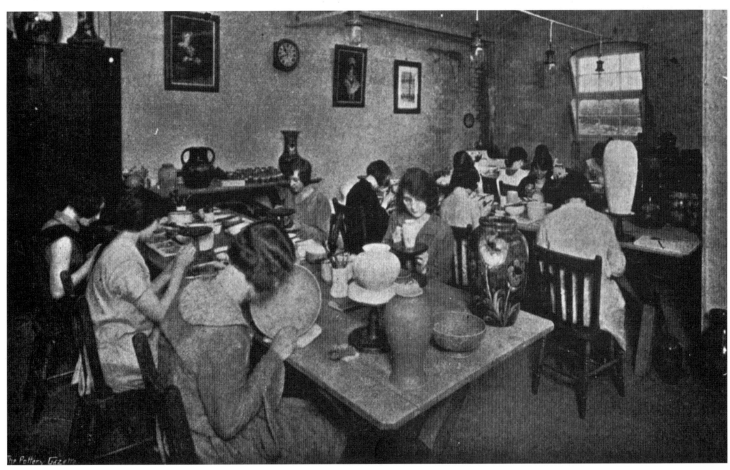

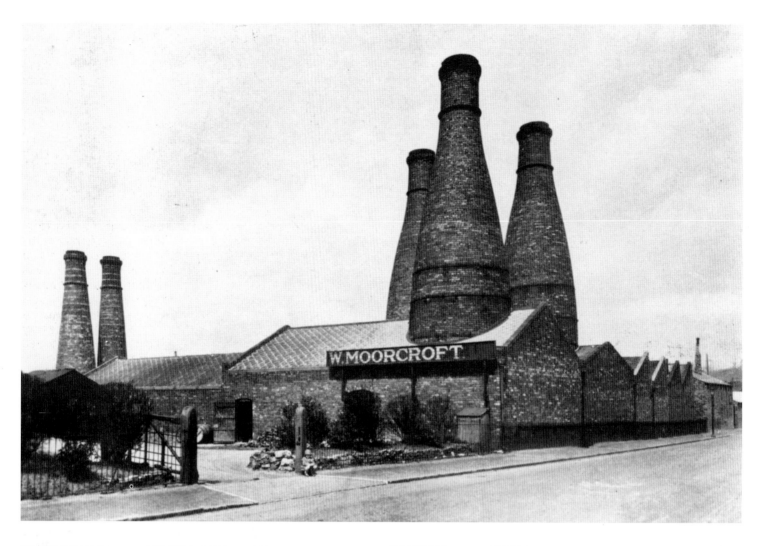

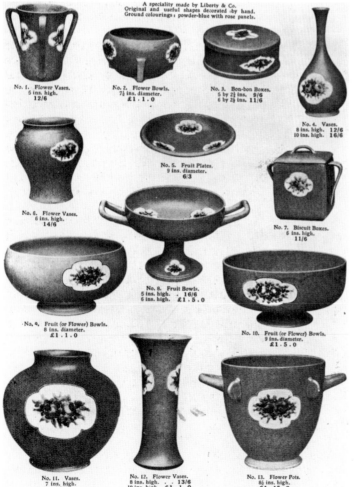

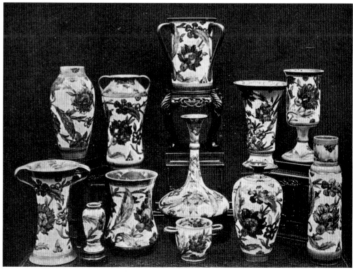

11 The Moorcroft factory at Cobridge, photographed in 1930. The smaller ovens on the left were for the flambé and lustre firings

12 Advertisement from Liberty's Yule-Tide Gifts catalogue, 1916

13 Persian Ware, illustrated in the Pottery Gazette, July 1916

'Household Requisites', as Macintyre's called them, were still made, but his responsibility for these was vicarious if it existed at all. A catalogue, published in 1902, provides a record of what was being produced at that time. Five pages of designs are devoted to the Dura Ware, and credited to Moorcroft, four to Aurelian Ware, and four to Tinted Faience and miscellaneous articles, only some which were designed by Moorcroft. The tableware that bore the Gesso Faience backstamp, with its design outlined in white, is represented by a jug and cruet set, showing that some of this early range was still in production in 1902. Also present are some surprising mismarriages, for example Moorcroft Florian-type decoration on revived rococo shapes. Tableware was an important part of Macintyre's production throughout this period and as late as 1905 new teapot and jug shapes designed by Moorcroft were being registered.

Moorcroft enjoyed great freedom at the Washington Works, and indeed his work during this period established his own reputation rather than his employer's. Within a year of its introduction Florian Ware was being sold by Liberty of London, Rouard of Paris and Tiffany of New York. Moorcroft was able to make full use of Macintyre's London showrooms, at 4 Thavies Inn, Holborn Circus, London EC4, and to exhibit his work widely at both trade shows and international fairs. He won his first gold medal at the St Louis International Exhibition of 1904; another followed at Brussels in 1910 and he was awarded a Diploma of Honour at Ghent in 1913. The connection with Liberty proved to be particularly worthwhile and from about 1902 pieces were being made with a printed Liberty backstamp. Moorcroft established a lasting association with the Liberty family, in particular with Alwyn Lasenby, Lasenby Liberty's cousin, with the result that Liberty remained one of his most faithful supporters throughout his lifetime. From 1901 Florian and other ranges were illustrated in Liberty's *Yule-Tide Gifts* catalogues but curiously these did not mention Moorcroft's name until after the move to Cobridge in 1913. Many patterns were particularly associated with Liberty, the Hazeldene landscape design, the Claremont toadstool design, the pomegranate and pansy designs, the monochrome Flamminian Wares, as well as the wide variety of simple but elegant floral designs with pale grounds and occasional lustre glazes that were characteristic of the 1903 to 1910 period. Some of the latter, with their delicate eighteenth century-style decoration, seem close to contemporary Liberty fabrics but only one, Bara, was claimed to be exclusive to Liberty, although it was also sold abroad by other retailers. Many of these patterns can be found with Liberty backstamps, but they were also sold through other retailers.

In the early 1900s Moorcroft began to replace the coloured grounds with white and cream and at the same time the designs became simpler but more colourful. These changes were made possible by better colour control during the firing and by the availability of a greater range of colours, which Moorcroft had developed himself. Flowers were still the main inspiration, particularly wisteria, lilac, tulips, roses and pansies drawn informally over the surface. More formal was the Eighteenth Century pattern of 1909, swags of English garden flowers draped carefully around the ware to capture the spirit of the contemporary Adam revival. Liberty's Bara pattern was similar in feeling. Later, from about 1910, the colours became stronger and the subjects more exotic. Typical of this period are the Spanish, brown cornflower, pomegranate, green landscape, Claremont and pansy patterns. These rich patterns changed the nature of Moorcroft's work as his style of drawing became bolder, sweeping over the surface and thrown into relief by the increasing use of dark mottled ground colours. There was also greater use of accidental effect; delicate slip-trailing allowed the colours to spread beyond their defined areas and to merge together to add texture and tonal variation. Lustre finishes were regularly used, to add sparkle, and to enrich the colours of monochrome glazed wares.

These new styles did not pass unnoticed. In 1913, the *Connoisseur* reviewed an exhibition of Moorcroft ware at the Royal Institution in Albemarle Street: 'The examples shown included various specimens of types already familiar, but each susceptible to infinite variety of expression. The pieces . . . are wrought in simple but beautiful forms and decorated with appropriate designs. These show a marked originality of treatment, more especially as regards the colouration, which is never glaring or obtrusive . . . In some of the representations of conventionally treated pansies on a white ground, and rich combinations of red pomegranates and purple grapes with green, some of the most beautiful effects which have been produced in modern ceramic art were obtained.' In common with other contemporary criticism this review barely mentioned the Macintyre name, but it did reveal that Moorcroft was soon to have his own factory. This dramatic change had become increasingly inevitable as Macintyre's had decided to concentrate their efforts on the production of electrical porcelain. Art pottery seemed out of place in the Washington Works, and so in 1913 the decision was made to close the department. Moorcroft's continually developing personal reputation at the expense of his employers may also have been a factor but, when it came, the separation was amicable. Moorcroft was allowed to take about twenty decorators, craftsmen and women with him, all of whom he had trained, along with moulds, equipment, stock and the valuable trade connections that he had developed.

Moorcroft bought some land at Cobridge, adjacent to the North Staffordshire Railway, and there he built a new factory to house his new business. At this critical stage in his career, he was greatly helped by support from two particular sources. First, the Liberty family looked beyond their conventional trade association to become debenture stock holders in the new venture. All were repaid by the early 1920s. Second, in 1913 Moorcroft had married Florence Lovibond, an inspector of factories for the Home Office. His new wife had a considerable influence on the design of the new factory.

In many ways the factory was revolutionary. The site itself was high and open, with good views, and the factory buildings filled under a third of the available space. Moorcroft's experiences at the Washington Works, a large conventional multi-storey Victorian pot bank ranged round a central courtyard, had made him determined to overcome the dangers and difficulties inherent in such a structure. He wanted to avoid the continual carrying of heavy materials and wares up and down stairs, the problems posed by dust and glazes, and the dangers of inserting machinery into spaces not designed for it. As a result he chose a small single storey layout, with well defined working areas, plenty of light and adequate lavatory and washing facilities. The building was designed by A. A. Longden, from proposals drawn up by Moorcroft and his wife, and it was built in ten weeks. Cast iron frame construction and plain windowless exterior walls certainly simplified construction, but the speed of the operation was still remarkable. It was the first truly modern factory building in the Potteries and the first to provide one floor production. It was no coincidence that the factory fully complied with the requirements of the new Pottery Regulations made under the Factories Act, which had also come into effect in 1913. The Moorcroft factory, simple and elegant in its own way, was an interesting blend of avant garde functionalism with the studio philosophy of William Morris and the Arts & Crafts Movement. The building was enlarged in 1915 and then again in 1919-1920 but the design principles and style of the original structure were carefully maintained, and so even today the revolutionary qualities of the factory can still be appreciated. In 1985 a fully detailed report and description of the factory was published by the Stoke-on-Trent Historic Buildings Survey of the City Museum and Art Gallery, entitled *Moorcroft's Pottery Factory Drawing No B199*.

In August 1913 Moorcroft moved into the new building with his small team of craftsmen and women and production started. Within a few weeks the oven was being fired. Initially many of

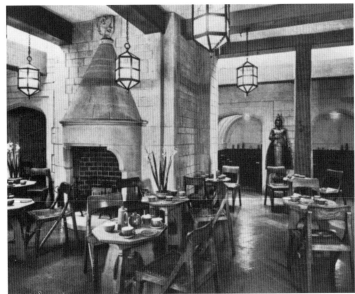

14 Liberty's Tudor Tearooms in about 1920, equipped with Moorcroft Powder Blue tableware

the patterns developed at the Washington Works were simply transferred to Cobridge, and so there is inevitably some confusion about the wares made during this transitional period. Some carry only signatures, some have Liberty marks, some have the new impressed marks adopted at Cobridge. There are also a number of wares that carry dates for the latter months of 1913 and early 1914; it is natural to assume that these pieces represent early Cobridge production.

New patterns were also developed as quickly as possible, among them New Florian, Persian and the range of wares decorated with floral and fruit panels contained in reserves. All these show the increasing use of colour, as well as Moorcroft's interest in the ceramics of the Middle East. However, the most important introduction during the early days at Cobridge was the Powder Blue tableware range. First produced in 1913, the range was originally known as Blue Porcelain by Moorcroft as he used a porcellaneous body similar to that developed by Macintyre's for their electrical wares. In any case, powder blue had a different meaning in commercial terms, and was used to describe blue-ground ornamental porcelains made by Wedgwood, Royal Worcester and many other factories. It was Liberty who named the range Powder Blue, but Moorcroft sold it as Blue Porcelain. It also became generally known as Moorcroft Blue. This speckled blue tableware was an immediate success, giving Moorcroft the steady production runs the new factory needed. It was made in an enormous variety of shapes and sizes, the majority of which were thrown and hand-finished on the lathe, yet the prices were reasonable. For example, in the early 1920s a 29 piece breakfast set cost £2.10.3d and a 1½ pint teapot 4/6d. Powder Blue tableware was used by Liberty in their new Tudor Tea Rooms and the range was also well regarded by contemporary critics. In 1937 Nikolaus Pevsner included the tableware in his *Enquiry into Industrial Art in England* and wrote: 'One of the best contemporary sets, William Moorcroft's famous Plain Blue, was designed in 1913, and is, in spite of that as "modern" as anything created now, and as modern as Josiah Wedgwood's sets, i.e. undatedly perfect.' Powder Blue remained in production until 1963, and trials were made in other colours, notably yellow.

The outbreak of the First World War affected Moorcroft but production was maintained by expanding export markets and by undertaking government contracts. Beer and shaving mugs and hospital inhalers, all hand thrown, were made in large quantities, and so Moorcroft was able to retain most of his staff. In 1915 he began to exhibit at the British Industries Fair, an event that became a regular feature of the Moorcroft calendar. However, it was during the 1920s that the Moorcroft reputation really developed. Rich colours, strongly drawn patterns and a range of natural subjects, both domestic and exotic, characterise the wares

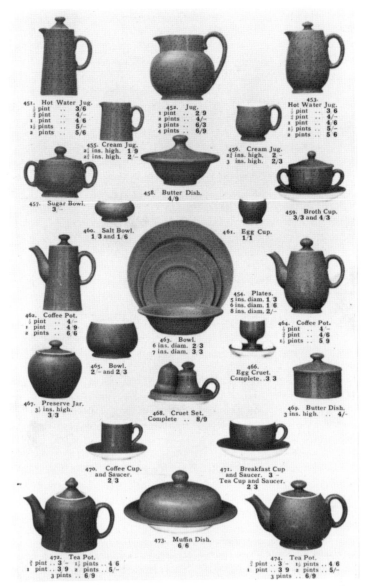

15 Liberty advertisement showing the Powder Blue tableware range, about 1920

of this period. English flowers were still used, in new, more vibrant combinations, but more powerful were the patterns based on fruit, orchids, toadstools and exotic flowers, such as the Australian waratah, of the 1930s. The landscape design reappeared in richer forms: the sombre, nocturnal Moonlit Blue, the dynamic autumn colours of Eventide, so typical of the 1920s and the cool tones of Dawn, with its matt saltglazed finish. Other designs reappeared constantly over a long period of time, including peacock feathers, fish, and butterflies. Animals never featured, except on some commemorative wares. As with the Florian Wares, the relationship between the surface pattern and the shape of the pot was always carefully controlled. It is difficult to find a Moorcroft piece with unhappy proportions, a feature that reveals his debt to the Far East. Some shapes he used throughout his life, others appeared once only. Moorcroft, a true potter, was always fascinated by the possibilities of clay, and so he designed many unusual objects as well. There are candlesticks, inkwells, pen trays, cigarette boxes, tobacco jars and matchbox holders, clockcases, toastracks, scent bottles, face masks and buttons, as well as a series of little plaques designed to be mounted as jewellery, their brilliant colours equating semi-precious stones. Many pieces were also designed to be mounted in silver, silver plate, pewter and brass. The best of the silver mounts were made by Francis Arthur Edwardes, a family friend and a teacher at the Burslem School of Art, and a traditional Arts & Crafts silversmith and enameller, while the most familiar of the metal mounts are the hammered pewter of the Liberty Tudric range.

Perhaps the greatest achievement of the 1920s were the monochrome glazed wares. Following the Flamminian wares introduced in 1905, their plain grounds relieved by small Japanese-style medallions, and the irridescent monochrome lustres that were produced from 1914, Moorcroft became increasingly interested in purer, more directly oriental styles of ceramics. Lustre production continued at Cobridge until 1922-1923 using a kiln specially built for the purpose. Many lustres of this period were based on the speckled Powder Blue colours. For a short period during the early 1920s dark monochrome stonewares were also made. However, it was the high temperature flambé glazes that were to represent Moorcroft's highest achievement in this field. Like many of his contemporaries, for example C. J. Noke, Bernard Moore and Howson Taylor, Moorcroft had always been interested in transmutation glaze effects. He had experimented with high temperature firing at the Washington Works, but he was not able to develop the process fully until he built himself a special flambé kiln at Cobridge in 1919. In this oven he was able to unlock the secrets of the process that was to turn him into a Master Potter during the 1920s and 1930s. The tones of deep red chartreuse and purple that characterise Moorcroft flambé are endlessly varied. Unlike Noke and Moore, who attempted to produce a controlled sang de boeuf colour, Moorcroft revelled in the unpredictability of the firing, the eccentricity of the colours and the uniqueness of each piece that was produced by this barely controllable process. He was always secretive about the flambé firings, and insisted on controlling the oven himself during the long days and nights.

The flambé wares greatly increased Moorcroft's reputation, at home and abroad. During the 1920s and 1930s Moorcroft pottery was being sold in Tokyo, Milan, Buenos Aires, and New York, among other places. He exhibited widely and enjoyed critical acclaim at Wembley in 1924, at Paris in 1925, and at other major displays. Awards included a Grand Prix at Antwerp in 1930, and a Diploma of Honour at Milan in 1933. In 1924 the *Daily Graphic* commented: ' . . . such a Master Potter is William Moorcroft, an artist of the most distinguished gifts, whose work may be seen in the Palaces of Industry and Art at the British Empire Exhibition. The master of today is the old master of tomorrow, and Moorcroft pottery will be the quest of collectors of future generations, for it is the perfect expression of the potter's art.' Museums were also acquiring examples of Moorcroft pottery during this period, particularly those in Germany, France, the United States and Japan. Also important was the relationship between Moorcroft and the Royal Family. This had started in 1913, when Queen Mary visited the Potteries and admired Macintyre's display of Florian Ware. The Queen's interest in ceramics was well known and she became a regular visitor to the British Industries Fair, always taking time to visit the Moorcroft stand and acquire choice pieces. These visits were fully described in the *Court Journal*, from 1917 onwards, along with the pieces bought by Her Majesty. Even the King was impressed, admiring the Powder Blue among other wares, a point not missed by the *Daily Graphic*: 'The King and Queen have expressed the highest appreciation of Mr Moorcroft's art, which has also won the enthusiastic admiration of the Queen of Roumania. Queen Mary is no new admirer of Moorcroft ware; she has acquired several delightful specimens in the past.' Royal support reached its climax in 1928, when Moorcroft was appointed Potter to Her Majesty Queen Mary. This Royal Warrant was a personal honour for Moorcroft. Writing in 1946, John Bemrose drew a parallel between this award and other Royal appointments, such as Master of the King's Music, seeing it as 'the laureate of a noble profession.' From about 1930 the phrase Potter to HM the Queen was widely used as an impressed mark and on paper labels.

The 1930s saw another dramatic change of style for Moorcroft, with a return to pale grounds and colours, and the extensive use of matt surfaces. Designs were simplified to suit current tastes, and patterns became more abstract. Some earlier designs were

16 The Commemorative Diploma awarded to Moorcroft at the Paris Exhibition in 1937

redrawn in this new style, for example honesty and fish, while other motifs were new, such as birds or corn. Semi-abstract and geometric Art Deco style borders were also widely used. Moorcroft responded to current enthusiasms for handmade studio pottery by emphasising the handcraft qualities that were inherent in his wares, and by relying increasingly on simple forms and soft, plain colours. The commercial success of these new styles was limited, partly because of their apparent rejection of the decorative and colourist tradition firmly associated with Moorcroft, and partly because of the international situation. Like many other British potters, Moorcroft had suffered directly the effects of the Wall Street Crash of 1929. Major clients had disappeared overnight, markets had shrunk, and decorative pottery seemed out of place in a depressed world. Export sales became the lifeblood of the business, helped by the international reputation that Moorcroft had come to enjoy. The home market was greatly reduced but abroad his wares were still highly regarded. The Moorcroft display at the Paris exhibiton of 1937 was enthusiastically acclaimed in *La Revue Moderne des Arts et de la Vie*: 'le plus célèbre artiste céramiste d'Angleterre a dû rechercher un cadre vaste pour y présenter un ensemble d'oeuvres qui fut digne de son magnifique talent. Moorcroft a brillamment moissonné les plus hautes récompenses, consécrations d'un art qu'il a porté à son apogée. Les plus illustres collectionneurs du monde entier, les critiques formés par toutes les cultures ont rendu hommage à la valeur exceptionnelle de ses créations.'

In Britain, Moorcroft found himself increasingly out in the cold. One by one his contemporaries gave up: Pilkington stopped production of their Royal Lancastrian Ware in 1935, Howson Taylor's Ruskin Pottery was effectively closed in 1933 and even Doulton were only making half-hearted attempts to maintain the production of Lambeth Art Pottery. The climate had changed, and the need for austerity was better reflected by the dull glazes and rough textures of the studio potters. Moorcroft struggled on, becoming increasingly experimental in his outlook, and determined to maintain the production of industrial art pottery. Coloured and flambé wares continued to be in demand overseas, and this demand carried the factory through the difficult years of the late 1930s.

In the Second World War this pattern was maintained. Exports of decorative pottery, helped by government contracts, enabled Moorcroft to retain his workshops, and a skeleton staff. For the home market, with the production of decorative wares prohibited, he made a range of plain ivory tableware known as Austerity Ware. The war years were a time of desperate struggle for Moorcroft, with only his will power keeping himself, and the pottery, alive. In October 1945 he was taken ill, and his son Walter came home from the army on compassionate leave. A few days later, on October 14, William Moorcroft died. Walter, demob-

ilised without returning to active service, took over the running of the factory.

Right up to his death, William Moorcroft was an autocrat in his own world. He insisted on total responsibility for every aspect of production, from the design through to the sale and distribution of the wares. He never employed a manager, or any other designer. Yet, at the same time, he fully appreciated the skills of the craftsmen and women that he employed. Designs were adopted, abandoned and then re-adopted for no particular reason. Half-completed pots would suddenly interest him no more, and be relegated to the ever growing pile beneath the work bench. Customers were expected to tolerate the unpredictabilities of the firing, and still pay good prices for good pieces. Alternatively they might be given the pots for nothing. Yet beneath all this was a sound business sense and a dedication that kept the pottery open when all around were closing down. He was inclined to refer to himself as an industrialist and, in an age when art pottery had come to be an anchronism, he was an important bridge between commercial production and the studio potter. He was, above all, a master potter and in 1913 he described his feelings towards his chosen field: 'I have always been charmed with the sense of freedom and individuality that has characterised the work of the Eastern potter, and it was after long dreaming of what was possible in this direction that I was first able to express my own feeling in clay. Perhaps no other material is so responsive to the spirit of the worker as is the clay of the potter, and my efforts, and those of my assistants, are directed to an endeavour to produce beautiful forms on the thrower's wheel, the added ornamentation of which is applied by hand upon the moist clay. This I feel imparts to the pottery the spirit and the art of the worker, and spontaneously gives the pieces all the individual charm and beauty that is possible, a result never attained by mechanical means.'

The reputation that Moorcroft enjoyed ensured he had plenty of imitators. Some companies actually produced wares designed to be mistaken for Moorcroft pottery, using the same patterns and colours. In the 1920s a Staffordshire company produced copies of Moorcroft pomegranate wares, using the same colours and the same slip-trailed technique. These wares are unmarked, but occur on shapes Moorcroft never used. The Bough Pottery in Edinburgh also produced Moorcroft replicas, and Jacobs produced a Moorcroft biscuit tin. Other companies did not actually reproduce Moorcroft designs but used the same techniques and colours to create a generally similar style. The early success of Florian Ware probably encouraged Minton to launch their Secessionist Ware in 1902, a range of slip-trailed ornamental and domestic wares designed by John Wadsworth and Leon Solon. Solon had, in any case, been producing slip-trailed tiles and panels since the 1890s. Another early imitator was George Cartlidge, whose Morris Ware, designed for S. Hancock & Company during the early 1900s, was decorated with slip-trailed floral patterns with a strong Florian bias. Jacobean Ware, produced during the 1920s under the Royal Stanley label, was a transfer-printed design of fruit and flowers in typical Moorcroft colours, while Hancock's Rubens Ware of the same period featured a painted pomegranate design. It was inevitable that slip-trailing should achieve a general popularity during the first decades of this century, particularly among tile designers and manufacturers, and so it would be unjust to call an artist such as Charlotte Rhead an imitator of Moorcroft. Yet Moorcroft has to take the credit for introducing a style of decoration that was to be so influential among both art and commercial potters.

17 Preserved at the factory are many drawings by Moorcroft used for transferring the designs onto the ware. Moorcroft would adapt each design to fit a particular shape, using a purple ink on tracing paper. The decorators would then rest the paper against the green ware and rub on the design, leaving a pale outline to be followed by the slip-trailers

18 Family group at Trentham in 1930, taken three years after Florence Moorcroft's death. Left to right: Edith Parry (Florence's sister), her husband Philip Lestor Parry, William Moorcroft, Walter Moorcroft, Beatrice Moorcroft

Chapter Two
William Moorcroft at James Macintyre & Company, 1897-1913
Macintyre Art Pottery, 1894-1898

Macintyre's opened an Art Pottery department in their Washington Works in the early 1890s. Little is known about their earliest productions, except that, from the start, designers drawn from outside the factory seem to have been invovled. Two early ranges, Taluf Ware and Washington Faience, were shown at the *Exhibition of Decorative and Artistic Pottery* held at the Imperial Institute in 1894. Both featured slip decoration, both had printed backstamps, and some Washington Faience designs were registered. The sprigged ornaments on Washington Faience were modelled by Mr Wildig.

In 1895 Harry Barnard was appointed director of the art pottery department. Trained in slip decoration at Doulton's Lambeth studio, Barnard introduced a new style of ornament featuring Art Nouveau patterns built up by hand in raised slip. This was name Gesso Faience and the range was launched in 1896-1897 with its own printed backstamp. In 1896 Barnard left Macintyre to join Wedgwood, where he continued the development of slip decoration.

When William Moorcroft took over the design and production of the art pottery in 1898, he had been working for Macintyre's for nearly a year. During this time he had designed new shapes for both useful and ornamental ware and introduced the Aurelian Ware that was decorated in printed patterns with enamel and gold. By the autumn of 1897 his new domestic ware had progressed far enough for the firm to register some of his new shapes, in November 1897 and January 1898, and three Aurelian Ware designs were registered in February 1898. The process of slip-trailing was by this time used widely and Moorcroft had begun experimenting with it for the decoration of the plain slipware before the end of 1897. During this experimental period some printed Aurelian designs were combined with slip-trailing.

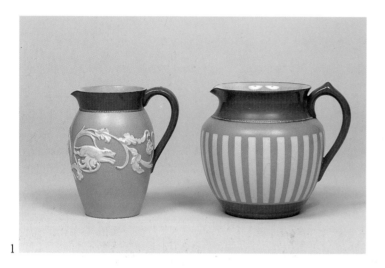

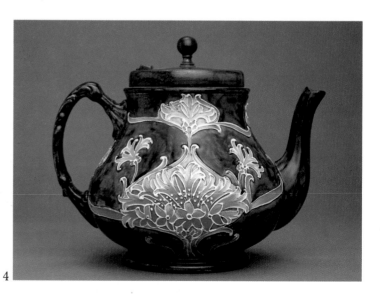

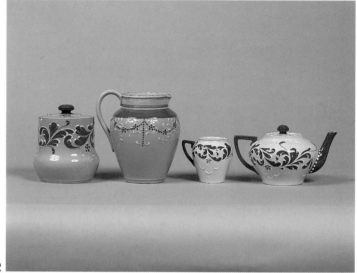

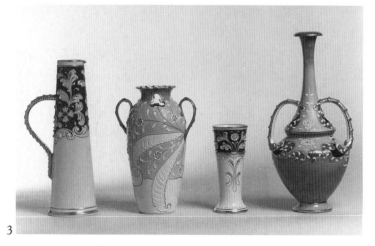

1 Early Macintyre art pottery, c1894. Left, Washington Faience jug with sprigged decoration modelled by Wilding; right, Taluf Ware jug with carved slip decoration in typical Macintyre colours. Faience jug height 5½ ins

2 Gesso Faience with slip-trailed decoration probably designed by Harry Barnard, c1896. Large jug height 7½ ins

3 Group of wares decorated with raised slip designs by Harry Barnard at Wedgwood, c1898

4 Macintyre shape teapot, registered in 1897, with Gesso Faience mark, but with cornflower design by Moorcroft, both the colour and the style suggest that this was an early example of Moorcroft slip decoration. Height 6½ ins

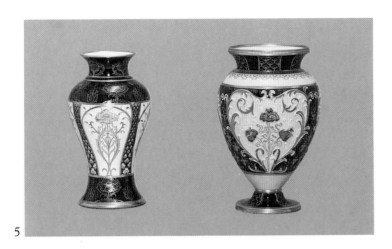

5 Left, an Aurelian Ware vase with a printed design of poppies; right, a vase with a related design in raised slip combined with printing, Florian Ware backstamp c1897. Larger vase height 8½ ins

6 Group of Aurelian Ware with transfer-printed patterns enriched with red enamel and gilding, designed by Moorcroft in 1897. Largest vase height 10 ins

7 Group of wares showing Moorcroft's development of his design from the printed Aurelian Ware vase on the left to the blue Florian Ware on the right, via slip-trailed tablewares, c1897. Jug height 6½ ins

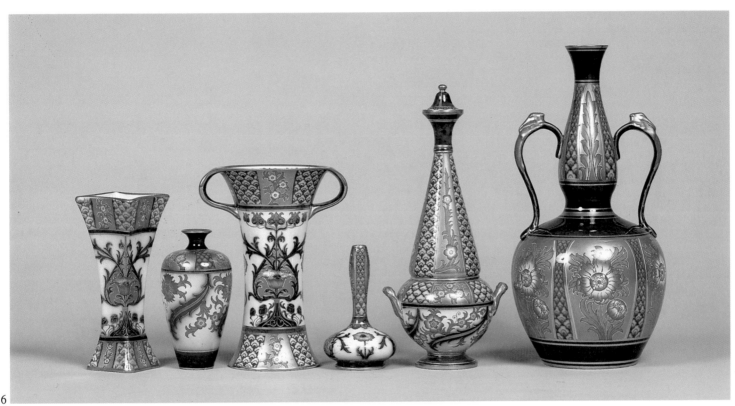

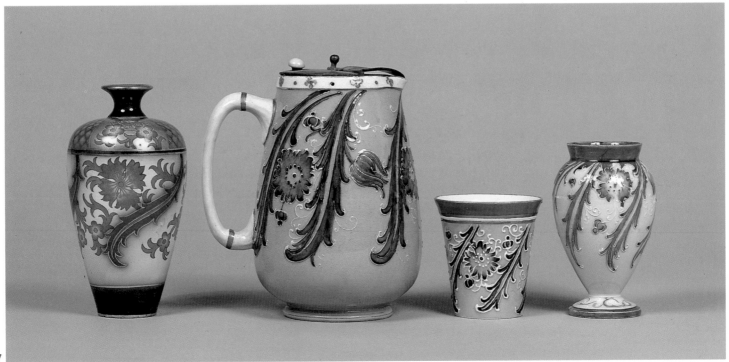

Florian Ware, 1898–c1906

Florian Ware, the range that established Moorcroft as a designer, was launched in 1898. Decorated with flowing floral patterns in applied raised slip, a distinctive technique and style that Moorcroft was to use for the rest of his life, Florian Ware represented a blend between contemporary Art Nouveau and the decorative traditions of William Morris and the Arts and Crafts Movement.

There are many different Florian patterns, the majority based on English flowers. Poppies, violets, tulips, iris, forget-me-nots, cornflowers, daisies, roses, narcissi, honesty were all used, as well as peacock feathers, butterflies, fish and the first of the landscape designs. At first coloured grounds were used, pale blues and greens often with patterns in darker tones of the same colour, but later white and cream grounds became more common, decorated with patterns in pinks, yellows and brown. Some designs, particularly those on white grounds, were enriched with gilding. Between September 1898 and September 1902 about ten Florian designs were registered, one of the last being the landscape design. The shapes were designed by Moorcroft as well as the patterns, and the coordination between the two is characteristically good. Shapes were inspired first by Middle and Far Eastern ceramics

and later, from about 1900, by classical pottery. Florian Ware was marked with a printed backstamp, and it was the first range to be regularly signed or initialled by Moorcroft. The backstamp remained in use until about 1905. Some versions of Florian Ware carried different backstamps, for example the Hesperian Ware made for Osler's, and the rare Butterfly Ware.

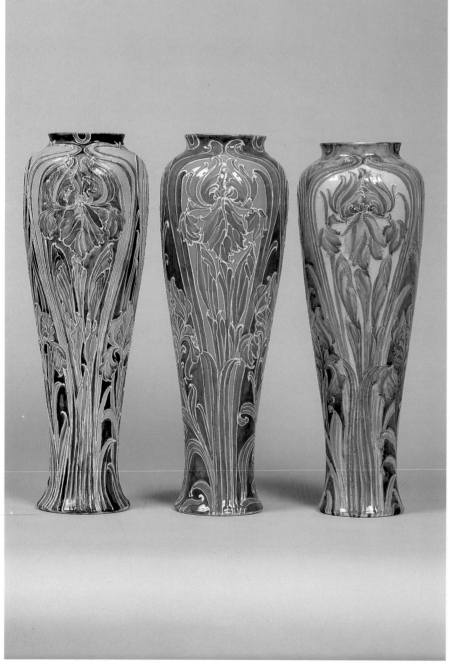

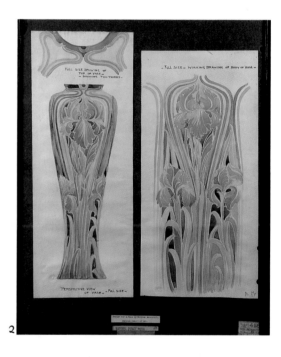

1 Three early Florian Ware vases decorated with the iris pattern in typical colours. The green vase is dated March 1899, and the blue vase carries the Hesperian Ware backstamp.
Largest vase height 16½ins
2 Design for a vase by William Moorcroft for which he received a bronze medal in 1898 in the annual National Competition organised by the Department of Science and Art.
3 Group of Florian Ware decorated with versions of the iris design. The four on the left show the early version of the pattern; the white ground version on the right is c1900.
Largest vase height 12ins
4 Group of Florian Ware decorated with versions of the violet design, which was registered in September 1898. All 1898–c1900. The smallest vase also carries a Liberty mark.
Largest vase height 12½ins

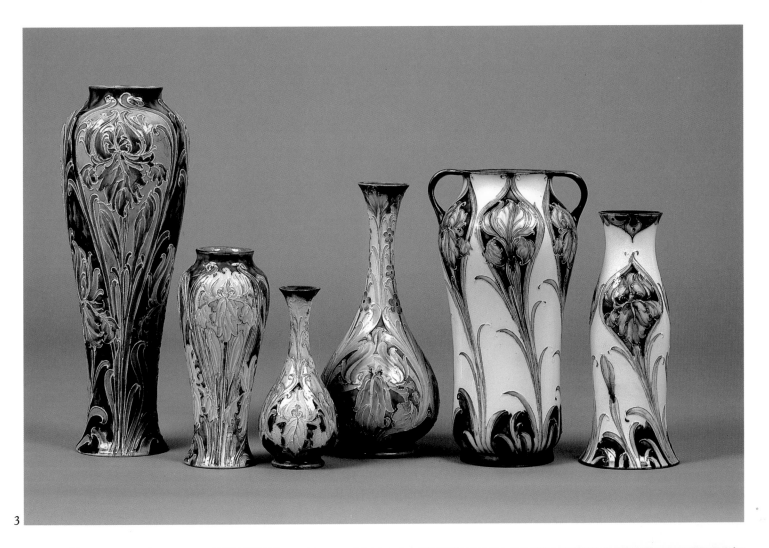

3

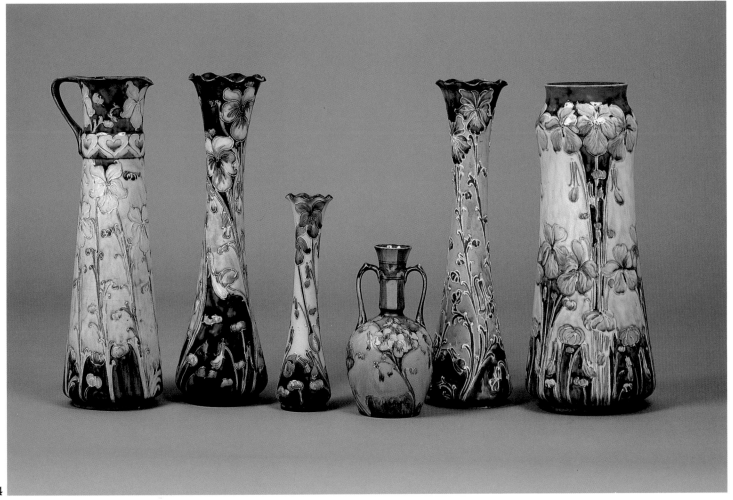

4

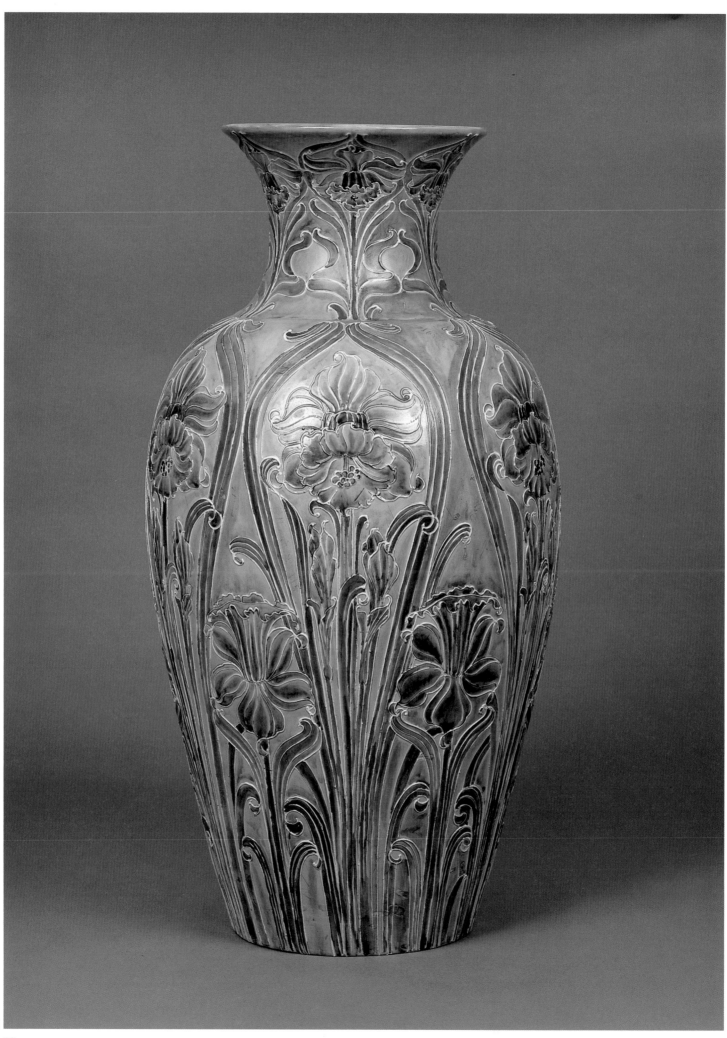

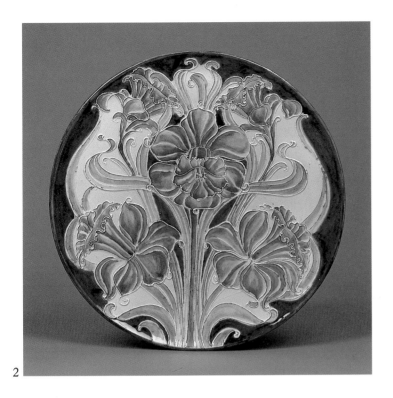

2

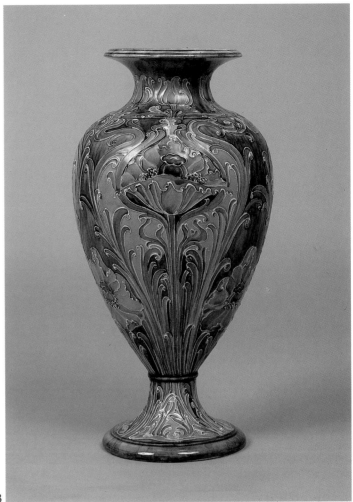

1 Large vase decorated with the iris design, showing the thick slip and pale colours of early Florian Ware. Dated July 1900. Height 24½ ins
2 Plate decorated with the daffodil design in typical Florian blues, c1900. Diameter 12½ ins
3 Florian vase decorated with the poppy design, registered in September 1898. Height 12¾ ins
4 Group of Florian Ware decorated with the poppy design, showing some of the early colours. The dish and the blue and yellow vase also carry Liberty marks. All c1900. Largest vase 12½ ins

3

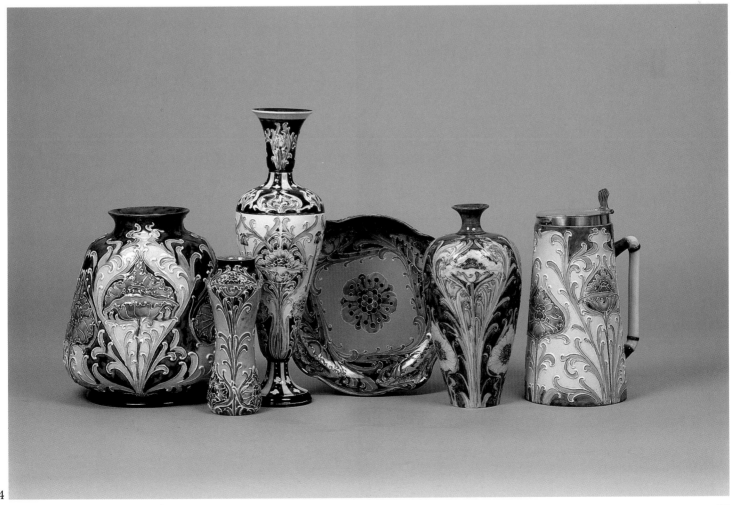

4

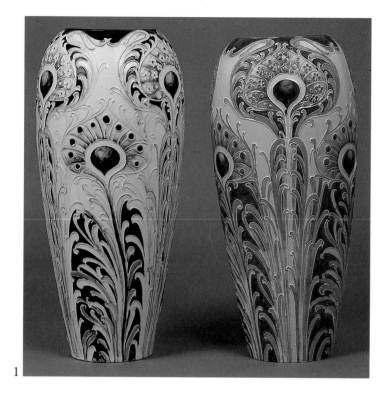

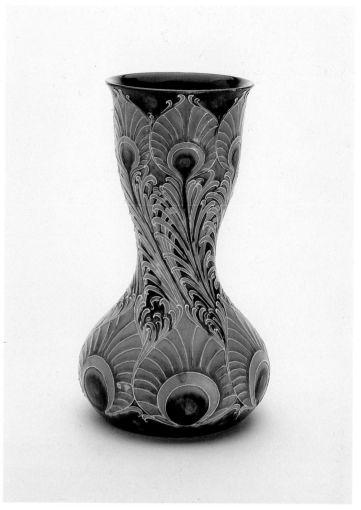

1 Two Florian vases decorated with versions of the peacock design, registered in October 1899. This is probably Moorcroft's most characteristic vase form, and it is still used today. Both c1900. Larger vase height 14½ ins

2 Florian vase decorated with the peacock design in unusual colours, c1900. Height 10¾ ins

3 Group of Florian Ware decorated with versions of the peacock design in typical early colours, all c1900-1902. Largest vase height 11 ins

2

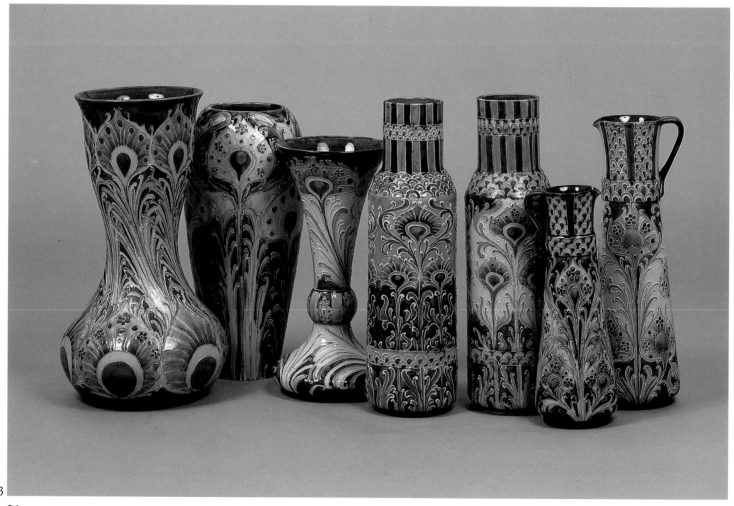

3

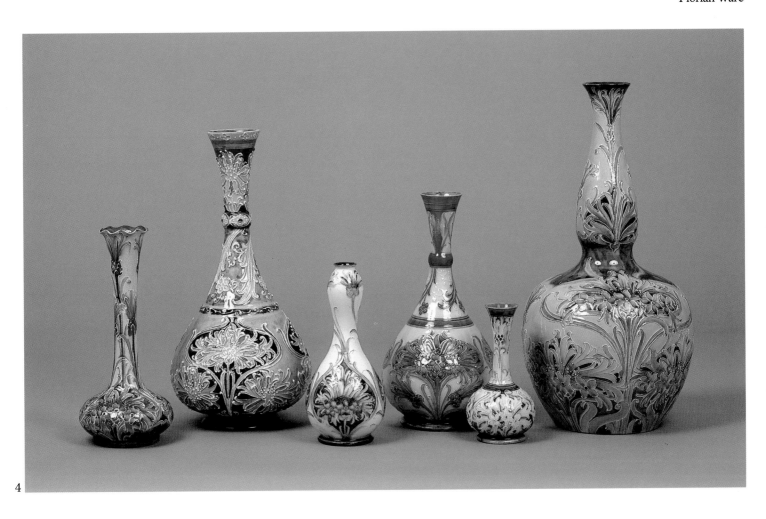

4

4 Group of Florian Ware decorated with the cornflower design, all c1900-1902. Largest vase height 13½ ins
5 Group of Florian Ware decorated with the daisy design, showing the development of the pale grounds. The vase on the right carries the Hesperian Ware mark, and has the typical mauve colour. All c1902. Largest vase height 10 ins

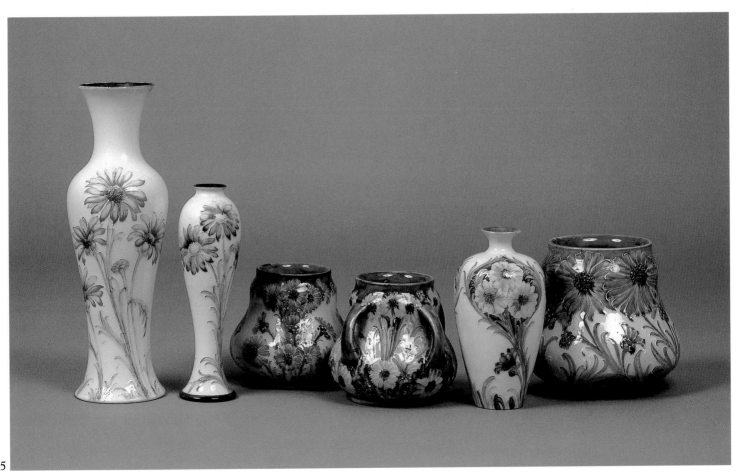

5

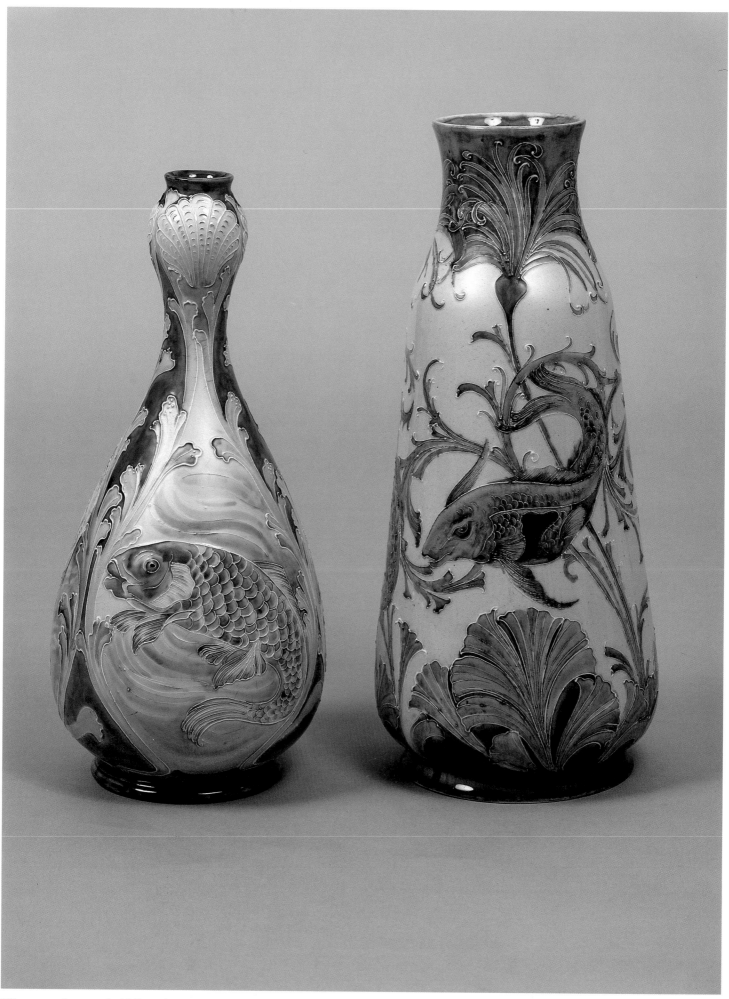

1

1 Two vases decorated with Japanese-style carp in an underwater setting, left Florian Ware, right Hesperian Ware with typical mauve highlights, both c1902. Larger vase height 13 ins

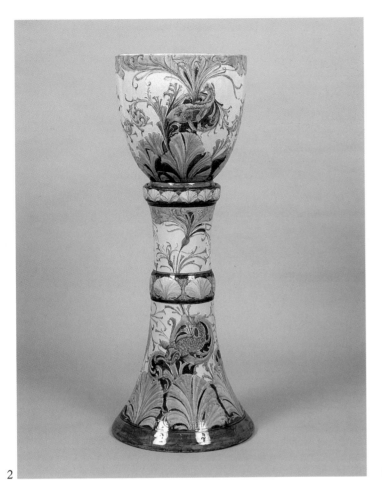

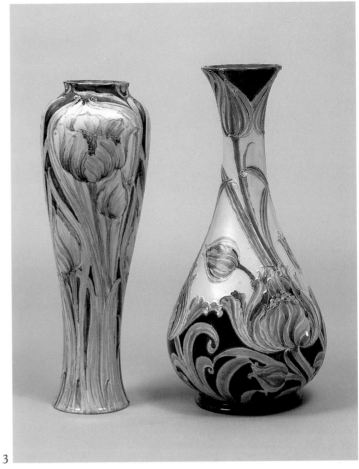

2 Hesperian Ware jardinière and stand, decorated with carp, seaweed and bands of shells, c1902. Overall height 34½ ins
3 Florian Ware vases, decorated with versions of the tulip design, c1900. Larger vase height 16½ ins
4 Group of Florian Ware decorated with the tulip design, and Hesperian Ware vase second from right, all c1900-1902. Largest vase height 13½ ins

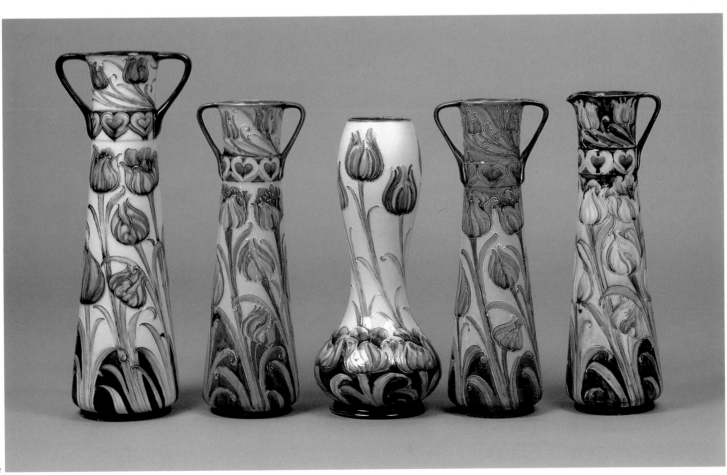

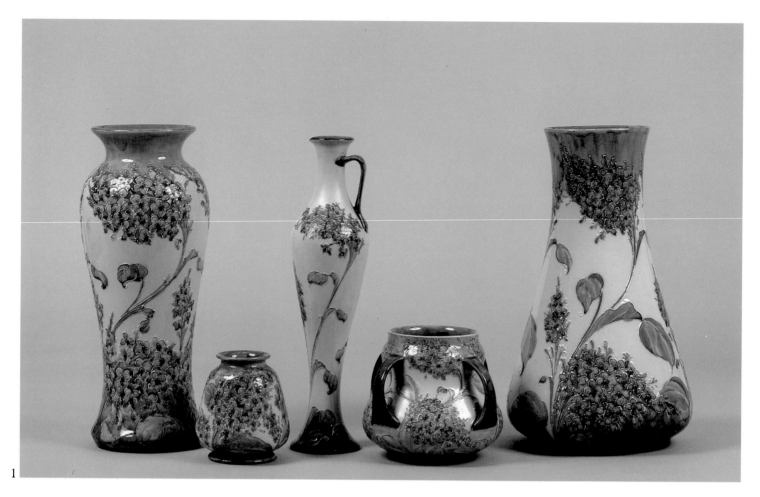

1

1 Group of Florian Ware decorated with the lilac design, c1902. Largest vase height 12 ins
2 Group showing different versions of the lilac design. Left, two Florian vases c1902, right, three pieces showing the pale grounds and rich gilding of the post-Florian period, c1905. Largest vase height 8 ins
3 Two Florian Ware vases decorated with the honesty design, showing the characteristic roughened and matt finished surface, c1903. Larger vase height 11ins

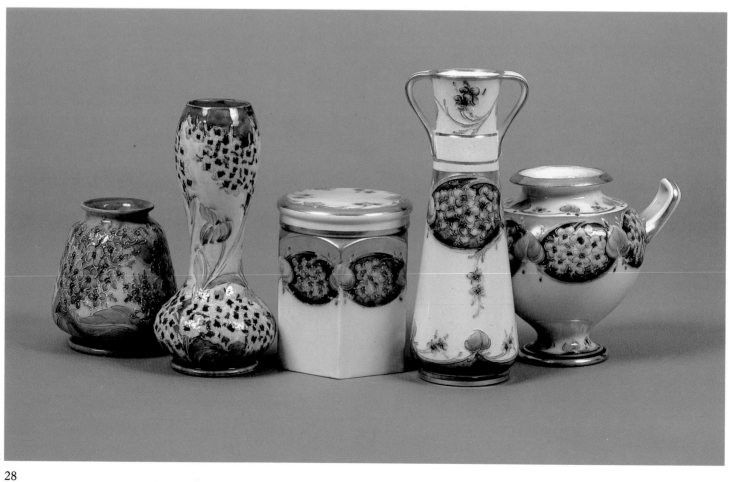

2

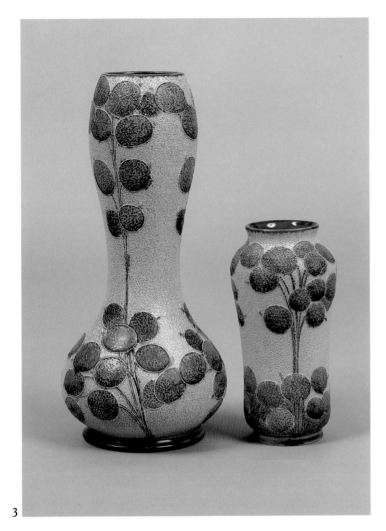

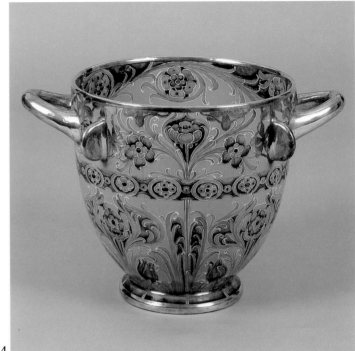

4

3

4 Jardinière decorated with daisy and poppy designs, additionally enriched with silvering, c1904. The shape is one that Moorcroft adapted from classical pottery, excavated at Pompeii. Made for Shreve & Company, San Francisco. Height 8¼ ins

5 Group of vases with butterfly designs, left to right, small vase with unusual colours and lustrous finish, marked Watkins Leadless Glaze, c1904, Butterfly Ware vase with characteristic dark ground, rich gilding and printed backstamp, design registered in 1899, Florian Ware vase registered in September 1898, and Florian Ware vase c1900. Largest vase height 11 ins

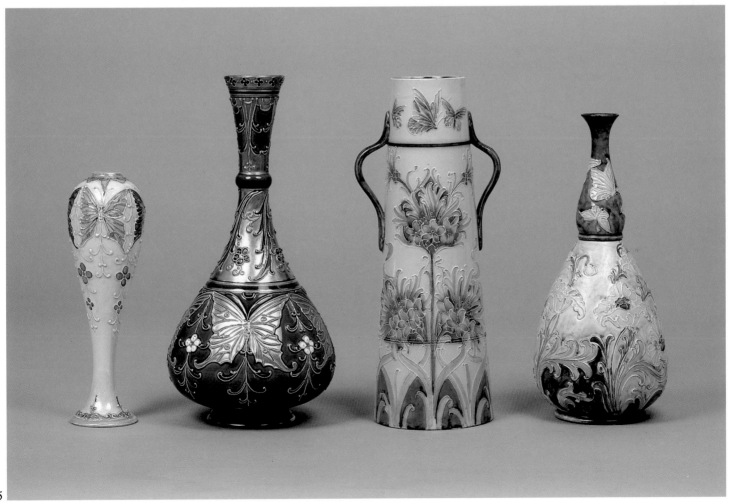

5

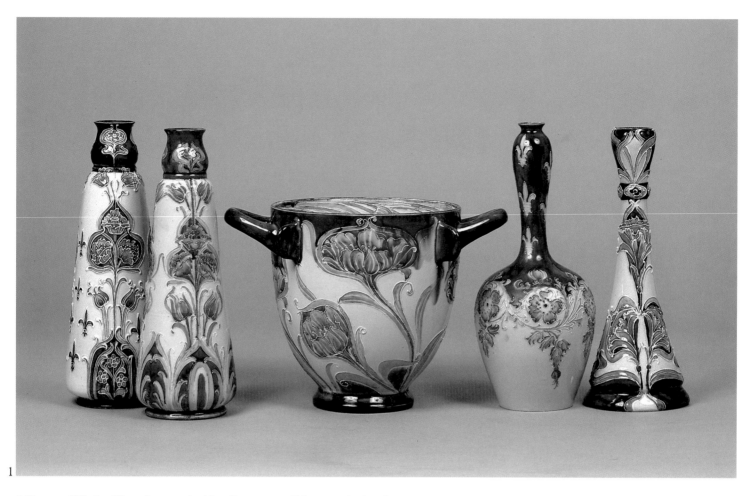

1

1 Group of Florian Ware decorated with tulip, poppy, wild rose and other flower designs, showing varied styles of slip trailing, c1899. Largest vase height 9 ins

2 Group of Florian Ware decorated with tulip, forget-me-not and other flower designs, most of which were registered in 1898, c1899. Largest vase height 9½ ins

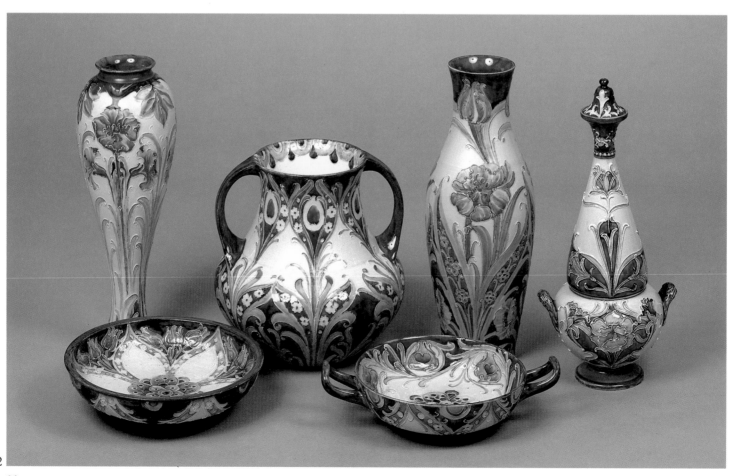

2

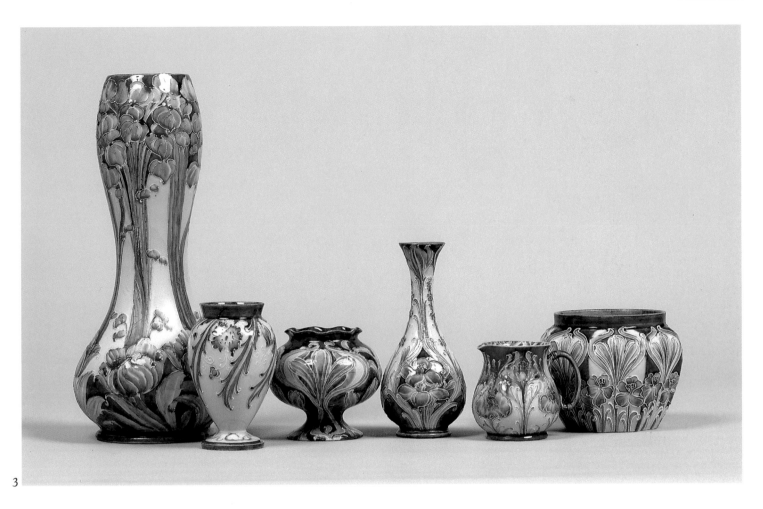

3

3 Group of Florian Ware decorated with primrose, crocus, fresia, tulip and other flower designs, c1899. Largest vase height 11 ins

4 Group of Florian Ware decorated with the iris and cornflower designs showing the distinctive salmon and green colours, c1900. Largest vase height 16 ins

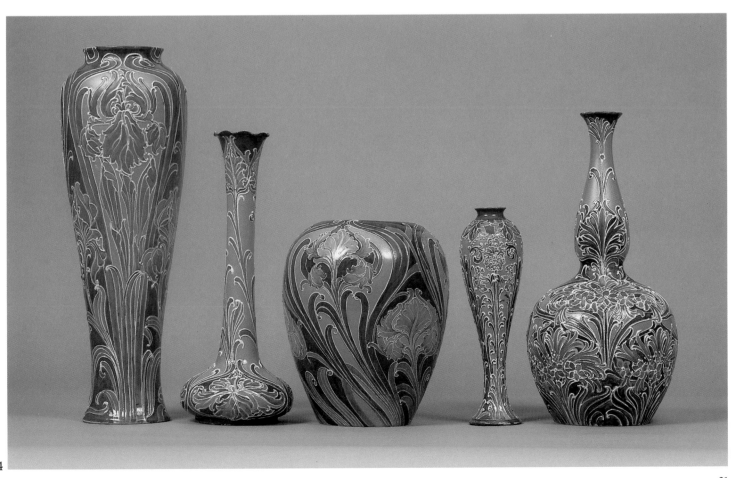

4

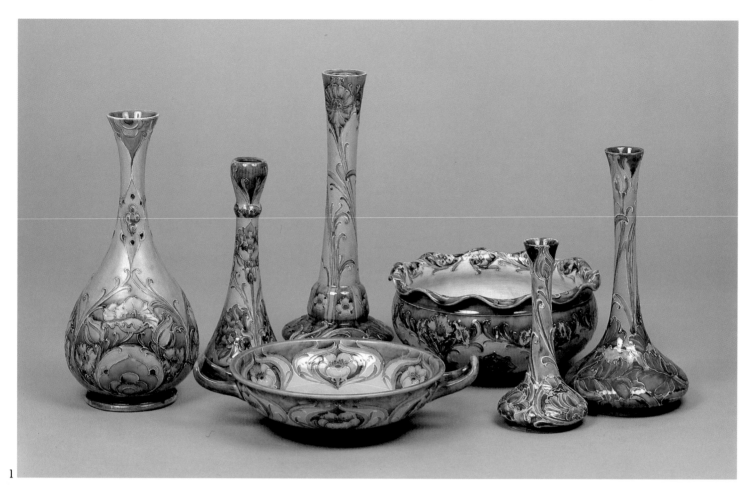

1

1 Group of wares decorated with Florian-style designs in blue and green, c1902. The two candlesticks and the bowl with handles carry Liberty marks. Larger candlestick height 9¾ ins
2 Group of Florian Ware decorated with assorted flower designs in blue, green and yellow, c1902. The dish has a Liberty mark and is in typical Liberty colours. Largest vase height 8½ ins

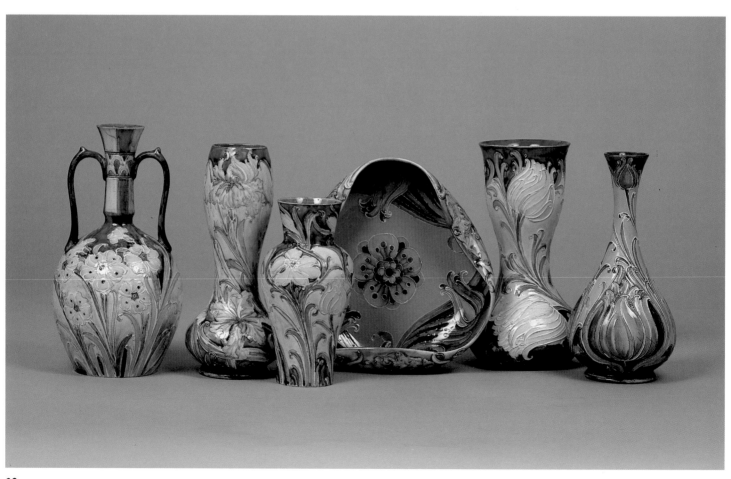

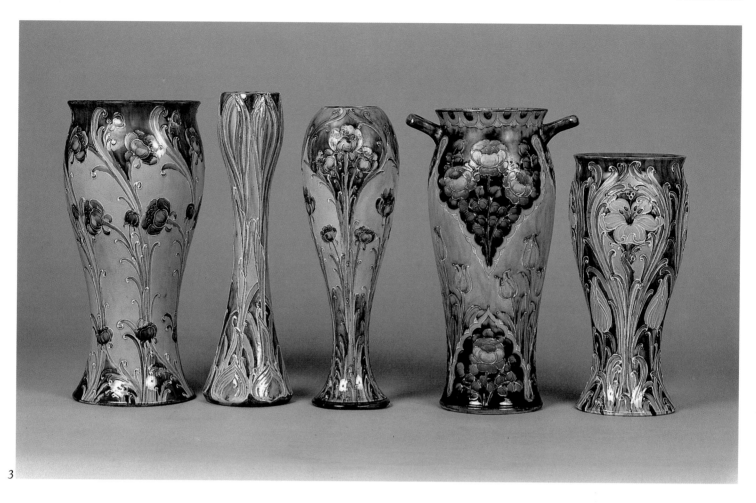

3

3 Group of wares decorated in Florian style with poppies, tulips and roses. The green ground vases have Liberty marks and the largest vase has a poppy design registered in September 1902. All c1902-1903. Largest vase height 12 ins
4 Group of Florian and similar ware decorated with various fresia, poppy, cornflower and harebell designs, c1902-1904. The smallest vase has a Liberty mark. Largest vase height 9½ ins.

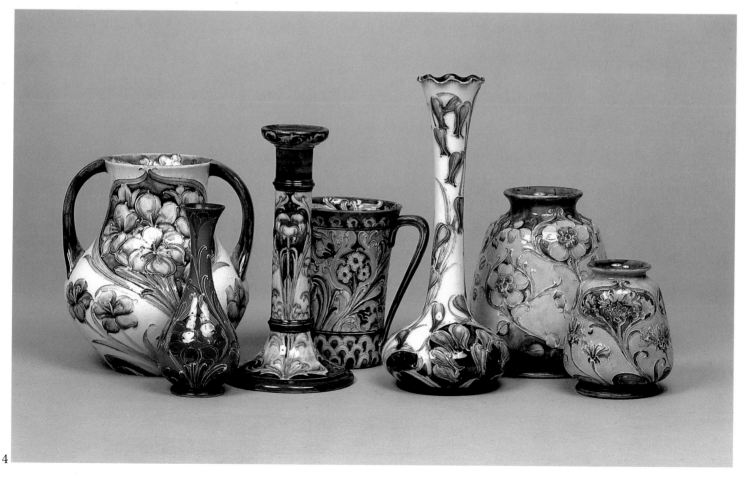

4

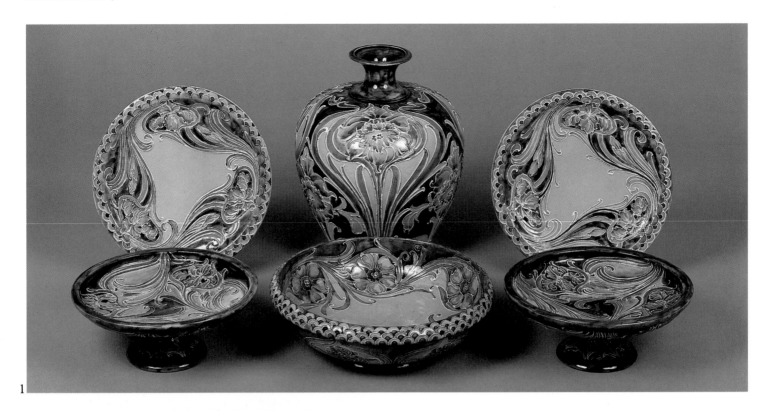

1

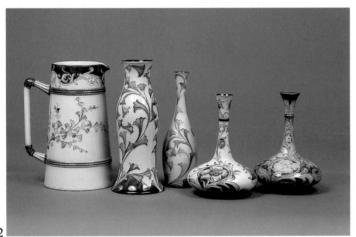

2

1 Group including tazze and plates from a dessert service and a Liberty bowl, all decorated with Florian-style designs, c1902. Vase height 8 ins
2 Group of four Florian Ware vases, two decorated with leaf designs related to the Lorne shape Dura Ware jug on the left. The jug shape was registered by Macintyre's in 1897. All c1902. Largest vase height 8 ins
3 Group of wares with Florian-style designs of poppies, daffodils and other flowers in characteristic Liberty colours, c1902. The small vase should have a flared rim. Largest vase height 9½ ins

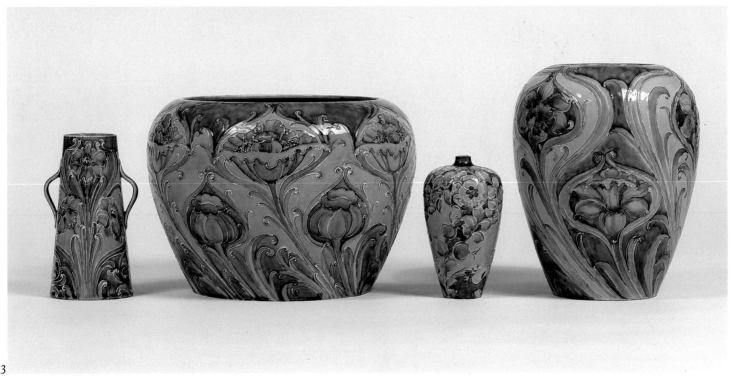

3

Later Macintyre Wares, 1902-1913

Although the styles and techniques of Florian Ware remained in use, Moorcroft began to move in new directions from 1903. Green and Gold Florian, design 404017, registered in January 1903, marked this change of direction. Intricately drawn and often richly gilded, the design with its tendril-like leaves has a strong Art Nouveau feeling. The main design features a flower and a tulip bud, but there is also a variant, a stylised dahlia flower, which has the same registration number.

There are three colour ways. The green is the most common and shows the best use of the gilding, the pink is less common and the blue is rare. These wares usually carry a printed Macintyre mark, the registration number and a Moorcroft signature. However, as a rule the pink version is unsigned, as these were finished outside Moorcroft's supervision in the enamelling rooms. This range was probably in production until about 1908. The other great change was the move to white or cream grounds, made possible by an increased range of colours and better firing control. The first of these was probably the Florian poppy design, 401753, registered in September 1902, and developed from the Dura tableware range. It was still being produced to order as late as 1914. This trend culminated in the Eighteenth Century Pattern, in production

from 1906 to about 1914, and the related designs introduced between 1907 and 1909. These featured roses, forget-me-nots and other garden flowers either contained in panels or drawn in sprays or garlands that made the most of the pale grounds.

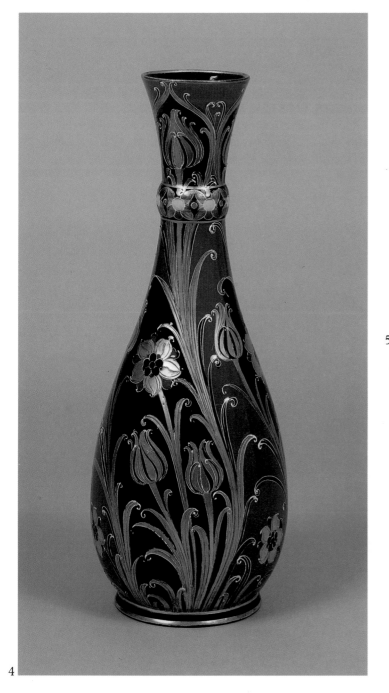

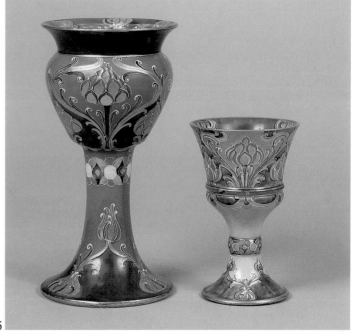

5

4 Vase decorated with the standard Green and Gold Florian design in green, with typical rich gilding, c1903. Height 16½ ins
5 Goblets decorated with the dahlia variant of the Green and Gold design, c1903. The pink version in unsigned. Larger goblet height 9½ ins

4

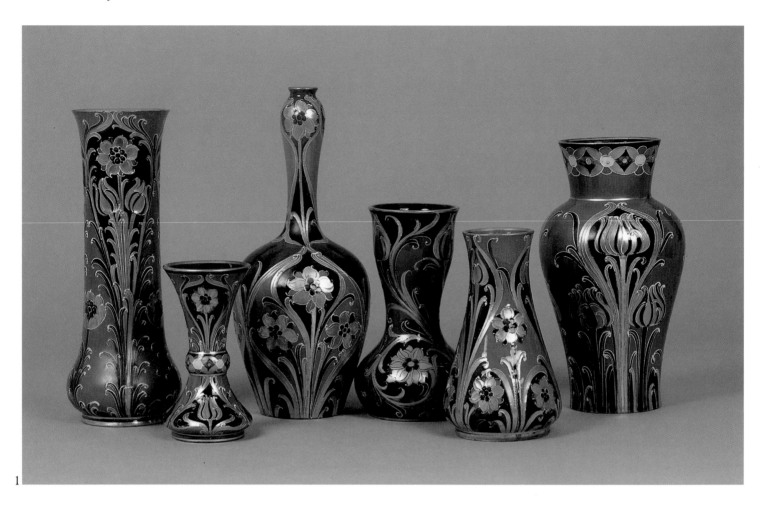

1 Group of vases decorated with the Green and Gold Florian design in green, c1903. Largest vase height 10½ ins
2 Group of vases decorated with the Green and Gold Florian design in blue, c1903. The vase without gilding is also unsigned, and so may simply be unfinished. Largest vase height 11 ins

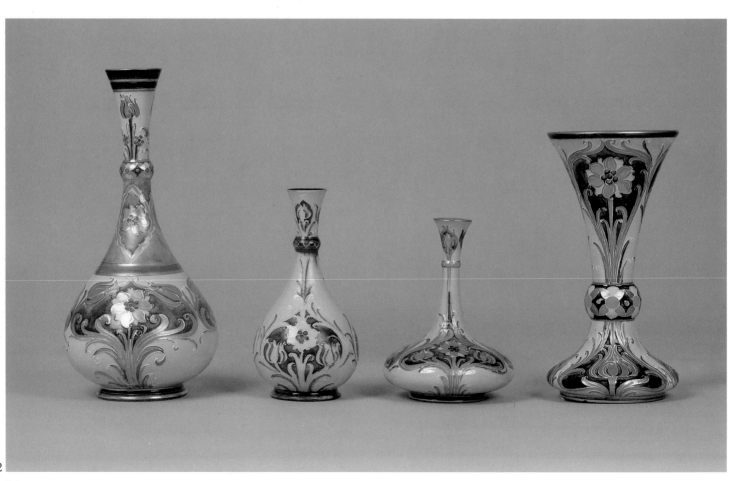

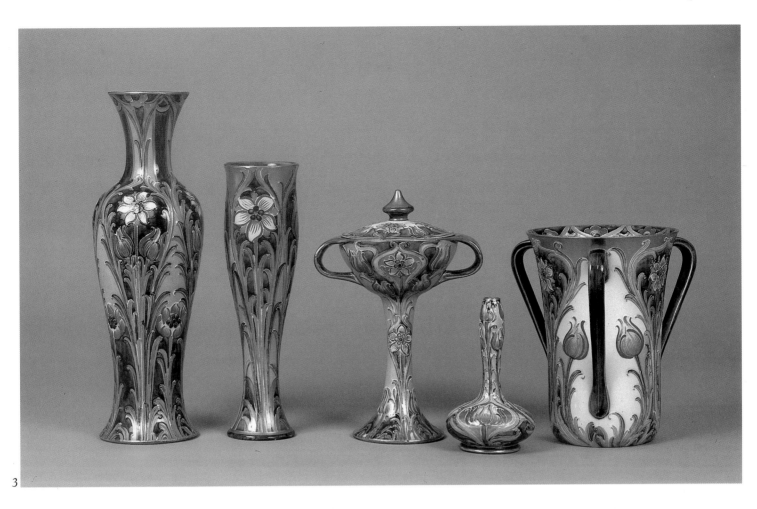

3

3 Group of wares decorated with the Green and Gold Florian design in pink, c1903. All unsigned except the slender vase second from the left. Largest vase height 12 ins
4 Group of wares decorated with a rose garland design on a white ground, enriched with gilding, c1907. Vase height 12 ins

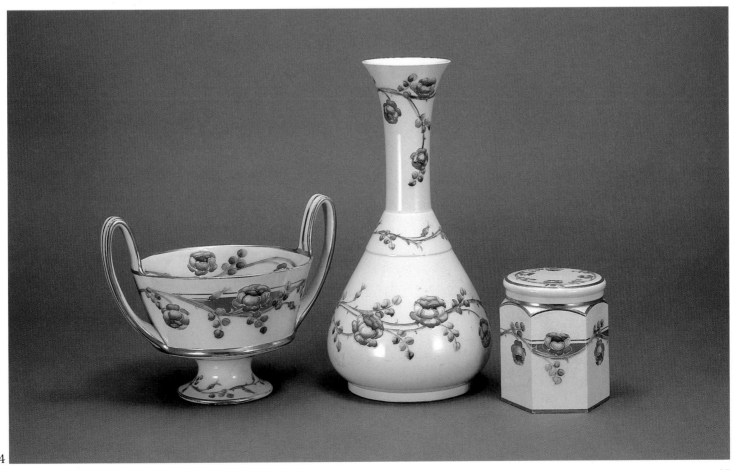

4

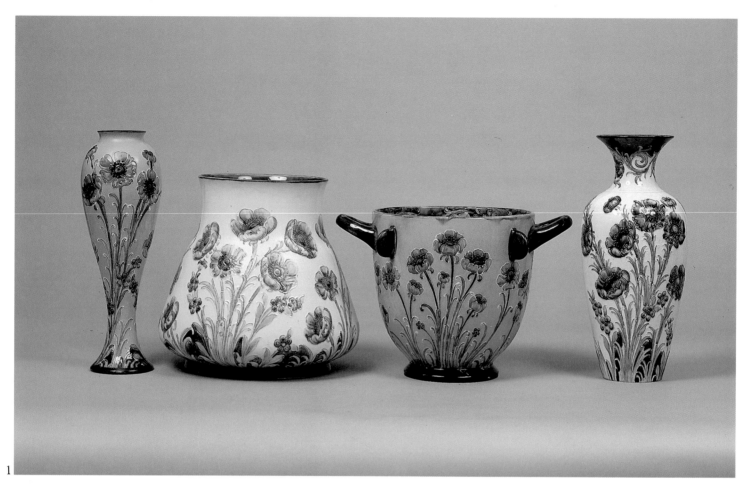

1

1 Group of wares decorated with a poppy design, showing the two colour ways. Registered in September 1902, the design is closely related to one of the Dura tableware patterns. Largest vase height 7 ins
2 Group of wares decorated with the poppy design, 401753, all c1903-1904. The shaker with its threaded base is unusual and is an enlargement of the miniature salts and peppers in the form of bird's eggs, designed to accompany egg-cups, that were a standard Macintyre range. Five of the eight pieces carry a Florian Ware mark. Jug height 11 ins

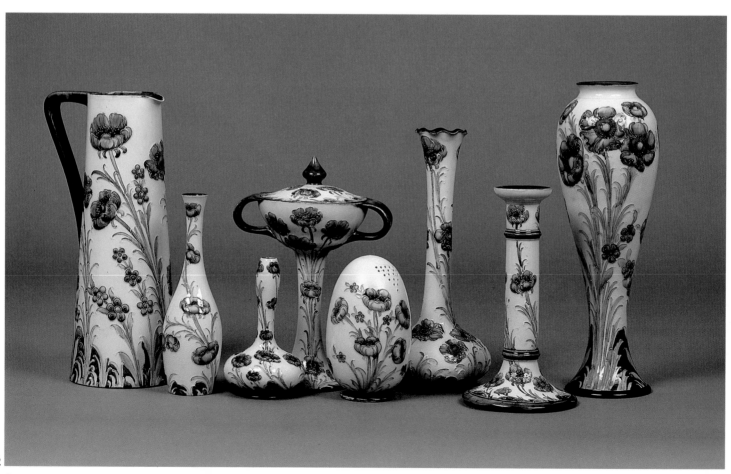

2

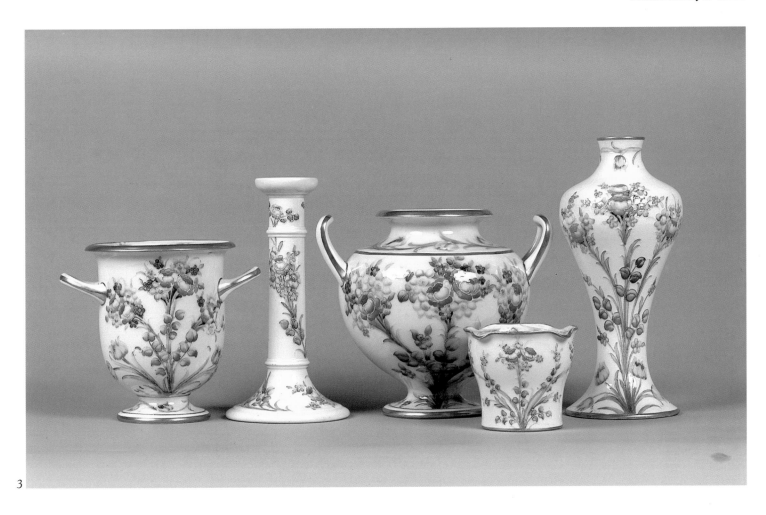

3 Group of wares decorated with sprays of roses, tulips and forget-me-nots, c1907. Vase height 9¼ins
4 Group of wares decorated with poppies, tulips and contained panels of forget-me-nots, c1908-1909. Largest vase height 9 ins

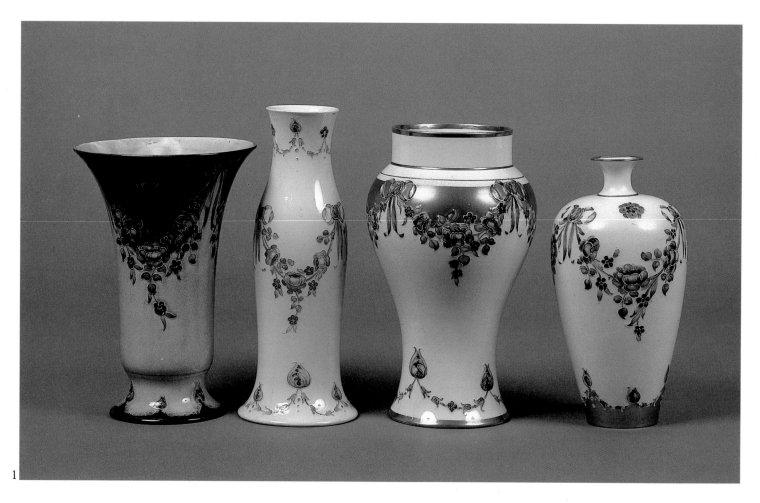

1

1 Group of wares decorated with the Eighteenth Century pattern, classical swags of roses and forget-me-nots, c1908. Trumpet vase height 10 ins

2 Group of wares decorated with a forget-me-not design contained within sharply incised panels, c1909. Largest vase height 8 ins

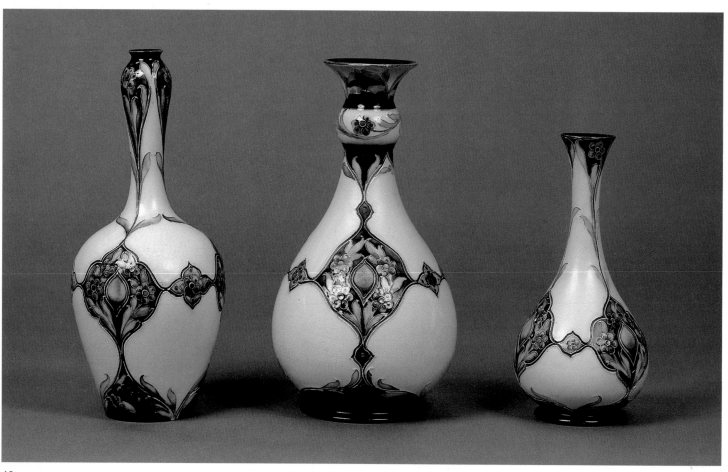

2

Macintyre Landscape Patterns, 1902-1913

The first Moorcroft landscape design, 397964, was registered in September 1902 and was included in the Florian Ware range. The characteristic design of trees in a rolling English landscape was first produced in shades of blue, with the tree heights varied to suit the shape of the vases. By the end of 1902 the green version was also in production and both were advertised in Liberty's *Yule-Tide Gifts* catalogue for that year, under the title Burslem Ware. The Liberty catalogue also mentioned the 'overglaze of yellow' that is a feature of many of the early landscape wares. Generally the Florian Ware mark is only found on the blue versions.

Liberty remained a major outlet for the landscape design, which was given the name Hazledene, and many pieces carry a Liberty mark However, the design was also sold through many other outlets. From about 1904 the colours gradually became richer and darker, culminating in the design of dark trees on an olive green ground that is typical of the period 1910-1913. This dark version of Hazledene was one of the patterns to be produced both at the Washington Works and at Cobridge, and so pieces carrying dates for 1913 and 1914 are quite common.

3 Two vases decorated with the landscape design, left a Florian Ware version in blue, right the green version with a Liberty mark, both c1903. Height 12 ins

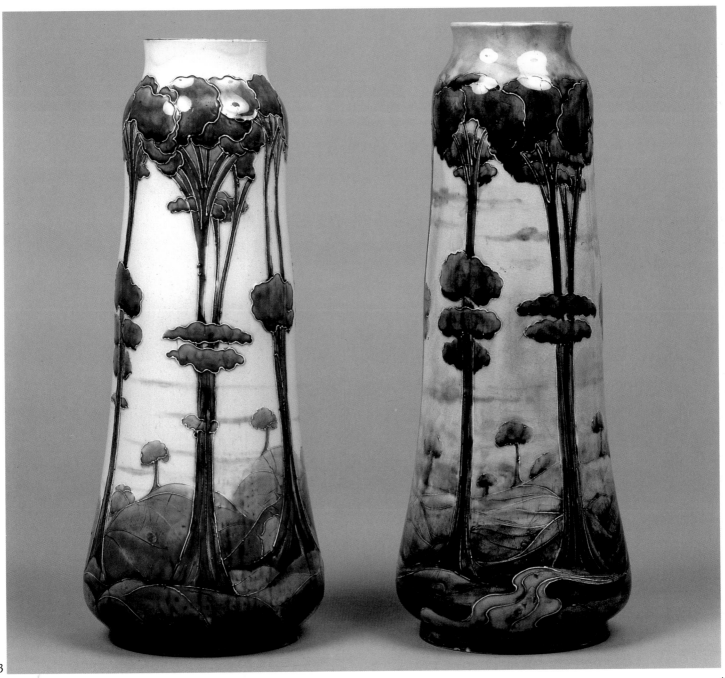

3

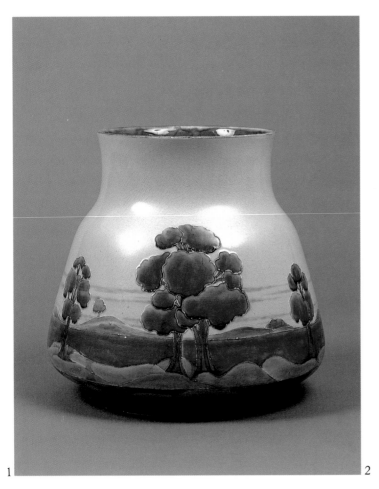

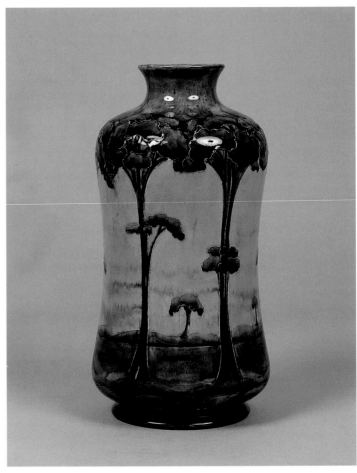

1 Florian Ware vase decorated with the landscape design, c1902. Height 10 ins
2 Vase decorated with the landscape design, showing the blended blue, green and yellow colours, c1903. Height 12ins
3 Group of wares decorated with versions of the landscape design, showing varied tones of green and blue, c1903-1904. The ovoid vase on the left, the tall flared vase and the jug carry Florian Ware marks. Jug height 8 ins

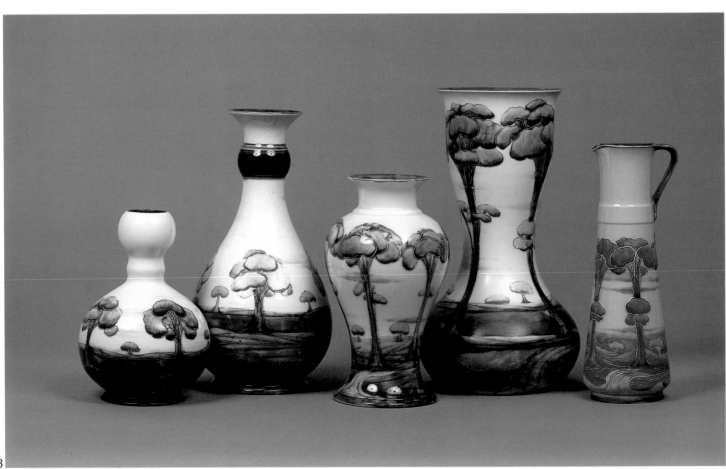

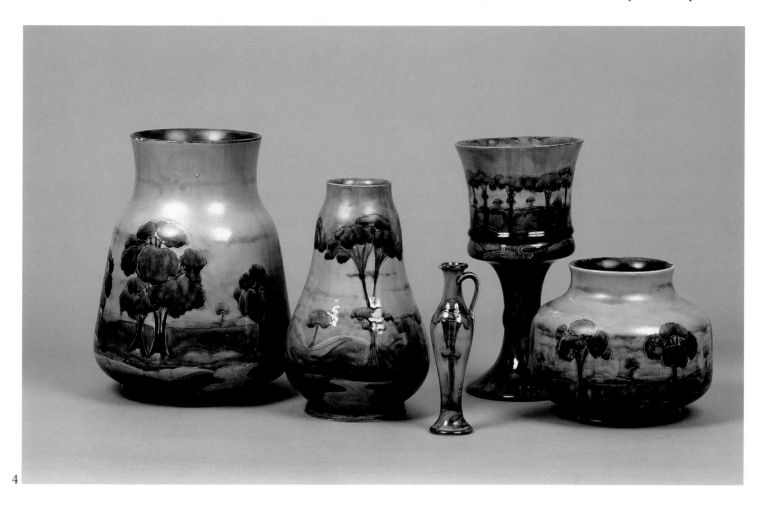

4

4 Group of wares decorated with the Hazledene landscape design in the colours associated with Liberty, including the typical 'overglaze of yellow', all c1903. Largest vase height 10ins
5 Group of wares decorated with the late, dark green version of the Hazledene landscape design, all carrying dates from 1912 to 1914. These show how the design was produced unchanged by Macintyre's and at Cobridge. Largest vase height 12¼ins

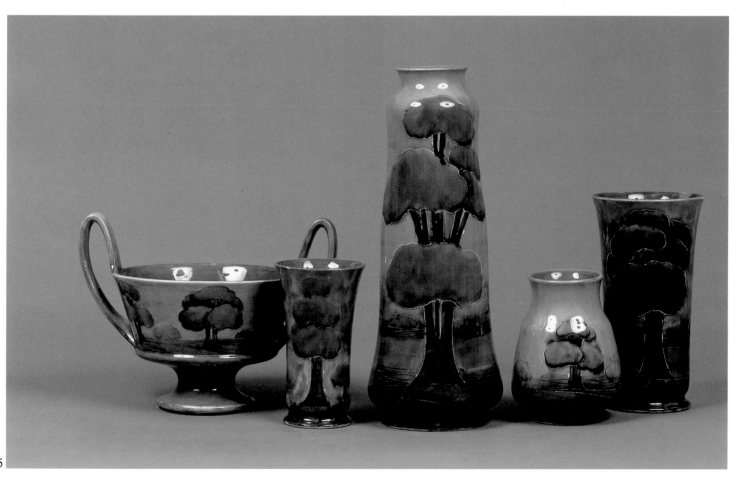

5

Liberty & Co and Lustre Wares

The close relationship between Liberty and Moorcroft had been established during the early days of Florian Ware and was based both on commerce and on the friendship between the Moorcroft and Liberty families. The Liberty backstamp had been in regular use on a number of designs since about 1901, and equally regular had been the appearance of many designs in the Liberty catalogues. Many lustres, including the ruby, feature in Liberty catalogues. Only one design, Bara Ware, was claimed to be exclusive, perhaps because of its links with Liberty fabrics, but many others have particular Liberty associations. Liberty never used Moorcroft's name during the Macintyre period as it was not their practise to reveal the names of designers or manufactures of wares made for them. Thus, although Florian Ware was sold under its own name, Liberty devised their own names for the later patterns, some of which later came into general use. These include the Hazledene landscape design, the Claremont toadstool design registered in October 1903, the Tudor Rose pattern registered in April 1904 and the pomegranate design introduced in 1910, and sold at first by Liberty under the trade name Murena. Liberty were also a major outlet for Moorcroft's first range to be decorated with monochrome and lustre glazes, the Flamminian Wares. These wares, with their bright red, green and blue streaked glazes and their Japanesque or Celtic foliate roundels, also featured lustre finishes for the first time. Registered in April 1905, Flamminian Wares were produced at least until 1915. By 1907 Moorcroft had developed other lustres, notably the ruby that was used over decoration outlined in slip, and he made extensive use of lustre glazes, both as monochromes and as a vibrant colour overlay for conventional patterns. Particularly notable are the wares with restrained floral decoration in a Japanese style and pale grounds washed with a luminous lustrous glaze, made from about 1907-1910.

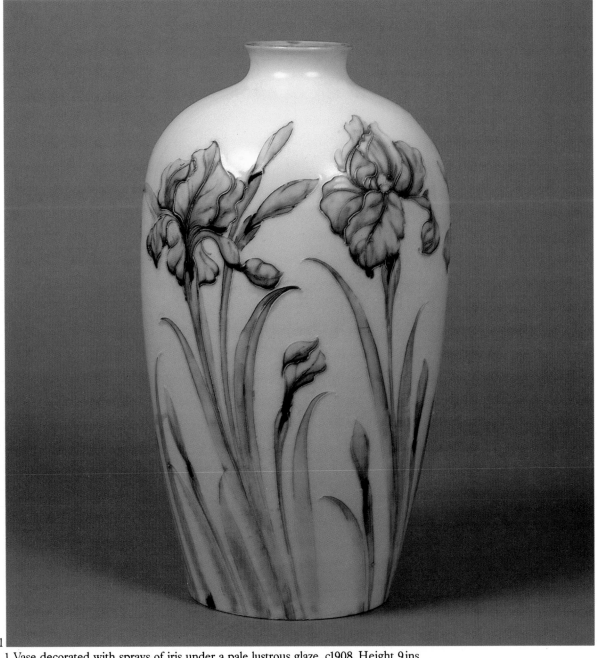

1

1 Vase decorated with sprays of iris under a pale lustrous glaze, c1908. Height 9 ins

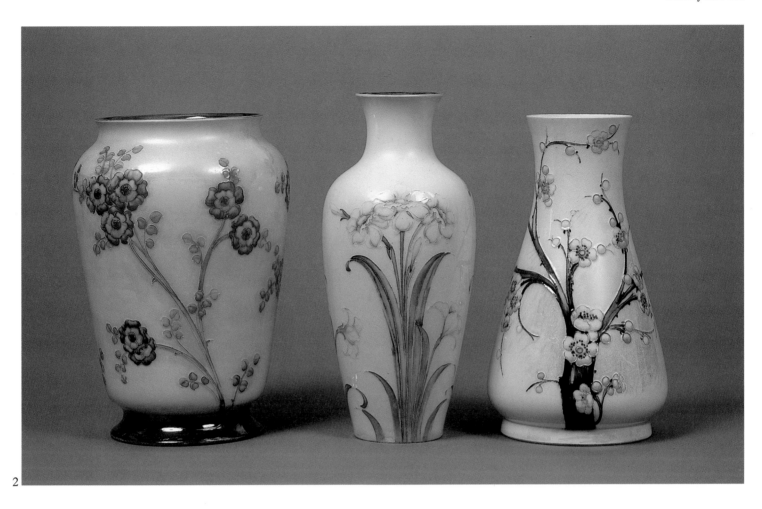

2

2 Group of vases decorated with roses, narcissi and prunus under pale lustrous glazes, c1908. Largest vase height 8 ins
3 Group of wares decorated with cornflowers, harebells, grapes and wisteria under pale lustrous glazes, c1908. Largest vase height 8½ ins

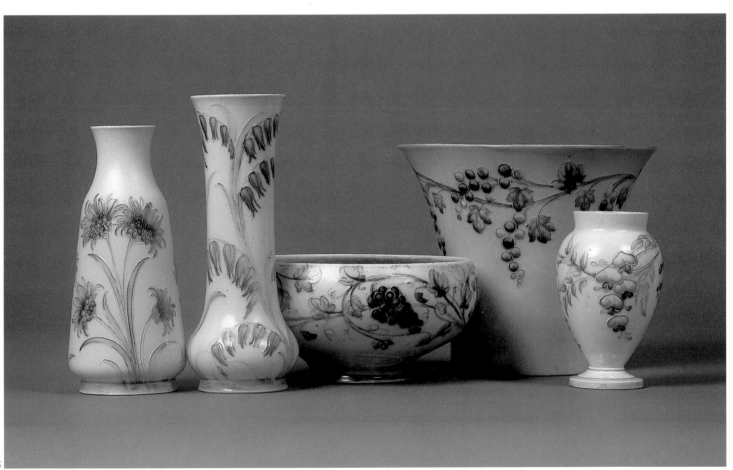

3

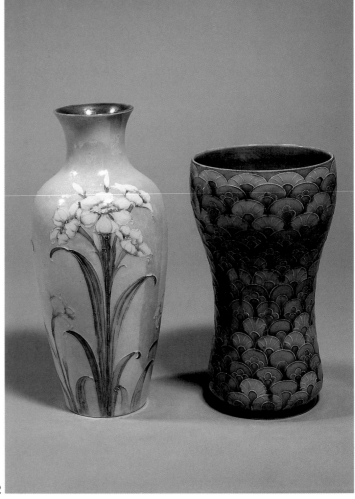

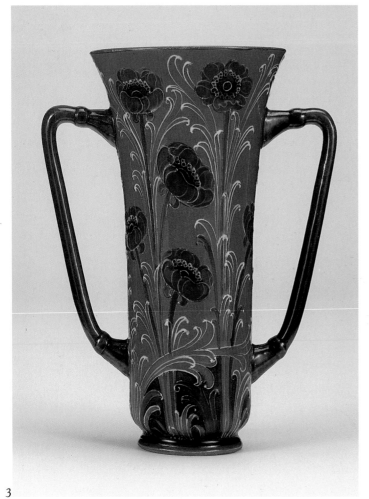

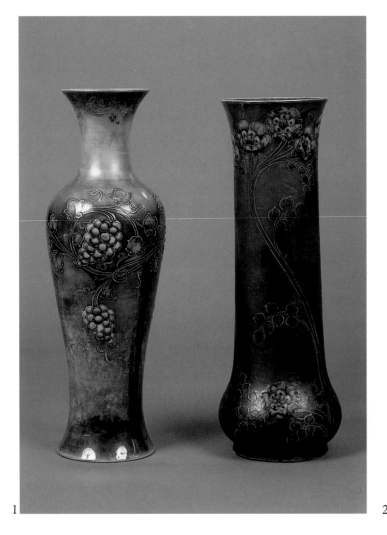

1 Two vases with mottled lustre glazes over conventional designs, left a grape design with Liberty mark, right, roses made for Tiffany, New York, both c1909. Larger vase height 16 ins

2 Two vases, left decorated with a narcissi design under a pale lustrous glaze, right decorated overall with a scale pattern in Japanese style, made for Liberty, both c1907. Larger vase height 9½ ins

3 Vase decorated with a poppy design, the flowers, stems and handles picked out in red lustre, c1908. Height 6¾ ins

4 Group of wares decorated with the Bara Ware design, made from 1908-1913. Vase height 10 ins

5 Group of wares decorated with the Tudor Rose design, registered in April 1904. Plate diameter 7 ins

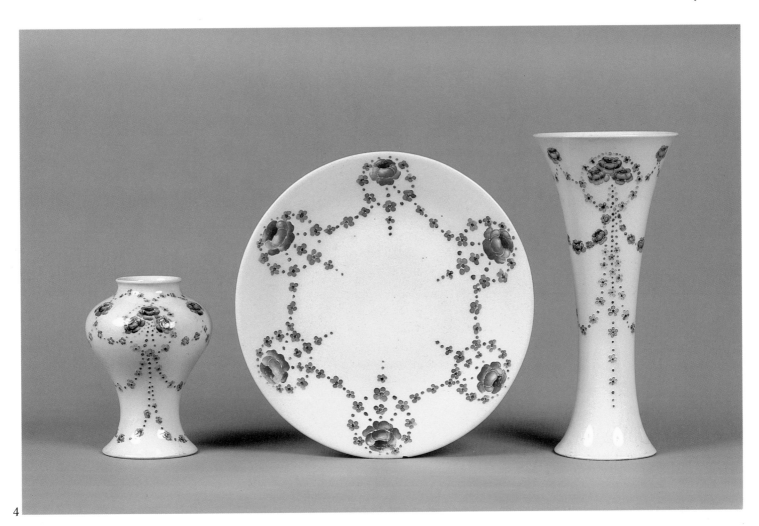

4

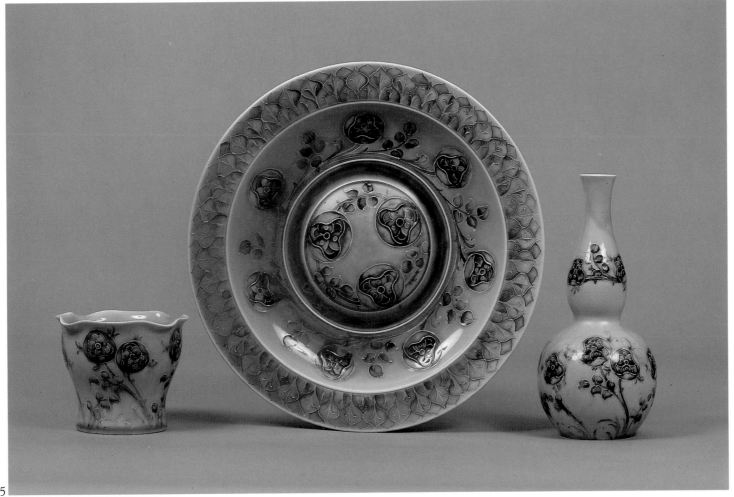

5

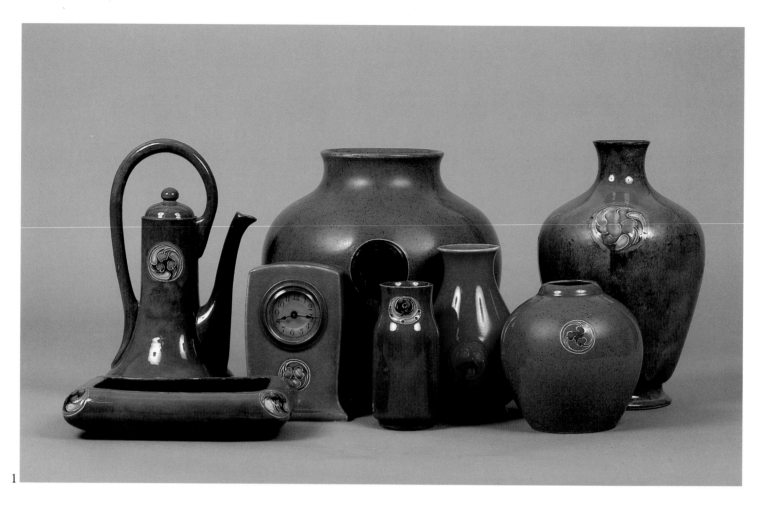

1

1 Group of Flamminian Ware showing the mottled glazes and the foliate roundels registered in April 1905. The green and red pieces carry Liberty marks and date from 1906-1913, while the blue vases were made at Cobridge in 1914. Coffee pot height 10 ins
2 Group of wares decorated with Hazledene, Claremont and prunus designs under a rich ruby lustre glaze. Ruby lustre was first produced in 1907. Largest vase height 10½ ins

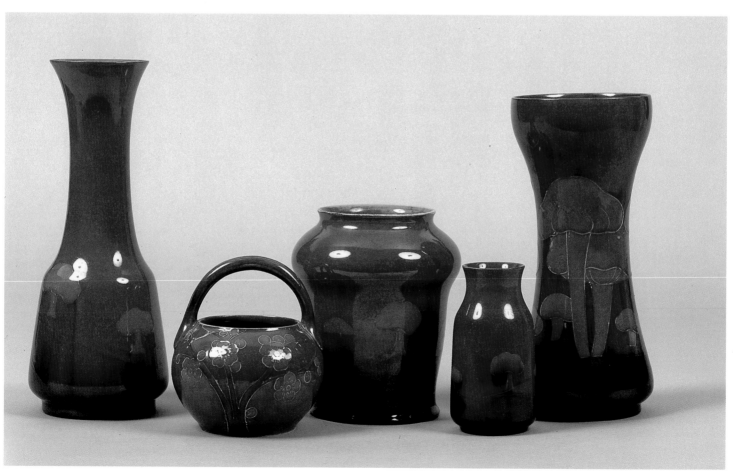

2

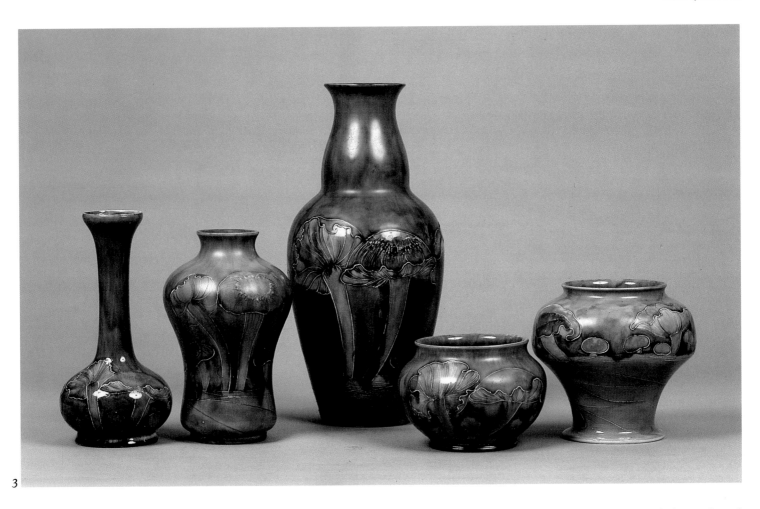

3

3 Group of wares decorated with the Claremont toadstool design, registered in October 1903, showing the characteristic dark mottled grounds, and the stylistic similarities with the Hazeldene landscape design. Most carry Liberty marks, and date from c1905. Largest vase height 13ins
4 Group of wares decorated with the pomegranate design, introduced in 1910, showing the mottled yellow and green ground typical of early examples of this design. The vases are dated 1912 and carry Liberty marks. Vase height 9½ins

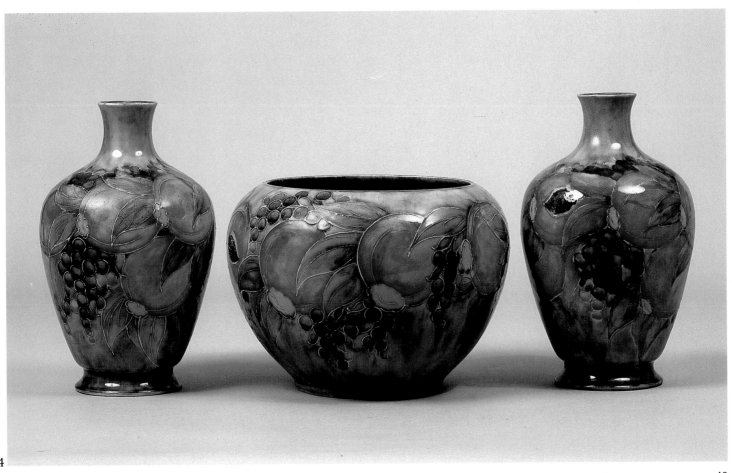

4

Macintyre Tablewares, 1898-1913

Tablewares and domestic wares had always formed a significant part of Macintyre's output since the 1880s. Gesso Faience tableware, probably designed by Harry Barnard, was in production by 1896, and some were still being made in 1902. The tablewares designed and made under Moorcroft's direction fall into three categories. The first, the printed Aurelian wares, featured Moorcroft's designs from 1897, but were not made in his department. The second, the signed tableware, was made and decorated exactly as the art pottery, and featured many Moorcroft designs such as Florian, Hazledene, Claremont, blue poppy, Flamminian, Eighteenth century and pomegranate. The third category was the Dura Ware, made in Moorcroft's department, but with designs simplified to serve a wider market. A Macintyre tableware catalogue of 1902 illustrates five Dura Ware raised slip designs, credited to Moorcroft, three Aurelian Ware designs not credited to him, and a miscellaneous range of other domestic wares featuring conventional Macintyre styles and techniques of decoration. Three shapes, Guildhall, Edward and Kimberley, were also designed by Moorcroft and these are included alongside the earlier Persian, Lorne and Sicilian. The range of useful wares designed by Moorcroft was wide and included such things as teapot stands, moustache cups, covered muffins, marmalade jars, egg-cups, biscuit jars and salad bowls as well as many different sizes and styles of cups, plates and jugs. In 1902 a 29 piece breakfast set in Dura Ware, finished with best gold, cost £3.1s.0d. Some Dura Ware and Aurelian Ware remained in production until about 1914, and some of the designs were subsequently developed by Moorcroft for use on decorative wares. Moorcroft tableware was produced throughout the Macintyre period, and some of his shapes were registered as late as 1905.

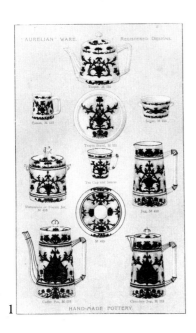

1

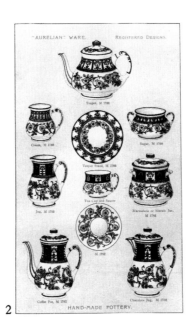

2

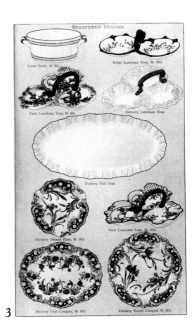

3

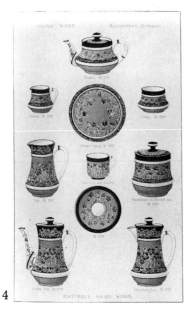

4

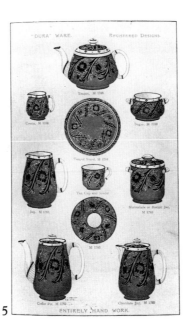

5

Pages from the Macintyre 1902 catalogue showing, 1, an Aurelian Ware printed design on the Lorne shape, 2, an Aurelian Ware printed design on the Persian shape, 3, Rococo style trays and dishes with Moorcroft decoration, 4, a Dura Ware raised slip design of poppies on the Edward shape, 5, a Dura Ware raised slip design on the Sicilian shape
Pages from the Macintyre 1902 catalogue showing, 6, an Aurelian Ware printed design on the Persian shape, 7, a selection of jug shapes decorated with conventional printed patterns, Aurelian Ware designs, standard Macintyre glazes, Gesso Faience and Dura Ware designs, 8, a Dura Ware raised slip seaweed or fern design on the Guildhall shape, 9, a Dura Ware raised slip design on the Kimberley shape

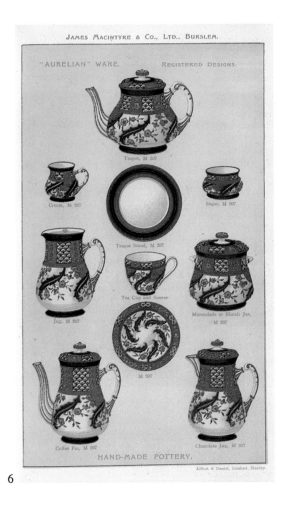

6

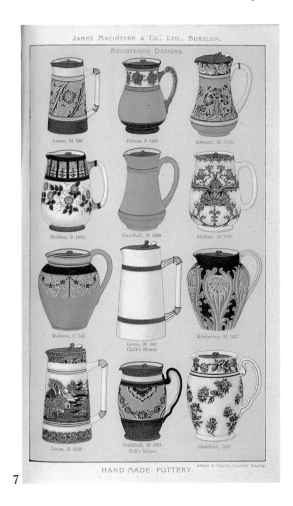

7

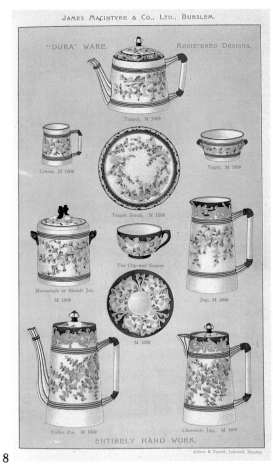

8

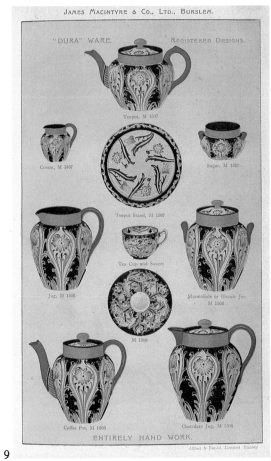

9

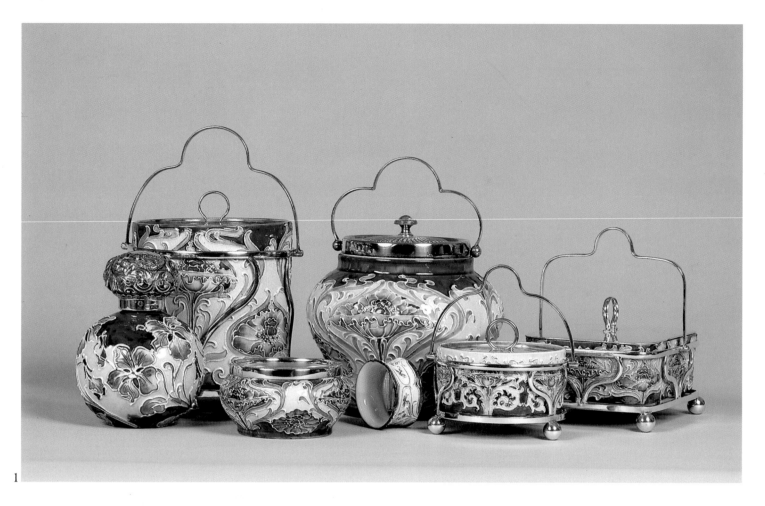

1 Group of signed domestic wares decorated with Florian designs, including biscuit barrels, butter dishes, a scent bottle and a napkin ring, c1901. Larger biscuit barrel height 6 ins

2 Group of signed domestic wares decorated with Florian designs and featuring elaborate plated mounts, c1901. Salad server length 12 ins

3 Group of signed domestic wares decorated with the Eighteenth Century design in different colour ways, all c1906. The tray, the ring stand and the pin box form part of a dressing table set. Tray width 13½ ins

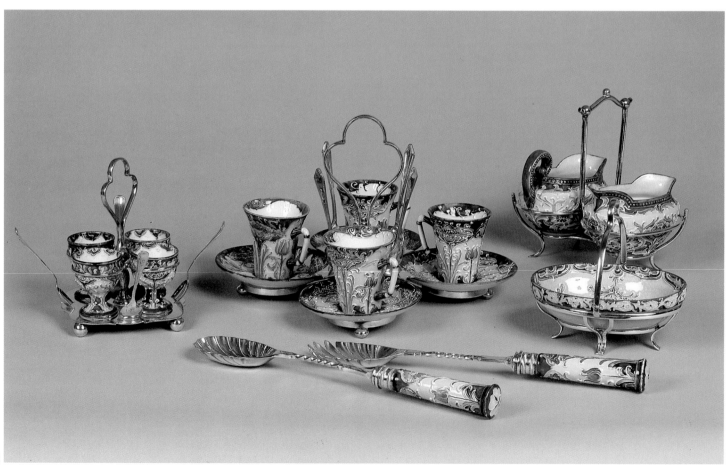

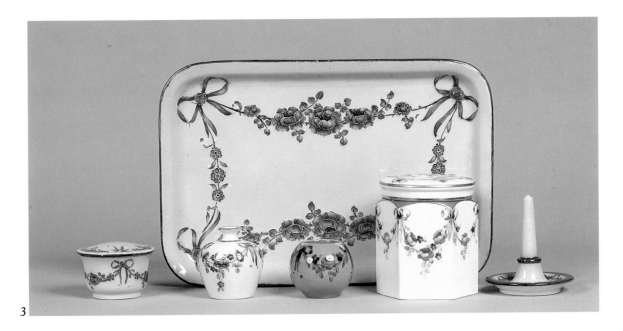

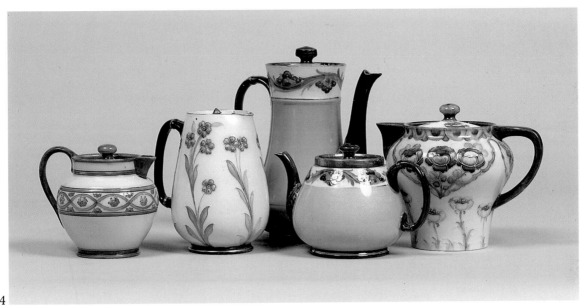

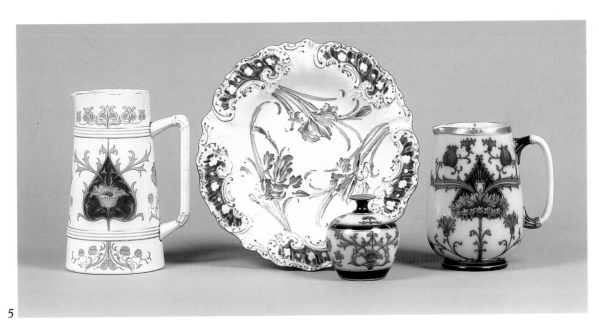

4 Group of jugs and teapots decorated with simple floral designs and plain or coloured grounds, all c1903. The shapes of the yellow teapot and the white hot water jug were registered in January 1898. Tablewares of this type may be signed or unsigned. Coffee pot height 8 ins

5 Group of domestic wares showing versions of the printed Aurelian designs registered in February 1898, and a Dubarry dessert plate with a raised slip iris design, all c1902. These wares are generally unsigned, but signed examples of the Dubarry iris design have been noted. Larger jug height 8 ins

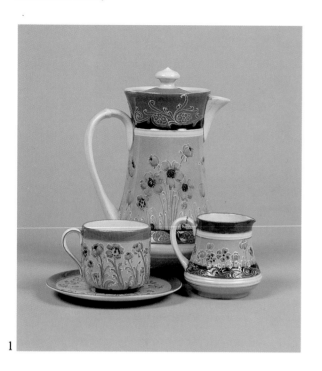

1 Group of Dura tableware with a poppy design registered in September 1902, on the Edward shape. Jug height 8½ ins

2 Group of domestic ware decorated with Florian designs, c1900-1902, all signed. Muffin dish diameter 7½ ins

3 Pieces from a teaset simply decorated with a border pattern from the 404017 design and a dark green ground, c1903, teapot signed. Teapot height 5½ ins

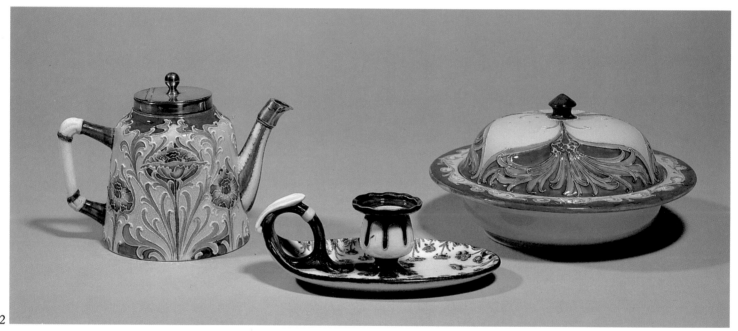

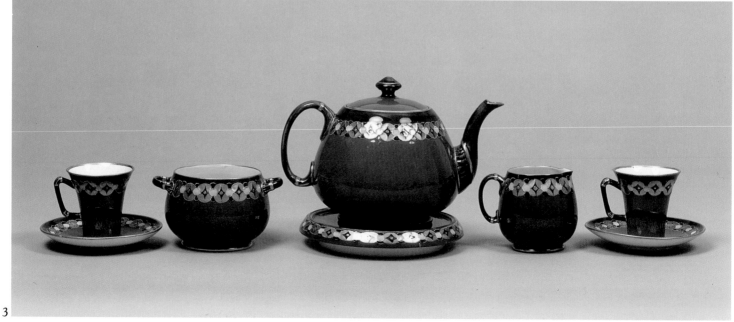

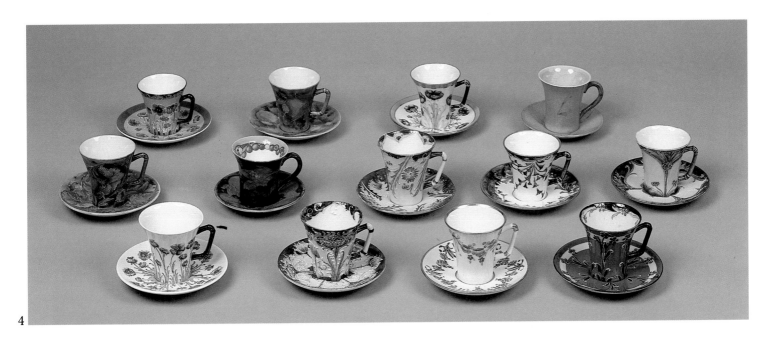

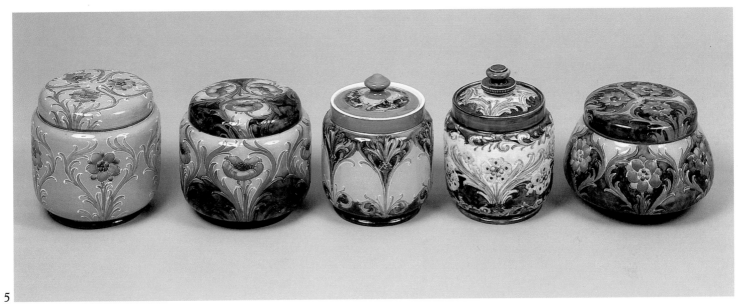

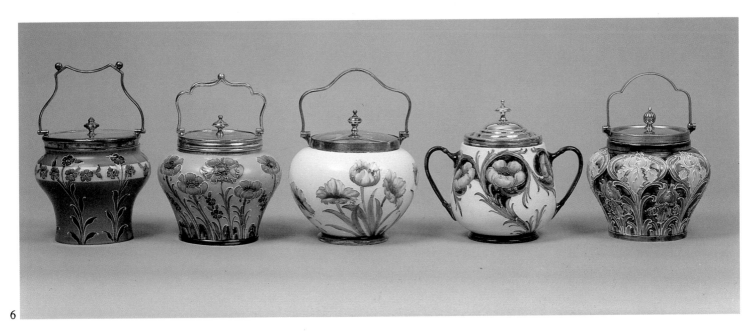

4 Selection of cups and saucers decorated with Florian, Dura, Eighteenth Century, pomegranate, Spanish and other designs, 1900-1914 (the yellow example is c1932).
5 Group of tobacco jars decorated with Florian and later designs, 1901-1906. All signed except the pink example.
6 Group of biscuit barrels decorated with Florian and later designs, showing different styles of plated mounts, 1900-1906. Mostly signed.

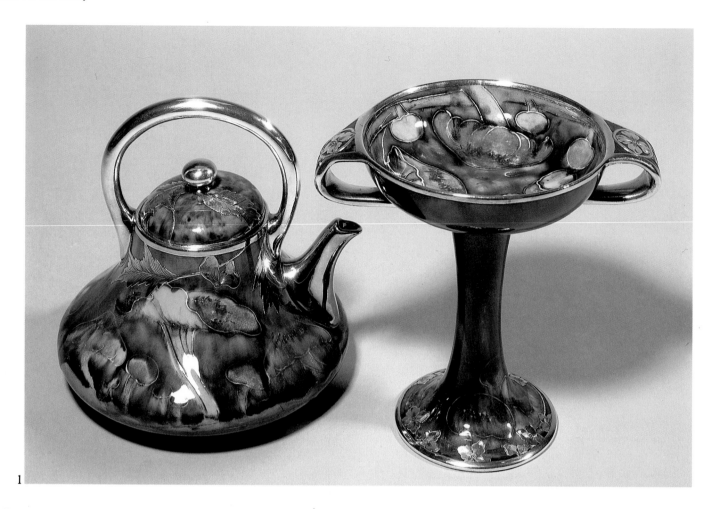

1 Teapot and bonbonnière decorated with the Claremont design, and additionally decorated with silver overlay and cut out silver leaves and flowers, c1905, made for Shreve & Co, San Francisco, Both signed. Teapot height 7 ins
2 Part of a tea service decorated with the Flamminian design, and additionally decorated with silver overlay and cut out silver leaves, c1905, all signed. Made for Shreve & Co, San Francisco. It is possible that the distinctive silver mounts shown on these wares were added in the United States. Teapot height 7 ins

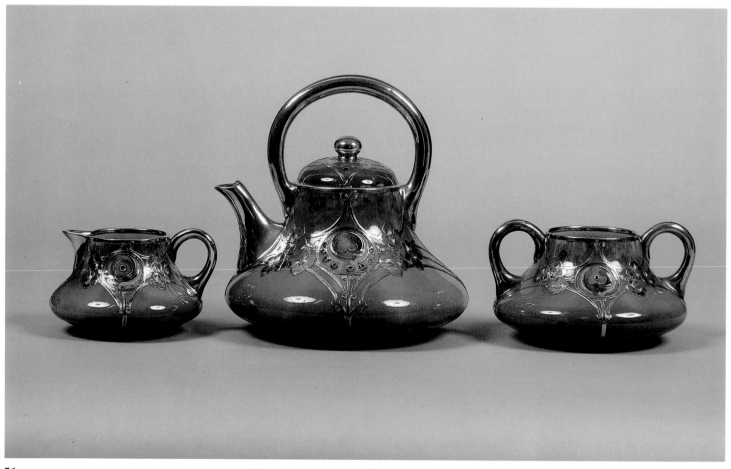

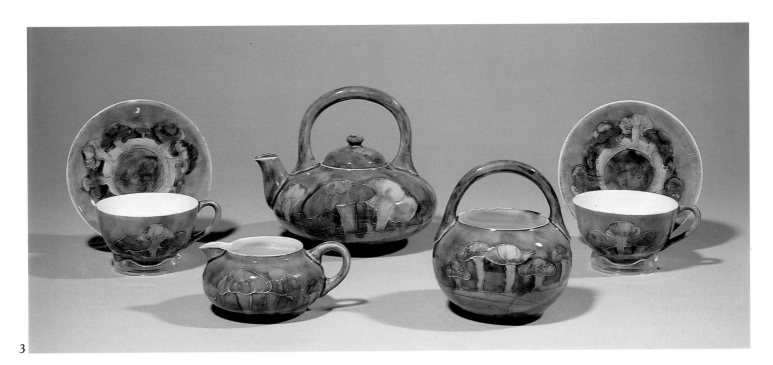

3

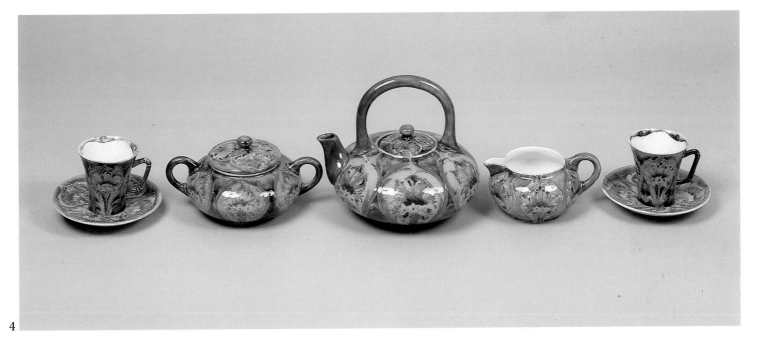

4

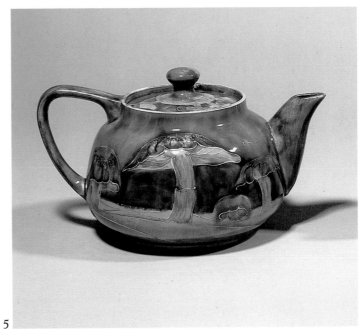

3 Part of a tea service decorated with the Claremont design, c1905, all signed. Teapot height 6 ins
4 Part of a tea service decorated with the cornflower design, c1911, all signed. Teapot height 6 ins
5 Teapot decorated with the Claremont design, the shape registered in January 1905, made for Shreve & Co, San Francisco, signed. Height 5½ ins

5

The Move to Cobridge, 1913

Transitional Patterns, 1910-1918

In August 1913 Moorcroft moved to his newly built factory at Cobridge, on the outskirts of Burslem, accompanied by a small team of assistants, the craftsmen and women he had trained and who had worked with him at the Washington Works. The move was prompted by Macintyre's decision to concentrate on electrical porcelain. Within a few weeks, the production of Moorcroft pottery was once again under way. Moorcroft had announced his intention to form his own company and continue to make his pottery in his own workshops. While Liberty were particularly supportive, he was inundated with orders from other distributors, anxious to help his new venture during this critical period. It was essential to retain their confidence and meet the demand for the designs with which the buyers and the public were already familiar. He therefore continued at first to develop designs he had launched successfully between 1910 and 1912, the pomegranate, Spanish, brown chrysanthemum (or revived cornflower) of 1910 and the pansy and wisteria of 1911. However, Liberty, among other distributors at home and overseas, still wanted the green Hazledene, the Claremont, the Flamminian ware, the Eighteenth Century and other designs characteristic of

his work since 1908. As most of the pottery was made to order he was prepared to revive even earlier patterns when asked to do so. Yet despite the demand for his work, Moorcroft was shrewd enough to realise that his enterprise, run as a cottage industry in the Morris tradition, would be unable to survive on art pottery alone. He therefore began, immediately, to design a range of tableware that could be made in relatively large quantities and attract a wider market. The speckled blue table ware, that he called Blue Porcelain and which Liberty sold as Powder Blue, was first made in 1913, and became the vital backbone against which the art pottery would be developed.

During this transitional period, Moorcroft also continued his distinctive style of marking. For some years the Macintyre marks had been increasingly insignificant, and had vanished completely from many of the Liberty pieces. At the same time the Moocroft signature had grown larger and more stylised. At Cobridge the signature became the main Moorcroft mark, supported by small impressed factory marks. Pieces made between 1912 and 1914 were often dated as well.

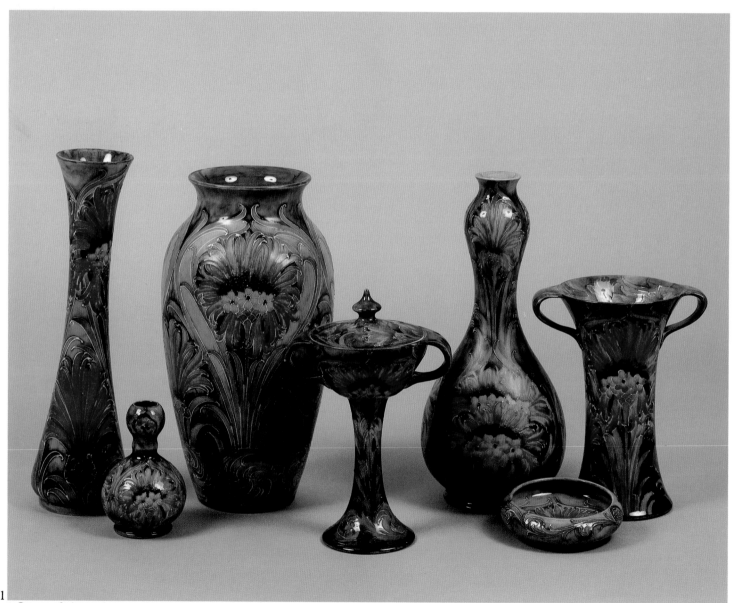

1 Group of pieces decorated with the revived cornflower or brown chrysanthemum design, showing the red flower on the mottled green ground. The narrow vase on the left and ashtray were made at Cobridge and are dated XI 1913, but all the others were made at Macintyre's. All c1912-1913. Tallest vase height 12¾ ins.

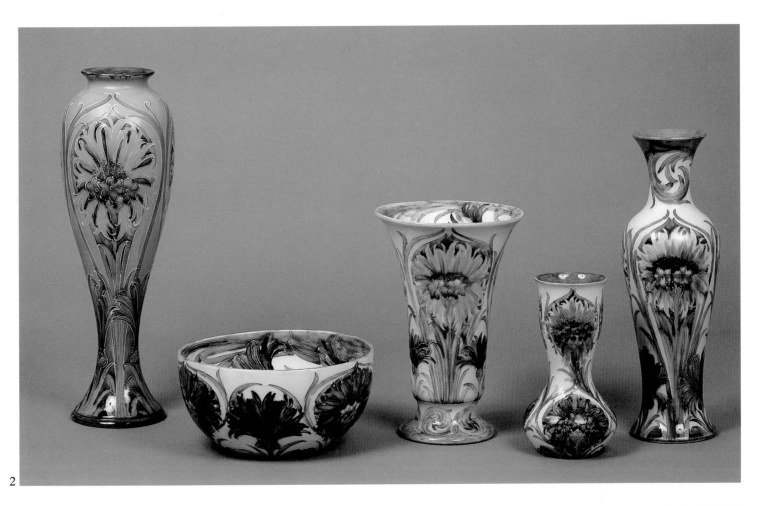

2

2 Group of pieces decorated with the revived cornflower design, showing yellow and purple flowers on pale green and cream grounds. Probably all made at Cobridge, c1913-1914. The trumpet vase in the centre and the bottle vase on the right are dated 1914. Tallest vase height 14½ ins.
3 Two vases decorated with the revived cornflower design, showing the blue and the cream grounds. Both made at Macintyre's, c1912. Larger vase height 10 ins.
4 Trumpet vase decorated with the brown chrysanthemum design in red. Made at Cobridge and dated XII 1913. Height 12½ ins

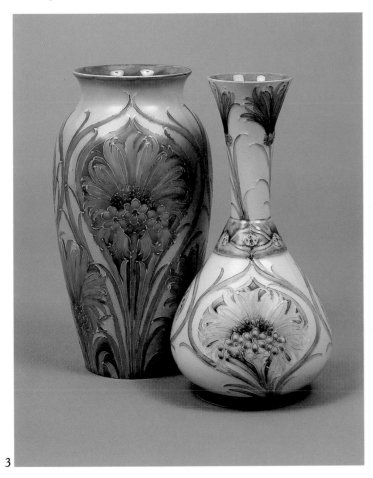

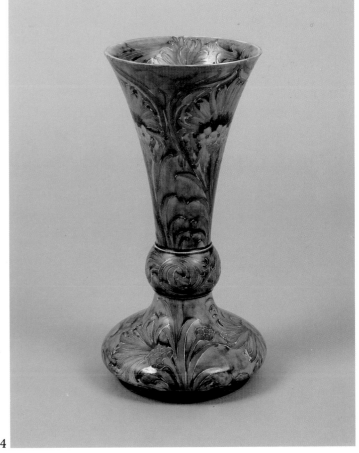

3 4

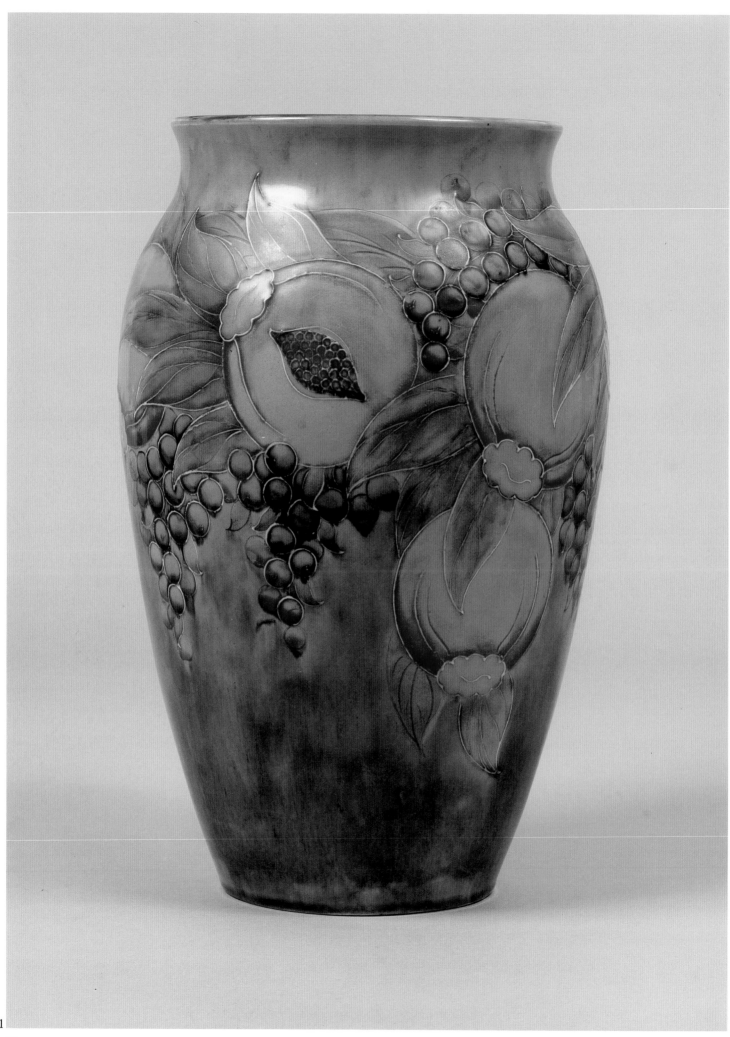

Pansy and Pomegranate Designs, 1910-c1938

Introduced in 1910 and 1911, the pomegranate and pansy designs marked a new stylistic departure for Moorcroft. Subtle and carefully balanced colours blending together over delicate slip trailing and pale or mottled grounds were the characteristic features of the new Moorcroft style. Decoration was limited to one area of the piece, usually an encircling band of pattern. The pomegranate design was drawn in an exotic and sensual style around the shoulder of the ware, while in the pansy and related wisteria designs of 1911/12 the flowers hung down from the rim. When first produced, these designs were sold extensively by Liberty, but their early success ensured the involvement of other retailers at home and abroad. In 1913 Moorcroft transferred the designs to his new factory and production continued almost without interruption. Pomegranate in particular became Moorcroft's most successful design, but both this and pansy remained in production until the late 1930s. During this period the designs were steadily changed. Early pomegranate, made between 1910 and the First World War, has a mottled yellow or green ground, but by 1916 these colours were already giving way to the deep purples and blues that dominated post war production. In the 1920s a simplified version was produced, with the fruit pattern contained between Art Deco bands. Pansy went through similar changes, the early white, ivory or celadon grounds giving way to dark blue from 1916. Because of their popularity, these designs were used extensively by Moorcroft and so can be found on all types of ware, including tablewares, with metal mounts and with flambé glazes.

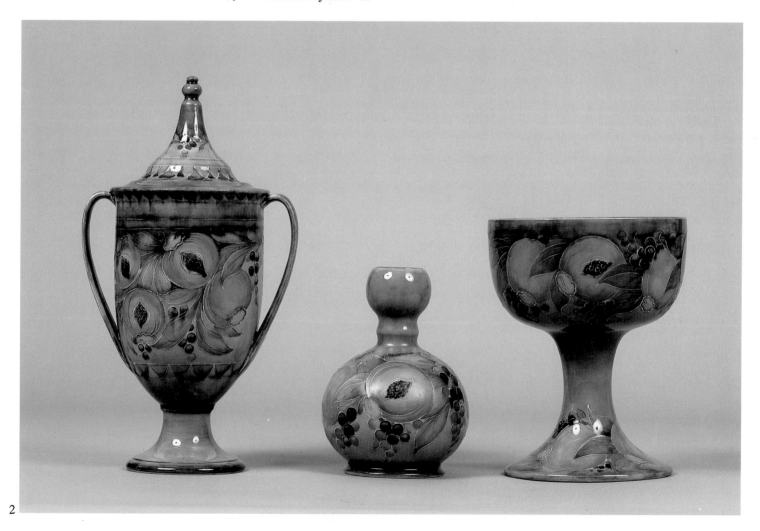

2

1 Vase decorated with the pomegranate design, showing the mottled yellow ground. Made for Liberty at the Macintyre factory in c1912. Height 15 ins
2 Group of wares decorated with the pomegranate designs, showing the mottled green ground, all c1912-1913. Covered vase height 12¼ ins

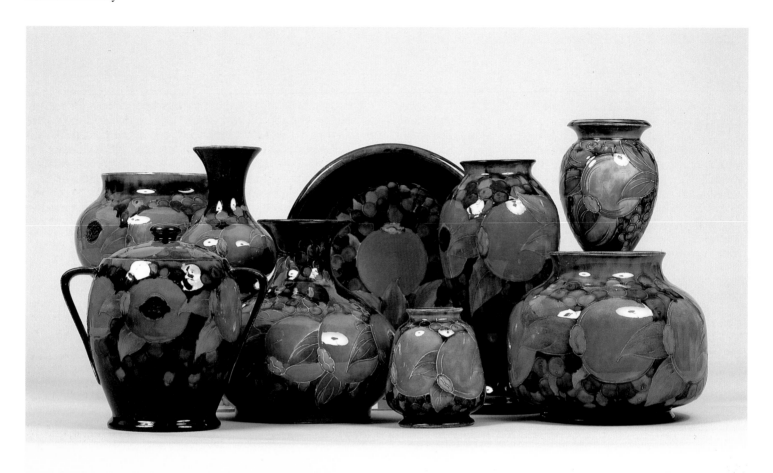

1

1 Group of wares decorated with the pomegranate design, showing varied green and blue grounds, all 1913–c1925. The raised vase on the far right is dated X 1913. Plate diameter 10 ins.
2 Group of domestic wares decorated with the pomegranate design on mottled green grounds, 1912–1914. The clock and the candlestick were made at Macintyre's. The tall pot pourri is dated II 1914. Largest piece height 6½ ins

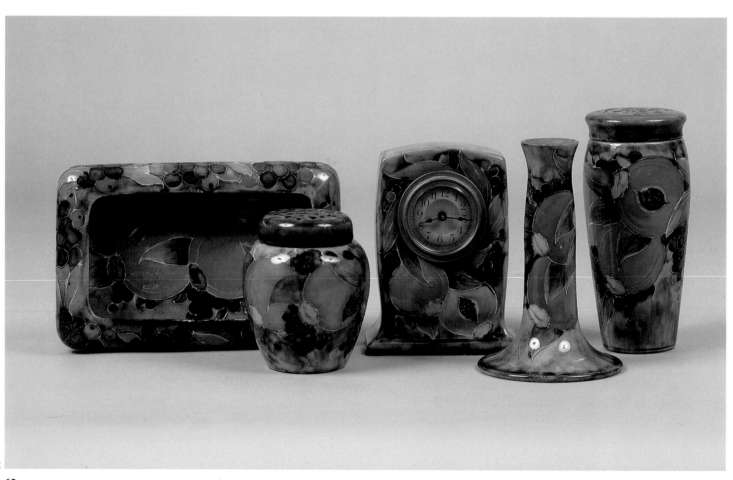

2

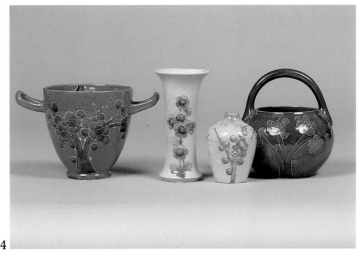

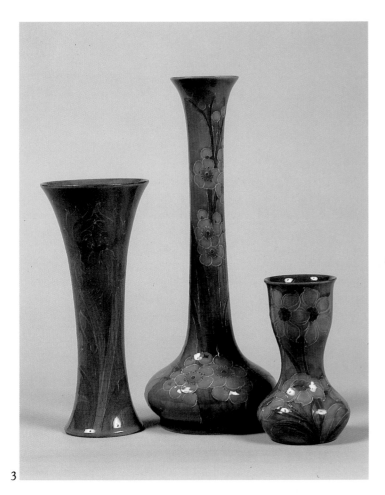

3

4

3 Group of vases decorated with various green flowers on green grounds, showing unusual transitional designs, 1912-1914. The trumpet vase was made at Cobridge, the others at Macintyre's. The smallest vase is dated 1912. Tallest vase height 14½ ins

4 Group of miscellaneous transitional wares decorated with the apple blossom design, showing different glaze finishes, 1912-1914. The red lustre basket and the trumpet vase were made at Macintyre's, the others at Cobridge. The Powder Blue handled vase is dated 1914. Basket height 5½ ins

5 Group of wares decorated with the wisteria design, showing the typical colours and style of drawing, 1912-1914. Tallest vase height 9½ ins

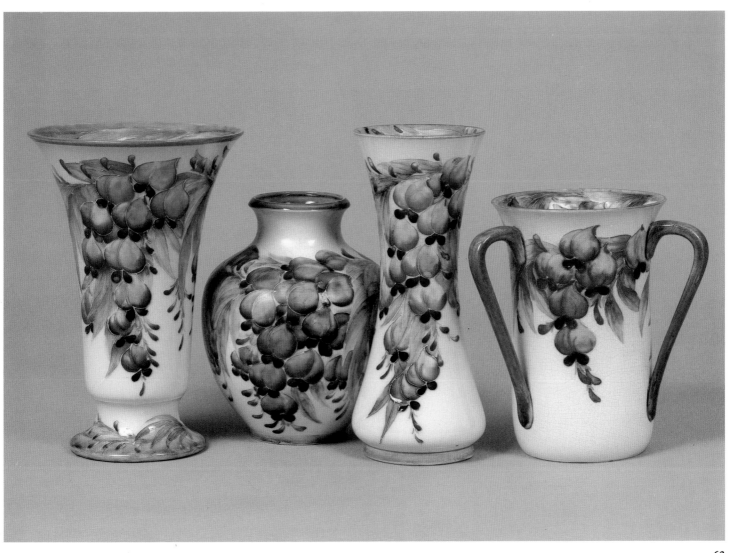

5

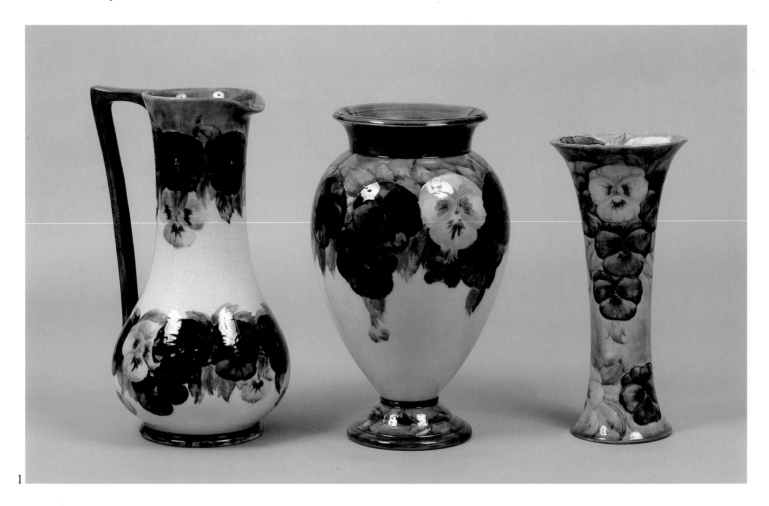

1

1 Group of wares decorated with the early version of the pansy design, showing the white and pale grounds. All made at Cobridge. The jug is dated 1916, the trumpet vase 1914. Jug height 14½ ins
2 Group of wares decorated with the early version of the pansy design, showing the white ground. All made at Macintyre's, 1911-1913. Tallest vase height 6¾ ins

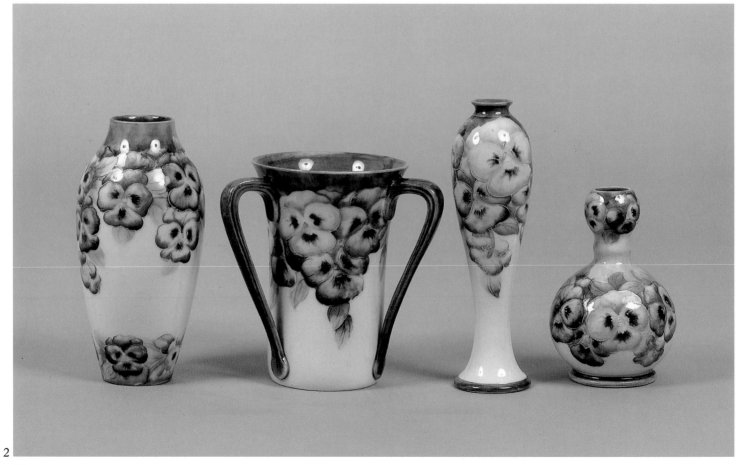

2

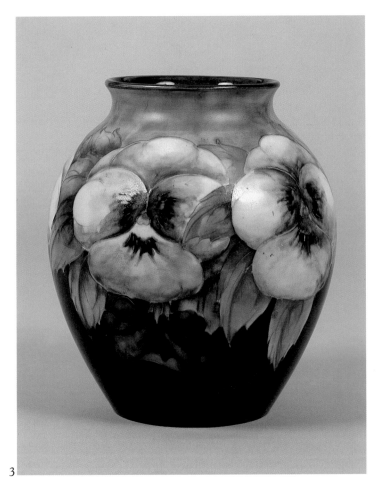

3

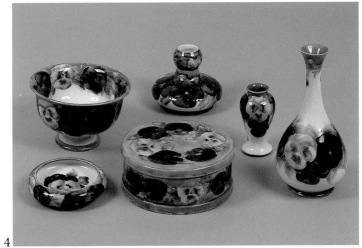

4

3 Vase decorated with the pansy design, showing the mottled darker ground, c1918. Height 8¼ ins

4 Group of wares decorated with the early versions of the pansy design, showing white and pale green grounds. All made at Cobridge, 1913-1916. The footed bowl is dated 1914. Tallest vase height 8 ins

5 Group of wares decorated with the later versions of the pansy design, showing the dark grounds characteristic of the 1920s and the 1930s. The plate is dated 1923, the two narrow vases are 1920-1925, the two round vases c1935. Tallest vase 10¾ ins

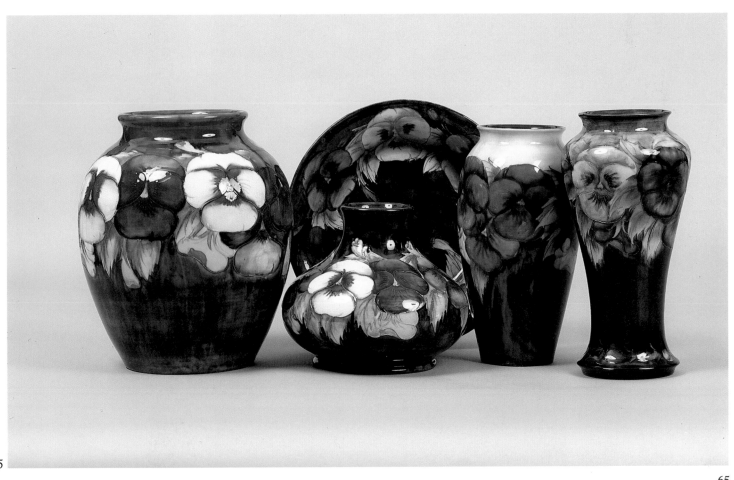

5

Spanish and Claremont

Introduced in 1910, the Spanish design brought together two aspects of Moorcroft's work. The designs were drawn in the flowing, linear style typical of the Florian Wares, and still showed the influence of William Morris, but the colours had become much richer, featuring the dark reds, yellows, greens and blues associated with the pomegranate design. This lively and decorative pattern, drawn to cover the surface of the ware, incorporated a number of flower forms already used by Moorcroft, for example, iris, cornflower and tulip, but its colours make it quite distinctive. The design was made at both the Macintyre and Cobridge factories, and probably remained in production until the early 1920s. Versions in other colours can occasionally be found, notably greens and blues.

The toadstool design, introduced in 1904 and named Claremont by Liberty, remained in use for nearly forty years. During the transitional period between 1913 and 1915, the design underwent comparatively little change, but by the 1920s the drawing had become bolder and the colours darker and stronger. The name Claremont was used loosely in Moorcroft's workrooms but was not applicable to the later toadstool or mushroom designs, when the motif was used under flambé or other decorative glazes in the 1920s and 1930s, or the simplified designs of the 1930s, painted in light colours on the pale matt grounds typical of the period.

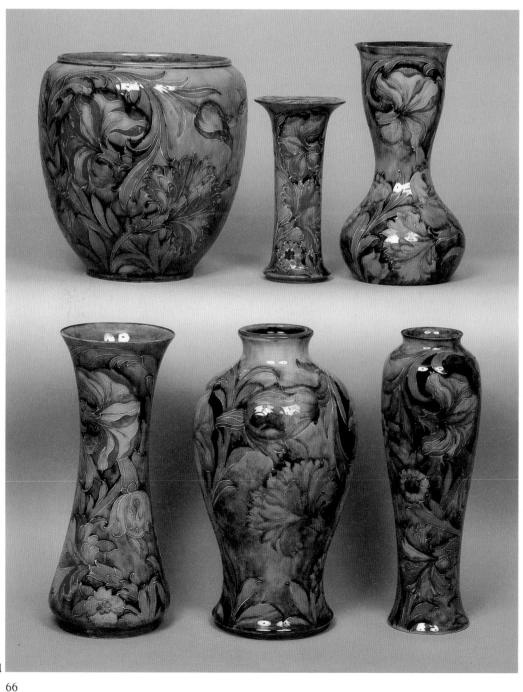

1

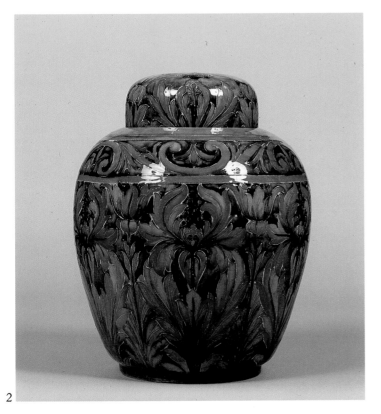

2

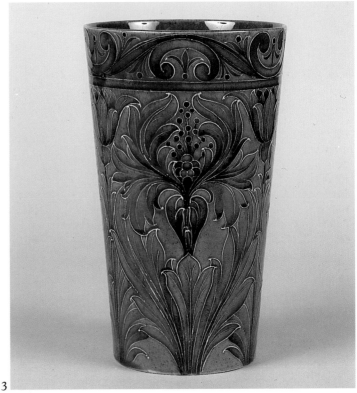

3

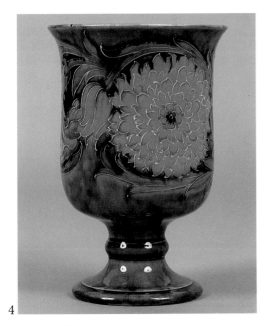

4

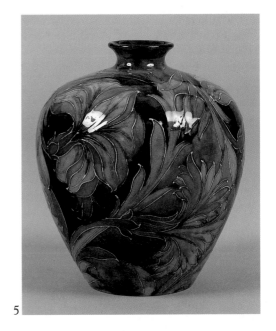

5

1 Group of wares decorated with the Spanish design, showing the typical colours and the flowing patterns, all 1912-1916. The narrow vase bottom right is dated 1914. Tallest vase height 12½ ins
2 Covered jar decorated with a cornflower design in the Spanish colours, c1916. Height 9 ins
3 Vase decorated with a cornflower design in blue on a Powder Blue ground, similar in style to the covered jar, c1916. Height 13 ins
4 Goblet decorated with a version of the Spanish design showing a more open style of flower, c1912. Height 8¼ ins
5 Vase decorated with the Spanish design, c1916. Height 6¼ ins
6 Wares decorated with versions of the Spanish design. Left to right, a scent bottle in green, c1912, a vase with a simplified design on a mottled cream ground, c1930, and a vase with the conventional design, c1916. Cream vase height 5¼ ins

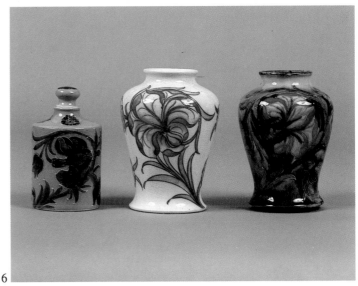

6

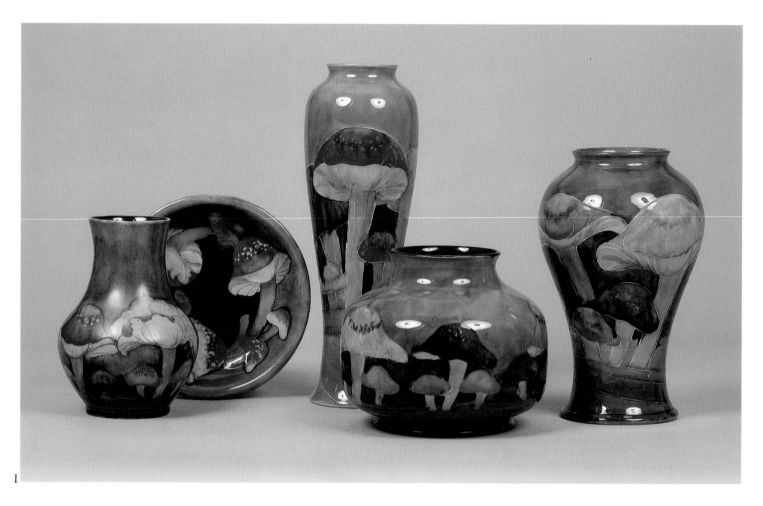

1

1 Group of wares decorated with the Claremont toadstool design, all 1913-1916. The tallest vase is dated 1914. Tallest vase height 12 ins

2 Group of wares decorated with the Claremont toadstool design, c1918. Candlesticks height 10 ins

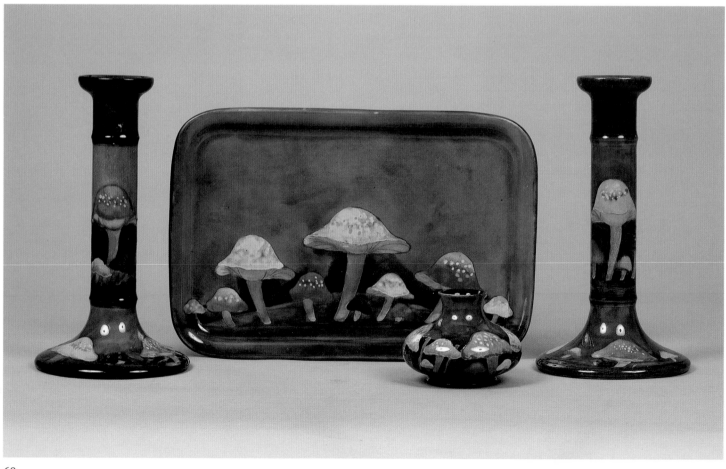

2

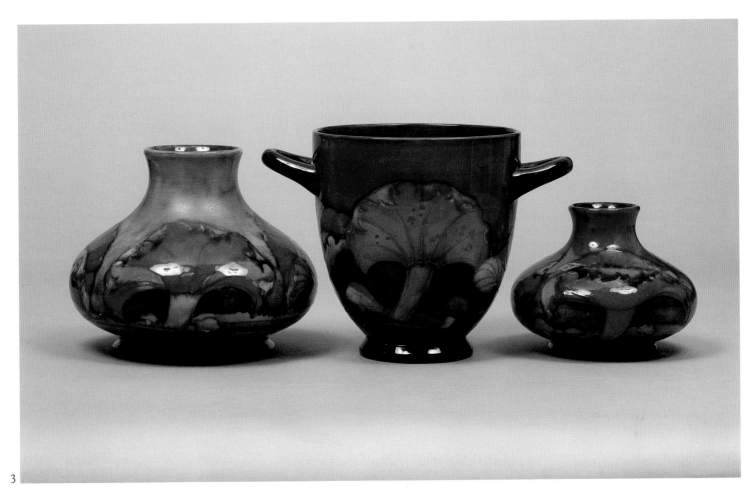

3

3 Group of wares decorated with the Claremont toadstool design under flambé glazes, all c1930. Handled vase height 7¼ ins
4 Large vase decorated with the Claremont toadstool design in the typical colours of the transitional period, c1916. Height 13 ins
5 Group of wares decorated with late versions of the wisteria and toadstool designs, showing the simplified drawing, light colours and pale matt grounds of the mid 1930s. Both vases are dated 1935. Taller vase height 19½ ins

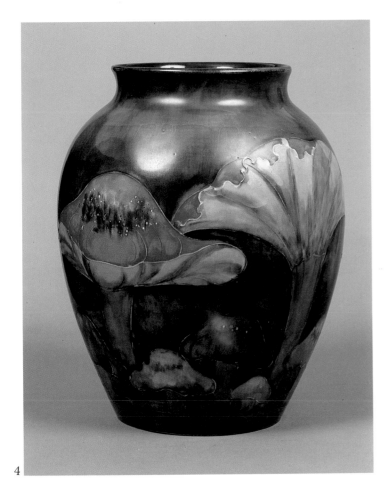

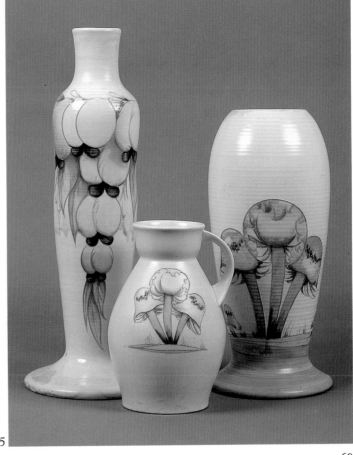

4

5

Chapter Four
Cobridge Productions, 1913-1945

Persian and Late Florian

While Moorcroft used some of his earlier designs at Cobridge, he embarked on fresh developments at the same time. The new designs reflected his desire both to move in new directions and to maintain the traditions he had established. Persian, introduced early in 1914, is an example of the former, while the Late Florian designs, developed during the First World War, are examples of the latter. Persian reflected the current enthusiasm for Middle Eastern styles of decoration and, although Moorcroft himself may not have been entirely satisfied with so untypical a design, it met a steady demand throughout the war and was not withdrawn until about 1920. The intertwined flowers that made up the pattern in strong colours on a pale ground were clearly inspired by Islamic tiles. Also partly Islamic in style were the range of wares featuring fruit and flower designs contained in panels on plain green, blue and grey grounds, produced between 1915-1916 and the early 1920s.

More characteristic was Moorcroft's continuing interest in Florian-style designs. Some of the early Florian designs had already been revived and redeveloped at the Macintyre factory between 1910 and 1912 and were to be revived again in a simpler and bolder form in the late 1920s and early 1930s. In between came the Late Florian designs, made during the early years at Cobridge and with a character of their own. The tightly drawn tulips, poppies, forget-me-nots and other flowers, the intricate surface patterns and the flowing forms of early Florian were still present, but the use of strong and rich colours created an entirely new effect. Similar colours were also used in a dramatic range of designs from about 1918 which featured narcissi, orchids, iris and other flowers drawn in a naturalistic style over the surface of the pots, often on dark grounds. Some of these designs may have been inspired by Thomas Moorcroft's botanical drawings. Lustre finishes were also used, another Macintyre tradition being maintained, while monochrome lustres were still an important part of Cobridge production.

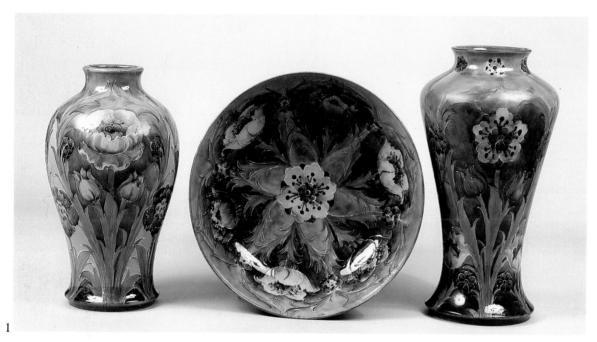

1

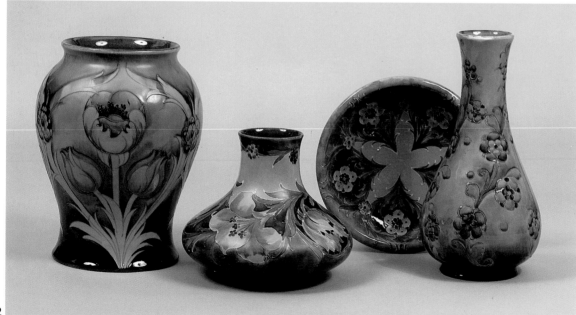

2

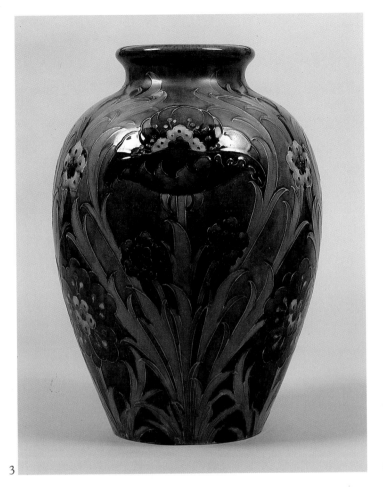

3

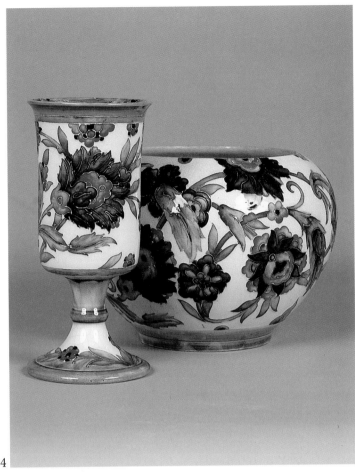

4

1 Group of wares decorated with the Late Florian design, showing the characteristic blue, green and yellow colours and the decorative drawing style reminiscent of early Florian, all 1918-1923. The bowl is dated 1918. Larger vase height 14½ ins

2 Group of wares decorated with early and later versions of the Late Florian design, the vase on the left showing the simplification of the style that took place in the late 1920s and early 1930s. Left vase c1930, others c1920. Tallest vase height 11¾ ins

3 Large vase decorated with a rich version of the Late Florian design, dated 1919. Height 16 ins

4 Goblet and bowl decorated with the Persian design, 1914-1916. Bowl height 6¼ ins

5 Group of wares decorated with the Persian pattern, all 1914-1920. The tazza is mounted on a Liberty Tudric pewter base. Larger vase height 9½ ins

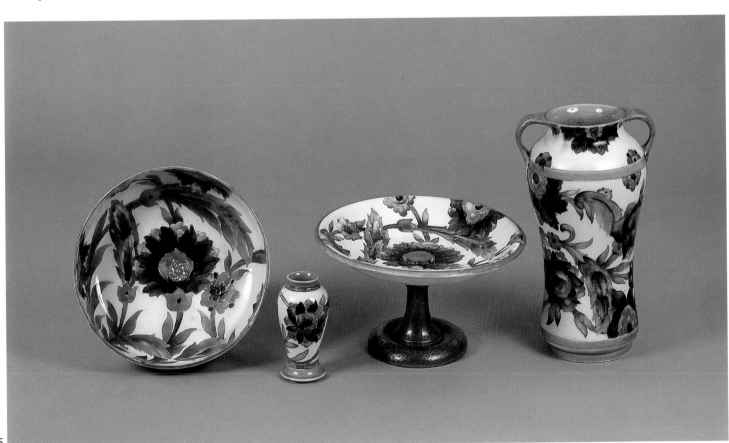

5

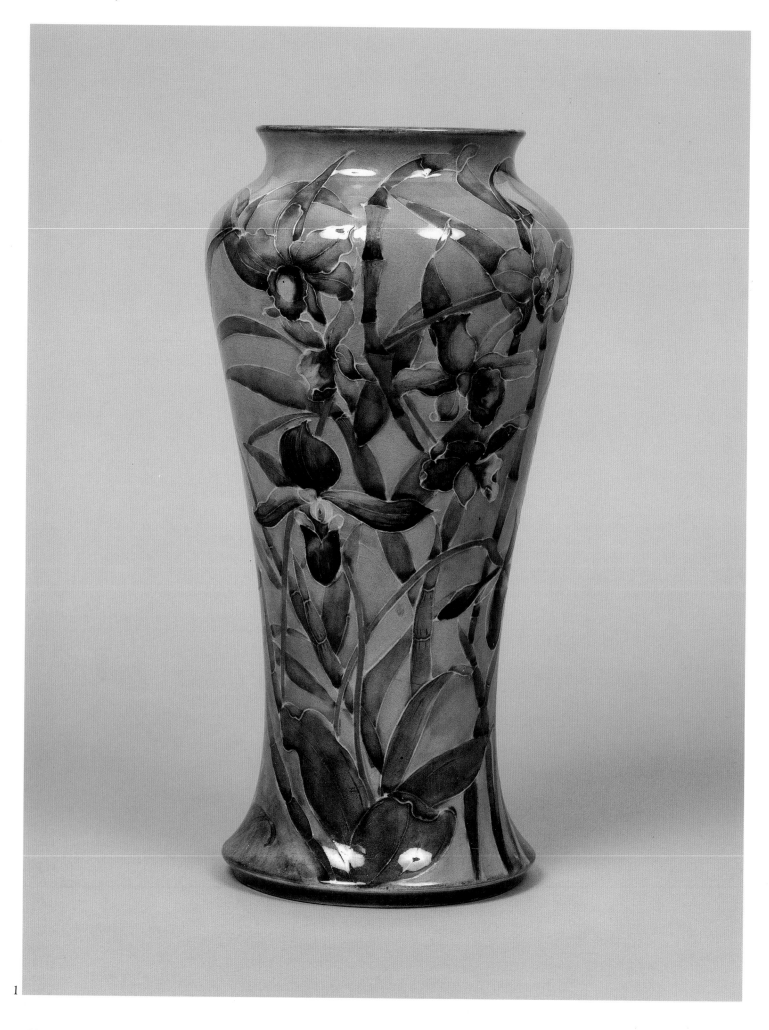

1

1 Vase decorated with an orchid design on a dark ground, perhaps inspired by Thomas Moorcroft's botanical drawings, dated 1919. Height 12¾ ins

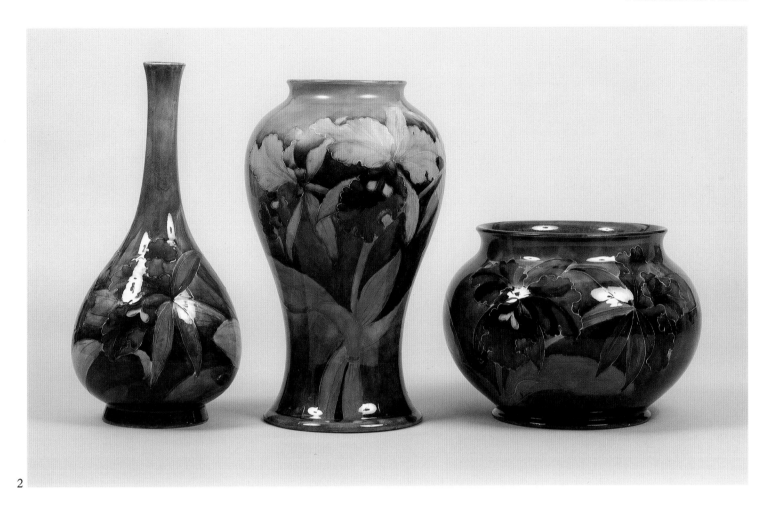

2

2 Group of vases decorated with an iris design on dark grounds, c1918. Largest vase height 13½ ins
3 Vases decorated with daffodil designs on mottled dark grounds, c1918..Larger vase height 11 ins
4 Vase decorated with a plum and leaf design on a mottled green ground, c1920. Height 11½ ins

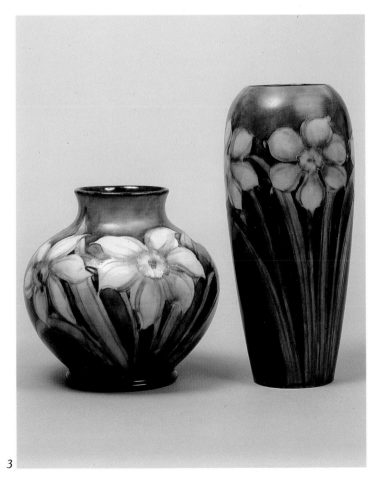

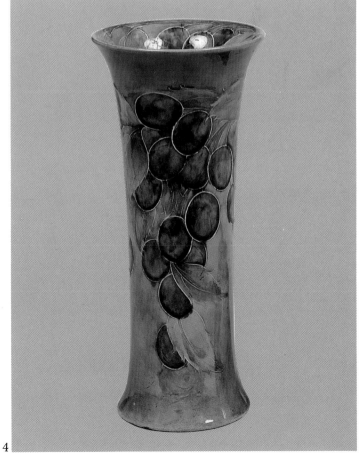

3 4

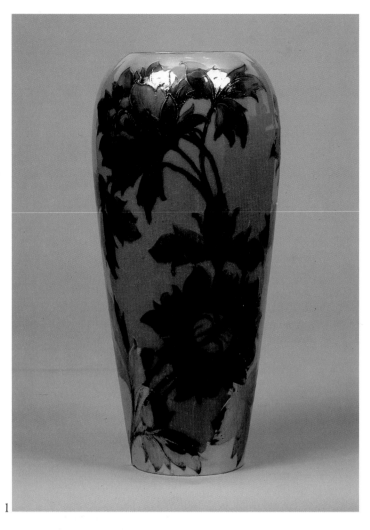

1 Vase decorated with a cornflower design under a lustre glaze, dated 1918. Height 12½ ins
2 Group of wares decorated with plain lustre glazes, showing a range of colours, c1916. Green vase height 10½ ins

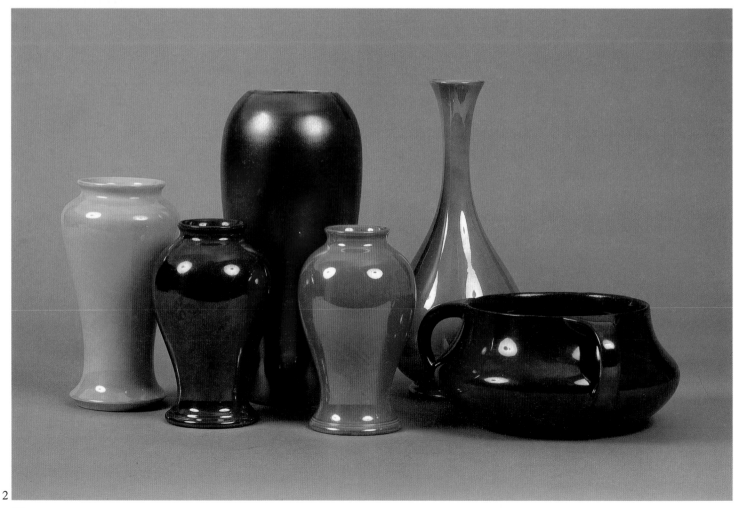

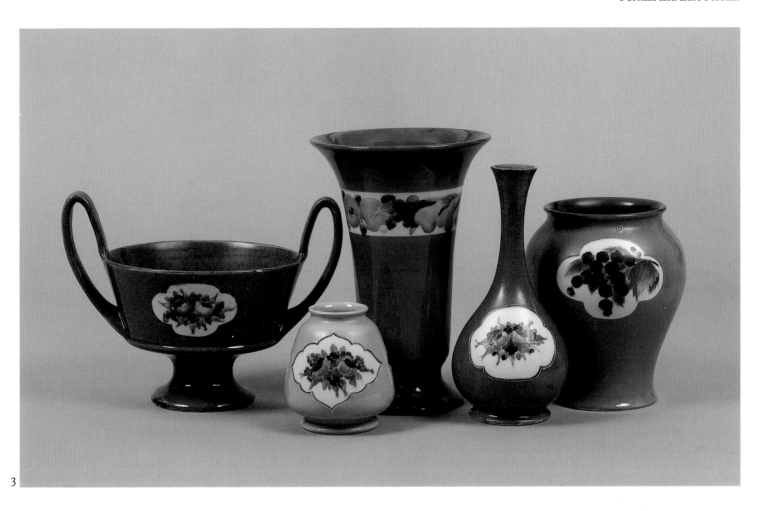

3 Group of wares with fruit and flower designs contained in panels on plain green and blue grounds, c1918. Trumpet vase height 9 ins
4 & 5 Covered jar and vase with forget-me-not and cornflower designs contained in panels on plain grounds, c1918. Vase height 9½ ins

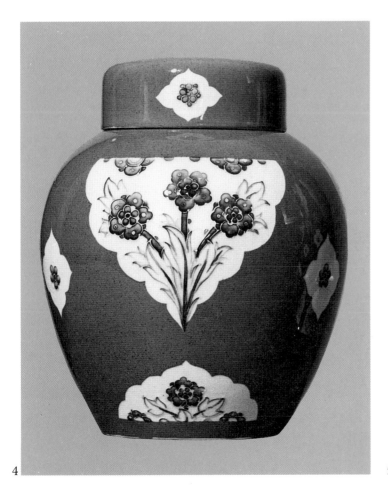

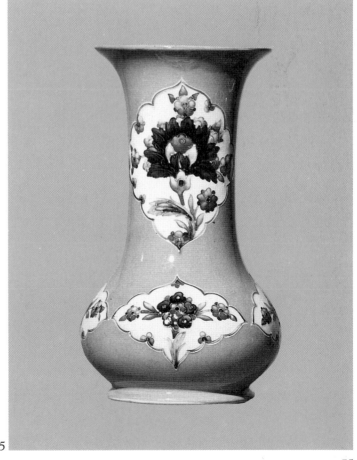

3

4

5

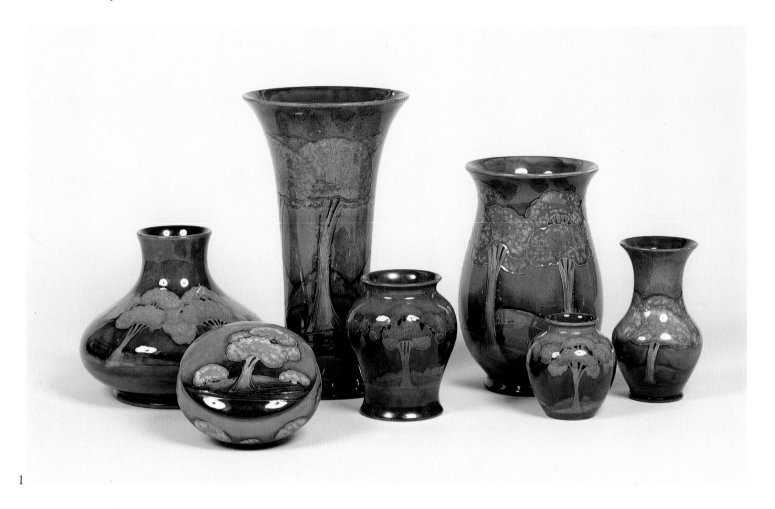

1 Group of wares decorated with the Moonlit Blue landscape design, c1925. Trumpet vase height 11 ins
2 Group of wares decorated with the Eventide landscape design, c1925. The trumpet vase and the inkwell have Tudric pewter mounts. Trumpet vase height 9 ins

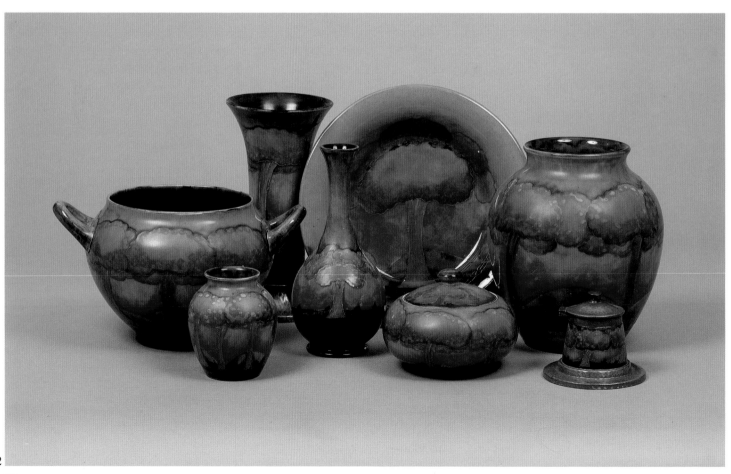

Later Landscape Designs

One of Moorcroft's most characteristic developments during the early 1920s were the later landscape designs. After the move to the new factory the green landscape design, generally known by the Hazledene name given to it by Liberty, remained in production for a few years, probably until about 1916. In 1921 Moorcroft turned to landscape again as a source of inspiration and began to experiment with trees in blues and greens on a Powder Blue base. This culminated in the Moonlit Blue design, launched in 1922. A year later another landscape range was launched, Eventide with its rich oranges, reds and greens, and in about 1926 the third design appeared. This was Dawn, with its pale blue, white and yellow colours and a matt-finished surface. All three designs were similar in style to their predecessors, with rolling hills and tall, leafy trees but later other trees appeared, for example willows and others with more simplified forms. Landscape designs were continually popular and appeared on many shapes and in many forms throughout the 1920s and 1930s, including tablewares, large exhibition pieces, with silver, or silver on copper mounts and with flambé finishes.

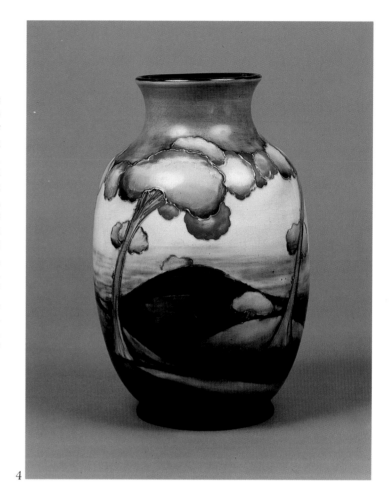

4

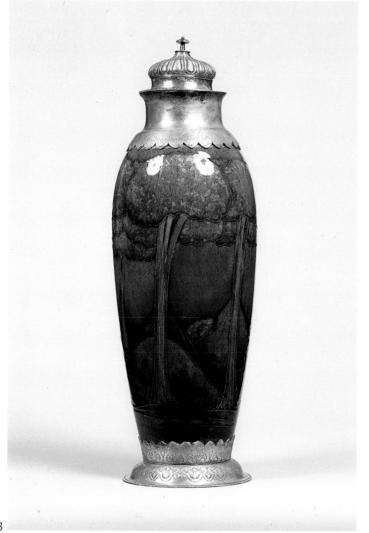

3

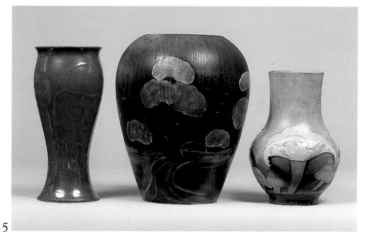

5

3 Large vase decorated with the Moonlit Blue landscape design, with silver mounts by Francis Arthur Edwardes. Hallmark 1923. Height 17½ ins
4 Vase decorated with the landscape design in unusual colours and a light flambé glaze, c1928. Height 11½ ins
5 Group of vases decorated with toadstool and landscape designs in unusual colours. Left to right, mushrooms under a brown lustre glaze, c1920, unsigned and unmarked, a dark version of the Dawn design, c1928, and mushrooms in browns with a saltglaze finish, c1934. Largest vase height 11½ ins

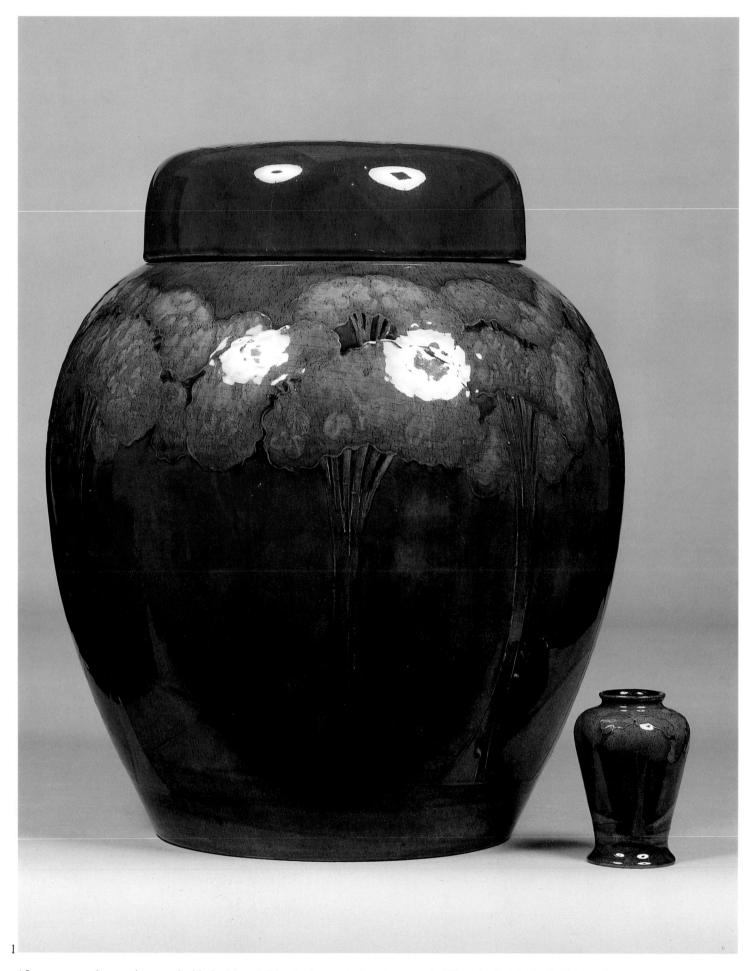

1

1 Large vase and cover decorated with the Moonlit Blue landscape design, shown at the Wembley Exhibition in 1924, and a small Moonlit Blue vase to show the scale. Small vase height 3ins

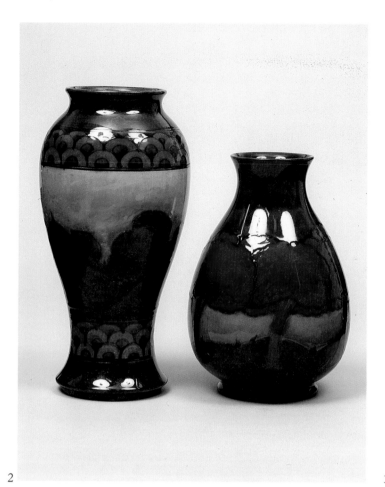

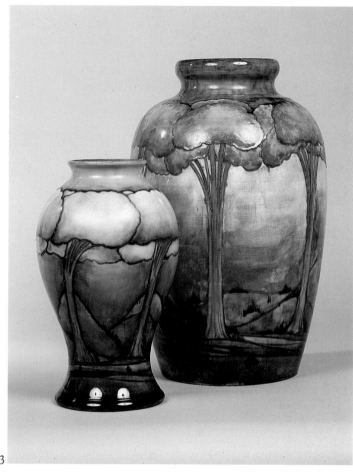

2

3

2 Two vases decorated with a landscape design under flambé glazes, one with geometric borders, both c1928. Larger vase height 12 ins
3 Two vases decorated with versions of the landscape design in unusual colours, left a blend of Dawn and Moonlit Blue colours, c1932, right, a blend of Eventide and Moonlit Blue, dated 1929. Larger vase 18½ ins
4 Two vases decorated with landscape and grape designs in sombre saltglaze colours, c1928. Larger vase height 8½ ins
5 Vase decorated with a version of the landscape design featuring a willow tree, c1930. Height 14½ ins

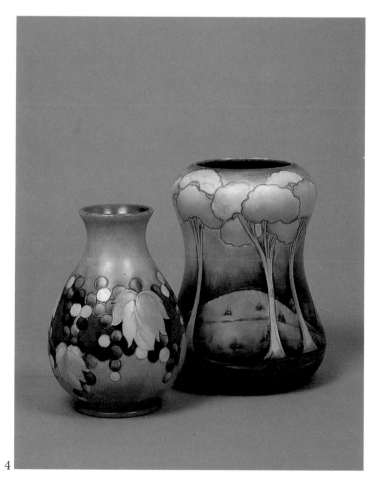

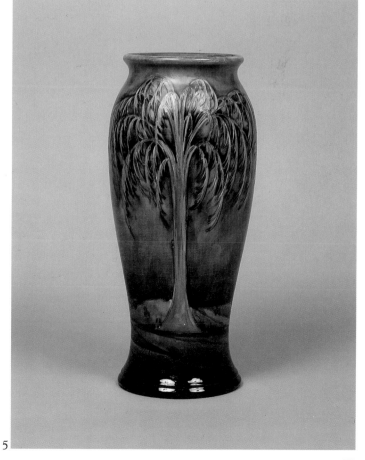

4

5

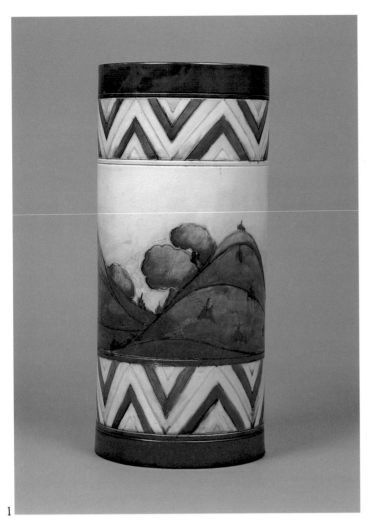

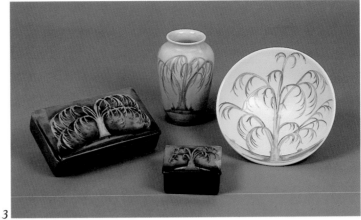

1 Vase decorated with the Dawn landscape design in typical colours, c1928. Height 14¾ins

2 Group of wares decorated with the Dawn landscape design, showing the variation of the colours under the matt glaze, c1928. Largest vase height 10½ins

3 Group of wares decorated with the willow tree version of the landscape design, c1930. Dish diameter 7ins

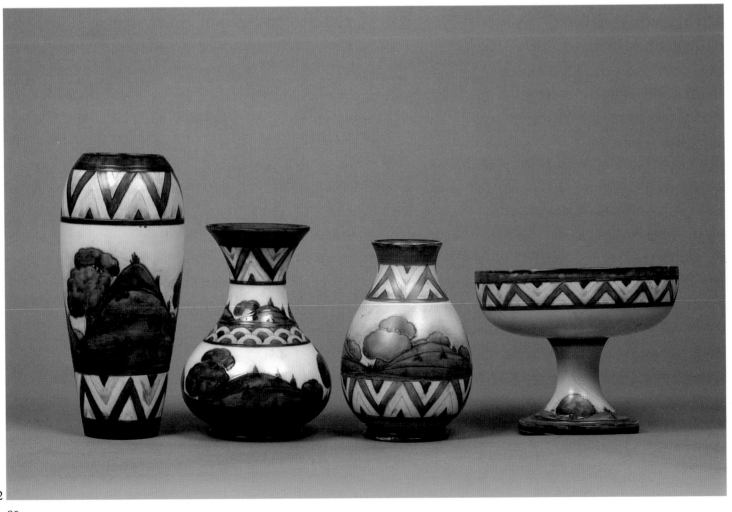

Later Cornflower Designs

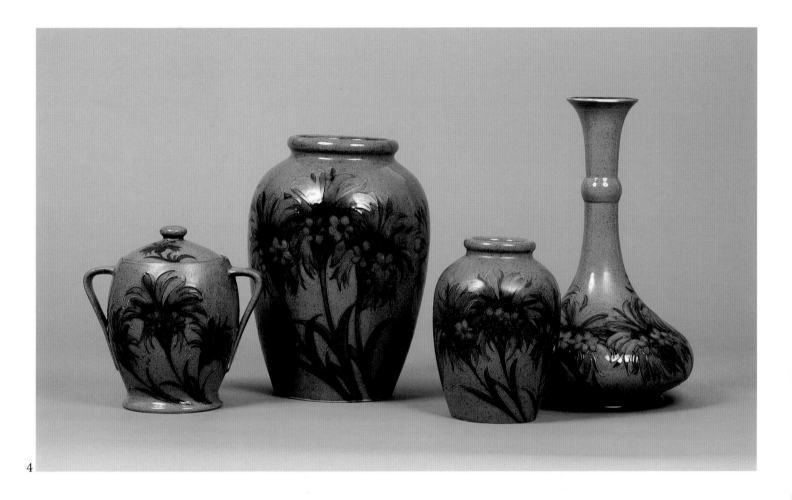

4

3 Group of Powder Blue wares decorated with a cornflower design, c1920. Largest vase height 12¼ins
4 Group of wares decorated with cornflower designs in a wide range of colours, 1925-1935. Largest vase height 12½ins

5

Domestic and Exotic Flower Designs

During the mid 1920s and early 1930s Moorcroft continued to use flowers as his main source of inspiration. At least ten new designs were produced during this period which featured a wide range of both domestic and exotic flora. This change of direction was marked by the appearance in about 1923 of the so-called big poppy design, which was derived directly from earlier Florian styles and, at the same time, a few earlier flowers, such as cornflower, orchid, poppy and wisteria, which Moorcroft particularly liked, had reappeared regularly in new forms or styles. However, in the late 1920s, a new series began to appear in which flowers were drawn in a direct style that was also botanically more accurate. English flowers were still the mainstay of Moorcroft's work, for example anemones, fresias, honeysuckle and other early summer plants, but there was an increasing interest in the exotic. The new orchid designs appeared, perhaps inspired by some of his father's botanical drawings, and then Moorcroft looked further afield for his ideas.

The Australian waratah and the South African *protea cynaroides* were drawn at this time. Rich colours and exotic styles were also applied to domestic subjects, notably the leaf and blackberry and the leaf and grape designs of 1928 with their strong autumnal colouring. These flower designs were used throughout the 1930s in many forms and styles, and often appeared under flambé glazes.

1 Group of wares decorated with the big poppy design, the two vases with flambé glazes c1929, the bowl and cover dated 1926. Larger vase height 10ins
2 Group of wares decorated with the big poppy design on dark grounds, c1925. The trumpet vase has a Tudric pewter mount. Largest vase height 12¾ ins

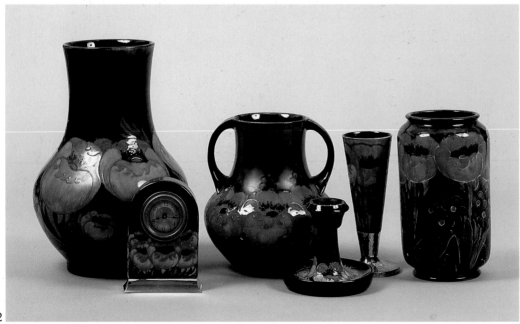

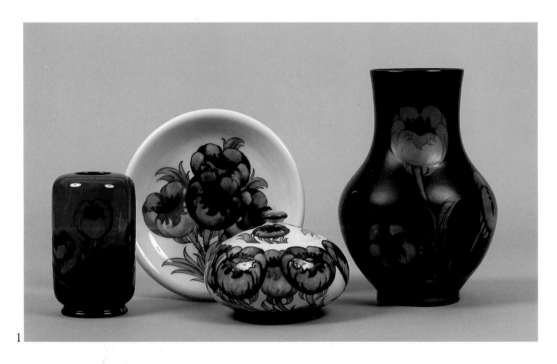

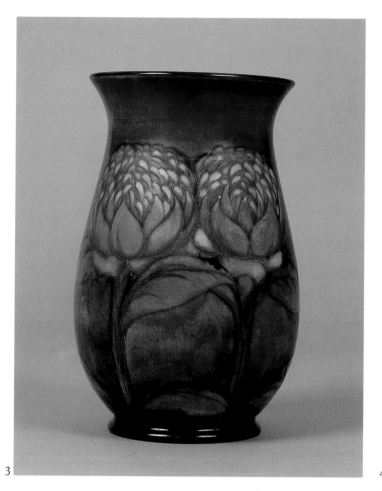

3

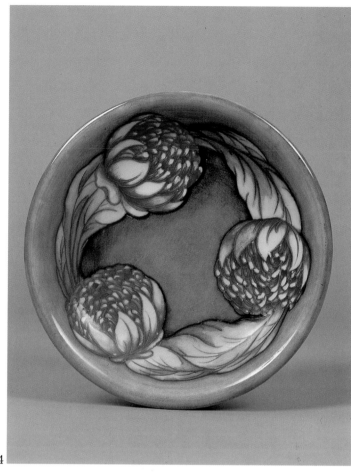

4

3 Vase decorated with the waratah design under a flambé glaze, c1932. Height 9½ ins
4 Plate decorated with the waratah design in natural colours, c1932. Diameter 8½ ins
5 Group of wares decorated with the waratah design, showing the version with a blue ground, c1932. Largest vase height 8¾ ins

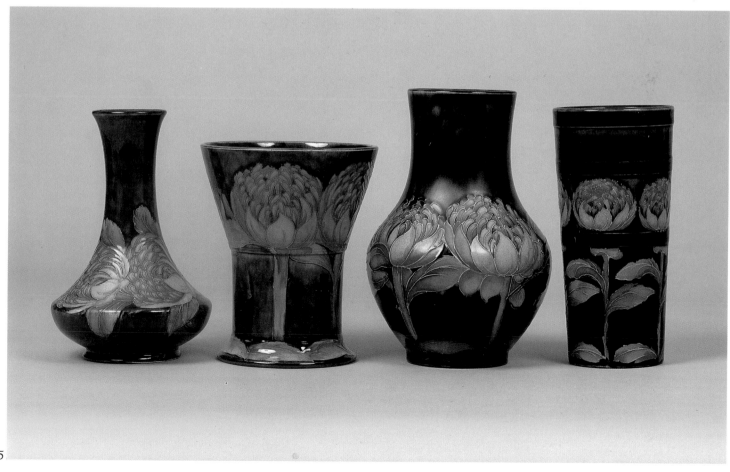

5

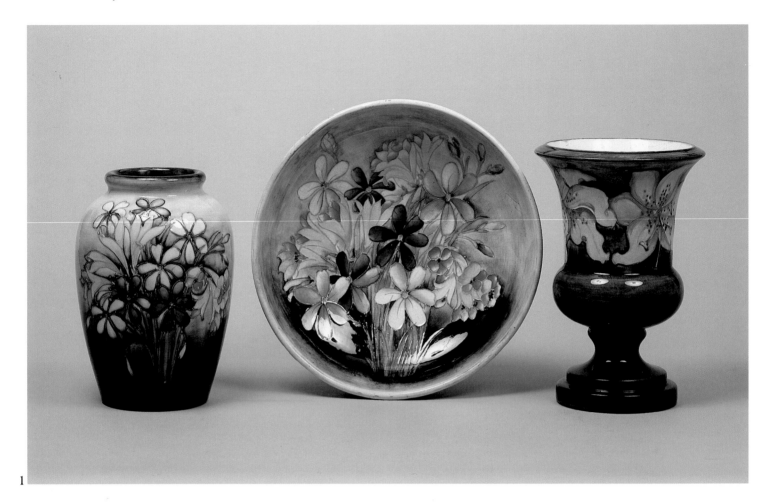

1

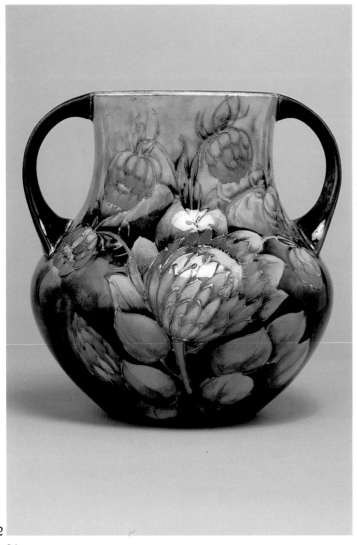

2

1 Group of wares decorated with orchids and spring flowers, c1936. Goblet height 10½ ins

2 Large vase decorated with the South African flower, *protea cynaroides*, in natural colours, c1930. Height 11 ins

3 Group of vases decorated with late versions of the wisteria design, two with dark blue grounds and the banded patterns of the late 1920s, one in the typical pale matt colours of the mid 1930s, and one in a revived Florian style, c1920. Largest vase height 13¼ ins

4 Group of wares decorated with a plum design on dark grounds, showing the similarity with wisteria, 1920-1925. Largest vase height 9¾ ins

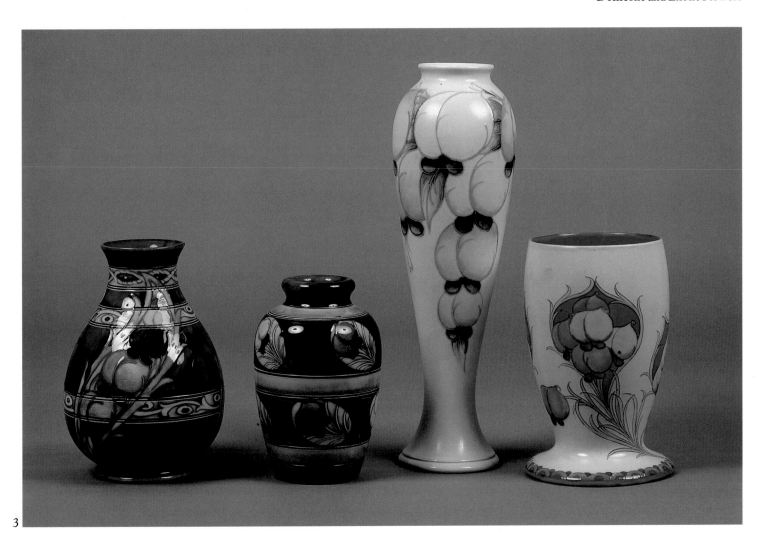

3

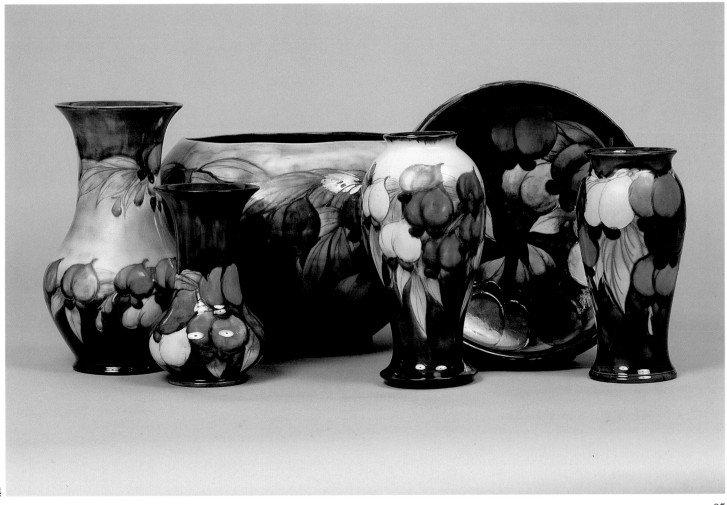

4

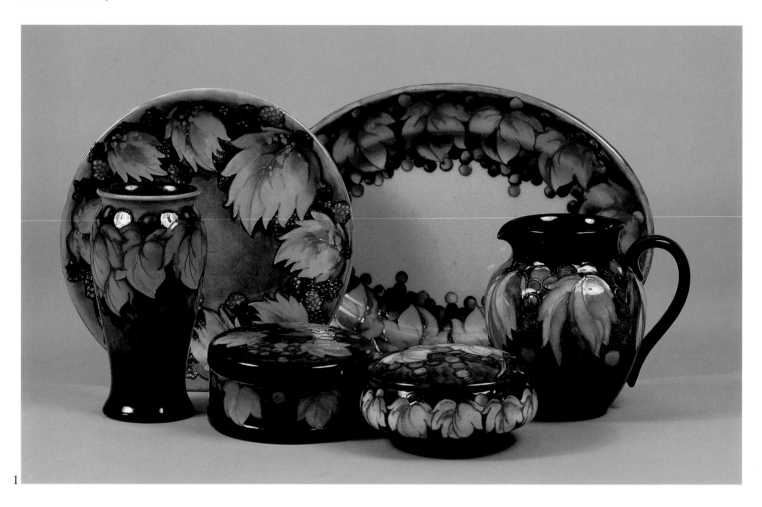

1

1 Group of wares decorated with grape and leaf and blackberry and leaf designs, showing a range of colours, 1928-1935. Vase height 7½ ins

2 Group of wares decorated with an orchid design, showing a range of colours. Larger vase height 10¾ins

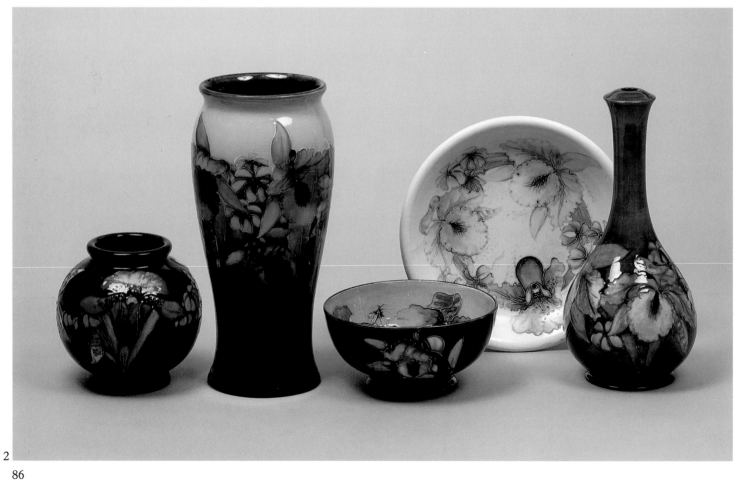

2

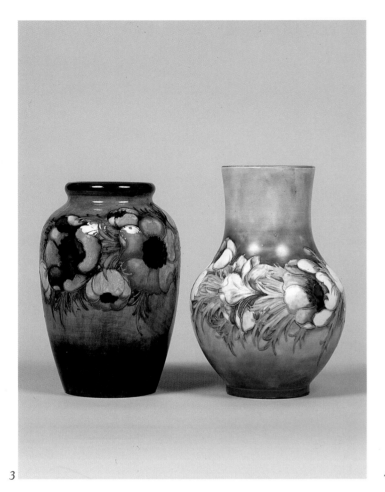

3

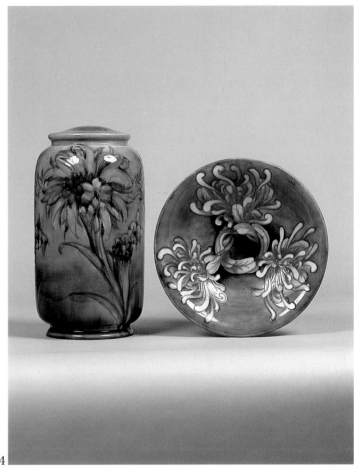

4

3 Two vases decorated with the anemone design in different colours, c1938. Larger vase height 9½ ins
4 Lamp base decorated with a late version of the cornflower or chrysanthemum design, c1936, and a plate decorated with a honeysuckle design, c1936. Plate diameter 10ins
5 Group of wares decorated with a fresia design, in three colour versions, c1935. Larger vase height 12 ins

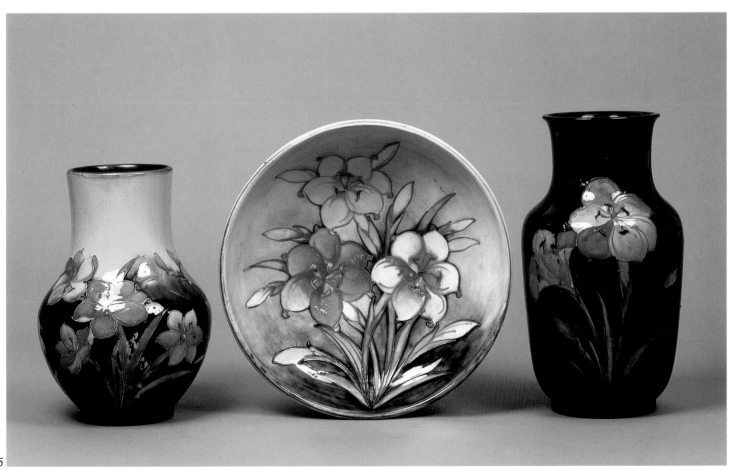

5

Later Fish Designs

During the Florian period, Moorcroft had used fish designs for some of his most splendid wares. Large jardinières and Hesperian vases were often decorated with carp drawn in a free and distinctly Japanese style. In the late 1920s fish reappeared, and continued to feature throughout the 1930s. However, these designs are very different. The Japanese element has disappeared, and the fish, now of less definable species, float freely over the surface of the ware, unencumbered by surrounding weeds and swirls. Many of the fish even have a cartoon quality, and on some pots this because quite surreal, with garden plants growing quite happily underwater beneath the fish. The occasional jellyfish or octopus adds excitement. Mostly drawn in greens and blues, the fish designs were often given a flambé glaze. Others occur in paler colours under matt magnolia glazes on the distinctive shapes of the late 1930s.

1 Group of wares decorated with fish designs in typical colours, c1930-1936. Largest vase height 19¾ ins
2 Group of wares decorated with a fish design under matt glazes, c1930. Largest vase height 16 ins

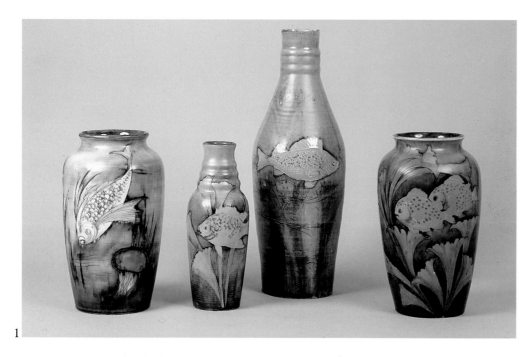

1

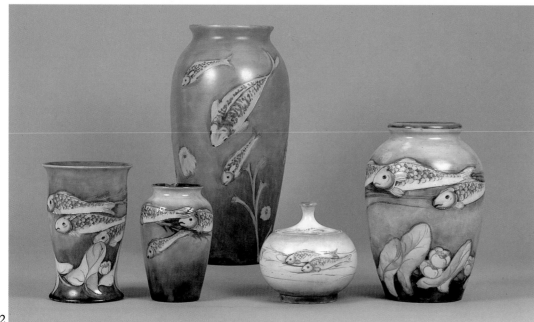

2

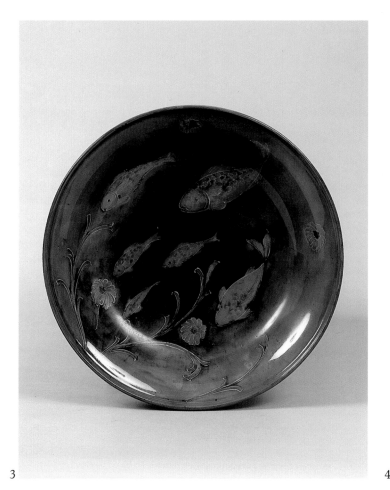

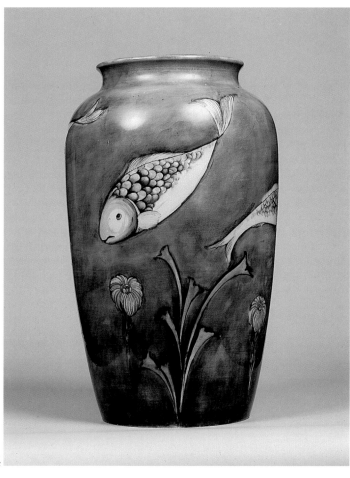

3

4

3 Dish decorated with a fish design under a flambé glaze, c1930. Diameter 11 ins
4 Large vase decorated with a fish design, dated 1931. Height 18¾ ins
5 Group of wares decorated with fish designs in typical colours, some with flambé glazes, all c1930 except the vase on the far right which is dated 1933. Largest vase height 14½ ins

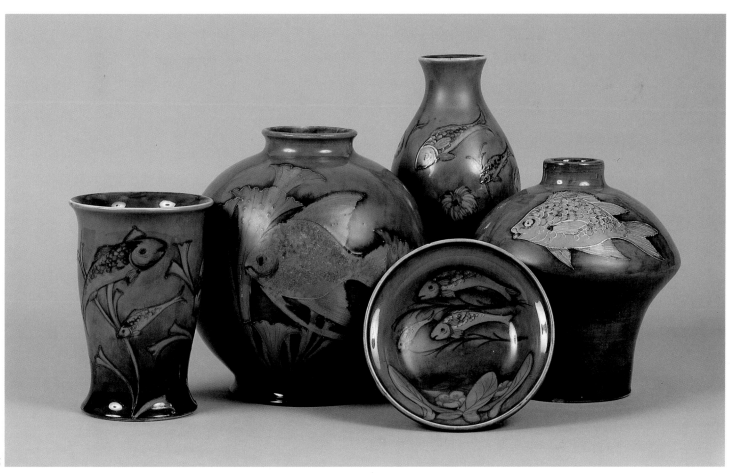

5

Flambé Wares, 1919-1945

In common with many of his contemporaries, for example, Bernard Moore, Charles Noke and Howson Taylor, Moorcroft developed an interest in transmutation and other orientally-inspired high temperature glazes in the early 1900s. He lacked the facilities to develop his own flambé glazes at the Macintyre factory and, during the First World War, at Cobridge, but in 1919 he decided to build a special kiln for the purpose. It was not completed until 1921 but by 1922 Moorcroft was already producing his first rouge flambé glazes, and using them either without additional ornament for a plain flambé ware, or as an overlay on ware that had been decorated in his usual style. During the next two decades Moorcroft became a master of the flambé process, and some of his most spectacular pieces were decorated by means of this complex and demanding technique. He never attempted to standardise his effects. He enjoyed the extraordinary blend of skill and chance that made every example of this flambé ware unique, exploiting to the full the range of rich reds, yellows and browns, shot with other colours, that could be obtained when the process was used successfully. He controlled the glazing and the firing of the ware himself, firing his kiln alone, and carefully nursing it through the vital transmutation process unaided. By this personal control, he was able to develop the wide range of flambé colours and finishes that were compared by experts with the sang de beouf and other monochrome glazes of the early Chinese potters. Although many of his finest pieces were devoid of ornament other than the glaze itself, he achieved equally dramatic results by using the flambé as an overglaze when flowers, fruit, foliage, toadstools and landscapes loomed through an overlay of rich red, chartreuse and other colours. Moorcroft received many accolades for his flambé glazes and continued to experiment with this exacting process until his death in 1945. He guarded his secrets jealously, revealing them only to his son, Walter Moorcroft, who developed his own flambé ware after his father died.

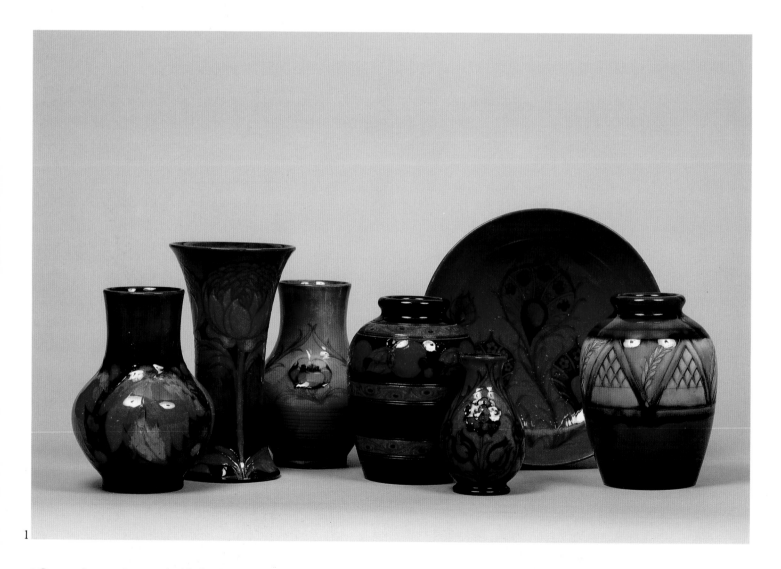

1

1 Group of wares decorated with flambé glazes over a range of designs, including blackberry and leaf, waratah, big poppy, pomegranate, peacock feather and wheat, 1925-1935. Bowl diameter 9¼ ins
2 Vase decorated with an even rouge flambé glaze in Chinese style, with silver cover and foot by Francis Arthur Edwardes, c1926. Height 10¼ ins

2

3

3 Owl standing on a rock, cast from a model by the artist and silversmith, Francis Arthur Edwardes, decorated by Moorcroft, in rouge flambé glaze. Edwardes modelled a very limited number of pieces, including animals, birds and grotesque masks that were treated in this way. Very few of them were made, and were seldom repeated. They were sold as individual pieces, or even unique examples of the pottery, but were not reproduced for general sale, about 1925. Height 8½ ins

4 Vase decorated with the Eventide design between bands of chevrons, with a light flambé glaze, c1925. Height 9½ ins

5 Vase decorated with the wisteria design under a rich flambé glaze, c1925. This has a Liberty paper label showing that the original price was £6.15s. Height 12½ ins

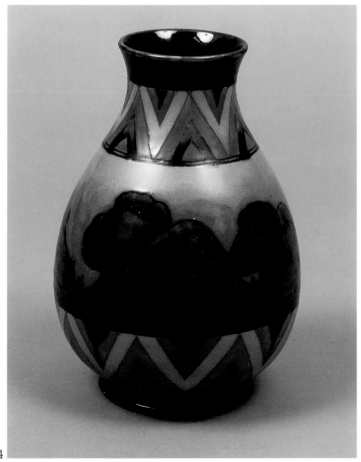

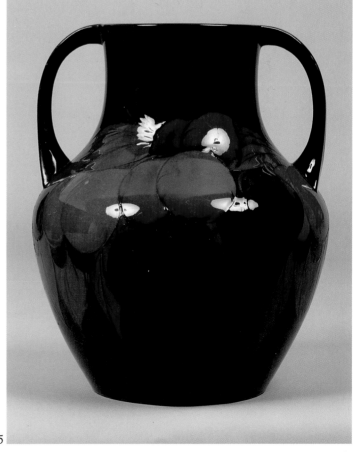

4

5

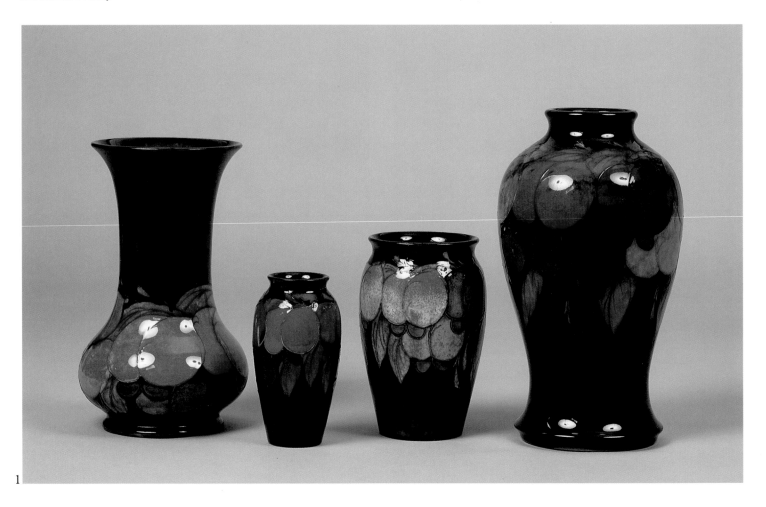

1

1 Group of vases decorated with the wisteria design under flambé glazes, c1928. Largest vase height 9½ ins

2 Group of wares decorated with a fresia design under flambé glazes, showing different intensities of red, c1934. Bowl diameter 12 ins

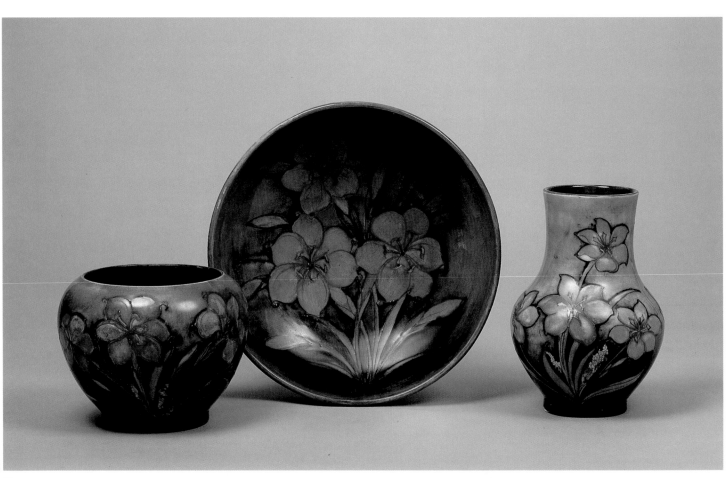

2

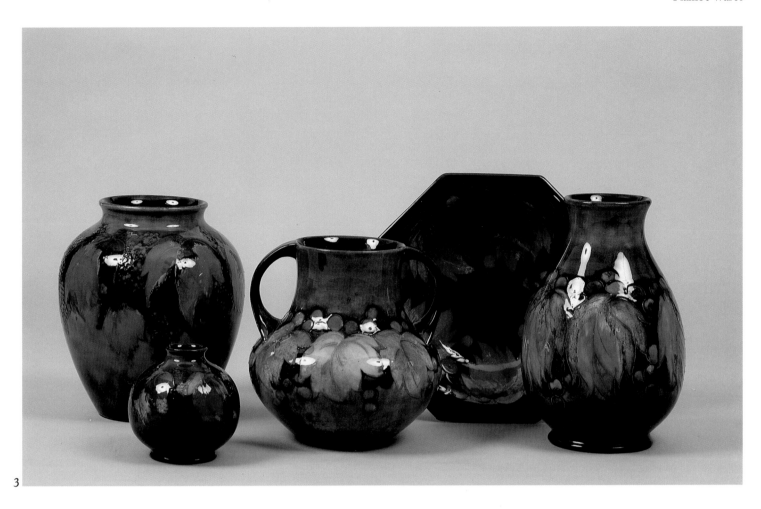

3

3 Group of wares decorated with leaves and fruit designs under flambé glazes, 1928-1934. Dish diameter 10 ins

4 Group of wares decorated with fish designs under flambé glazes, 1930-1938. Bowl diameter 7½ ins

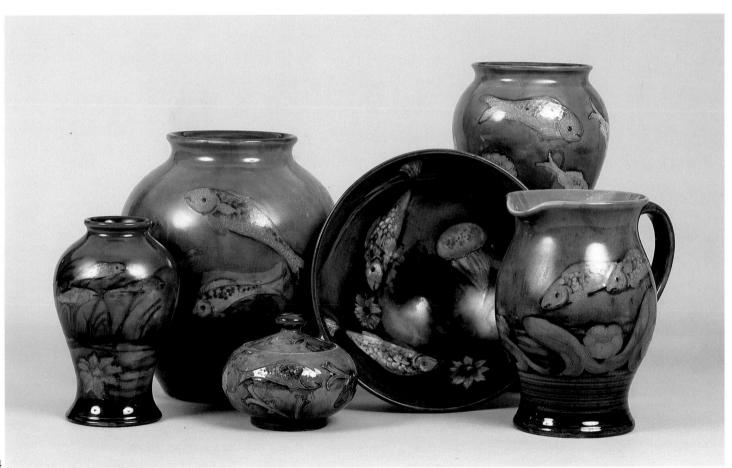

4

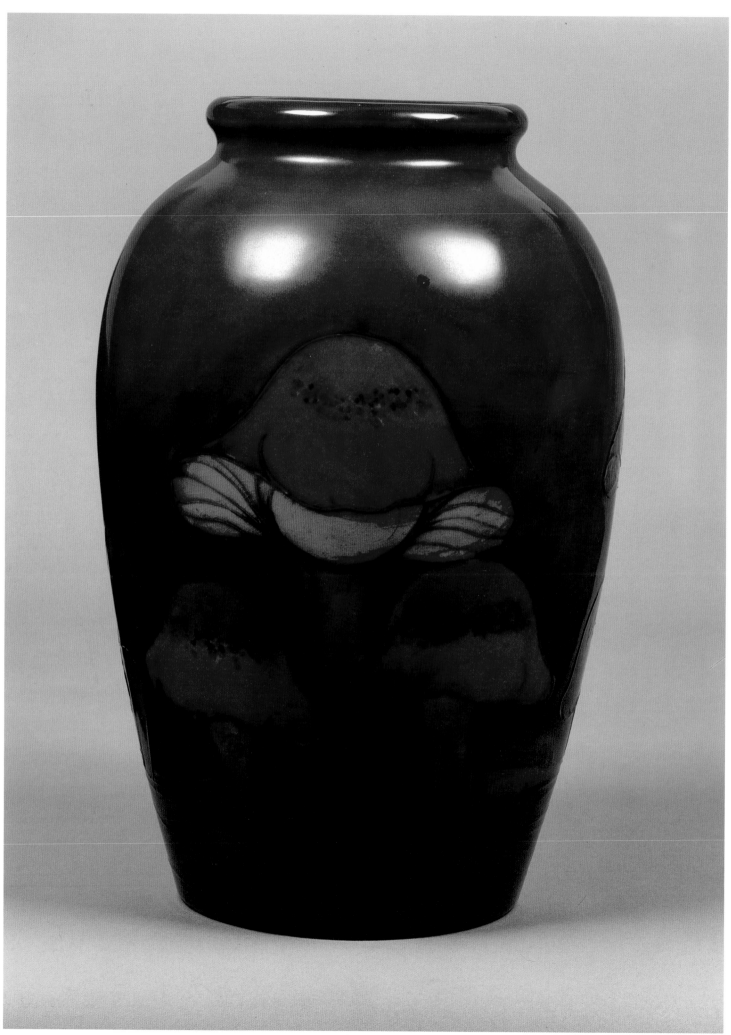

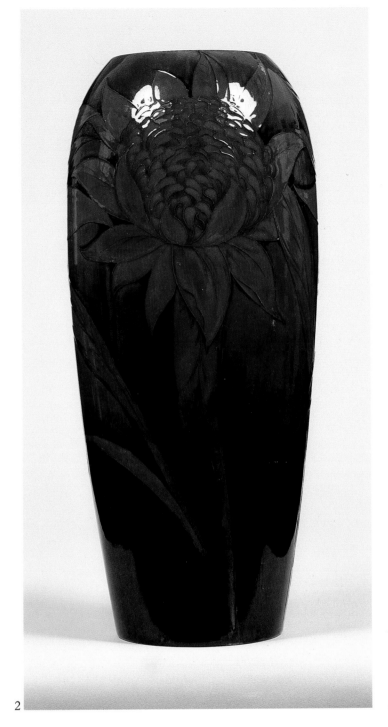

2

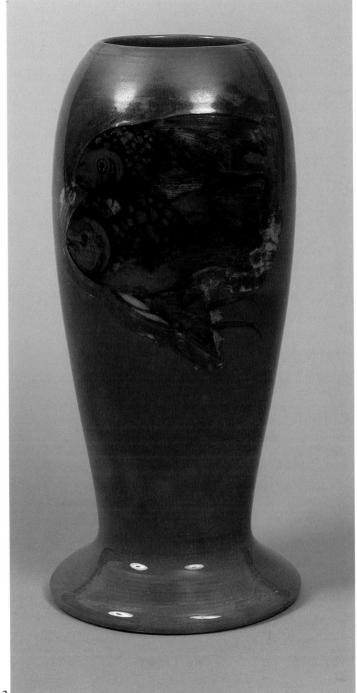

3

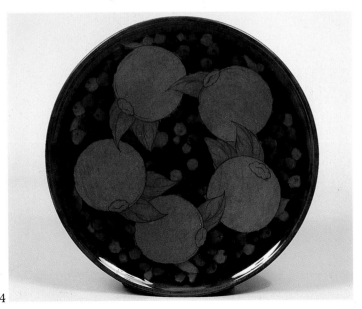

4

1 Vase decorated with the toadstool design under a flambé glaze, c1932. Height 13 ins

2 Tall vase decorated with the waratah design under a rich flambé glaze, dated 1939. Height 17 ins

3 Vase decorated with a fish design under a flambé glaze, c1938. Height 14½ ins

4 Charger decorated with the pomegranate design, under a rich ruby flambé glaze, c1925. Diameter 15½ ins

Miscellaneous Wares

Moorcroft always considered that the design and production of useful ware was as important as ornamental pieces. The backbone of this production throughout the 1920s and 1930s, and indeed until the early 1960s was the Moorcroft Blue tableware. During this period, other plain tablewares were produced, notably the yellow Sunray version, introduced in 1933 and made until 1939, and advertised in Liberty catalogues during the late 1930s. Decorative tableware, featuring most of the ornamental designs and fully signed, was also produced. While some plates and plaques were clearly ornamental, decorative tablewares were designed for the Moorcroft Blue shapes, but some interesting forms, inspired by Middle Eastern and oriental pottery and designed at Macintyre's, were used until about 1916. The useful wares were expanded to include dressing table sets, trays, mugs, candlesticks, beads, buttons and the characteristic square biscuit boxes. Ware designed to be mounted in silver, silver plate, pewter and other metals was also produced until the 1930s, maintaining the tradition established at Macintyre's since 1898. These included teasets, ashtrays and smoker's sets, inkwells and many other articles, including little plaques to be mounted as brooches. Moorcroft began to make miniature pieces at Macintyre's, at a time when miniature vases, jugs and beakers were popular, and production continued at Cobridge, along with small scent bottles and trinket boxes. These little pieces called for a delicacy of touch, taxing the skills of the designer, the potter and the decorator, and were therefore quite expensive to make.

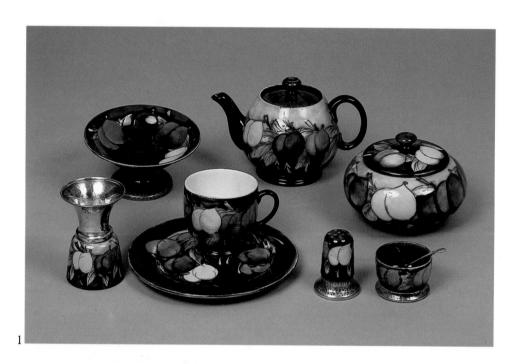

1

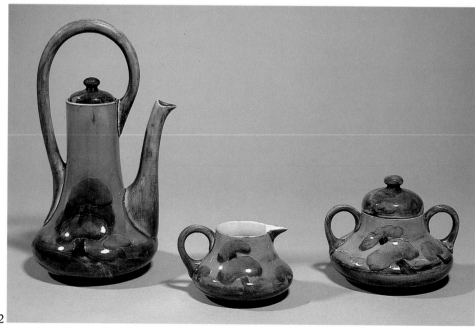

2

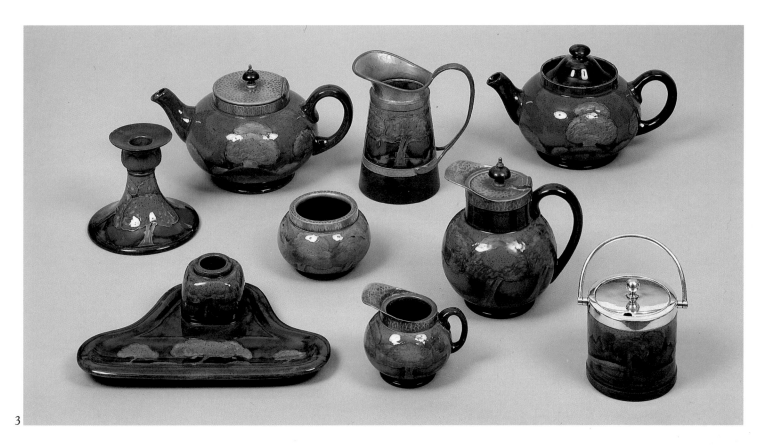

3

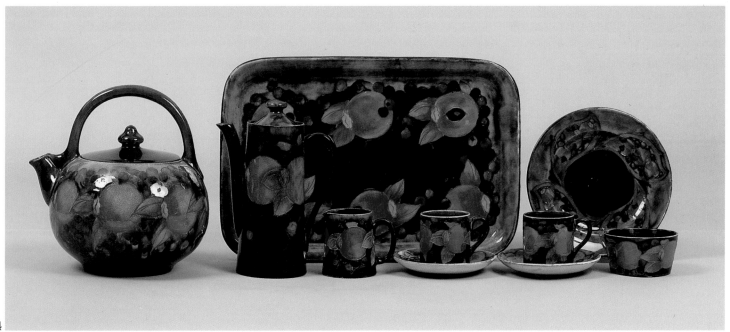

4

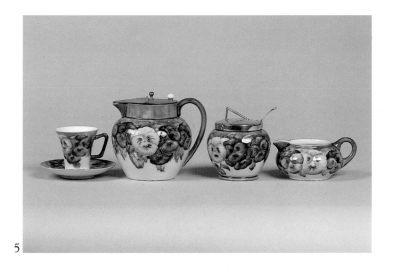

5

1 Group of domestic and tablewares decorated with a plum and leaves design, some with metal mounts, c1925. Teapot height 6 ins
2 Part of a teaset decorated with the green Hazledene landscape design, showing Middle Eastern forms designed at Macintyre's, made at Cobridge, c1916. Teapot height 10 ins
3 Group of useful wares decorated with the Moonlit Blue landscape design, and showing various metal mounts, c1924. Teapot height 5½ ins
4 Group of tablewares decorated with the pomegranate design, 1915-1930. Tray width 10½ ins
5 Group of tablewares decorated with the pansy design, some showing metal covers, c1914. Larger jug height 5 ins

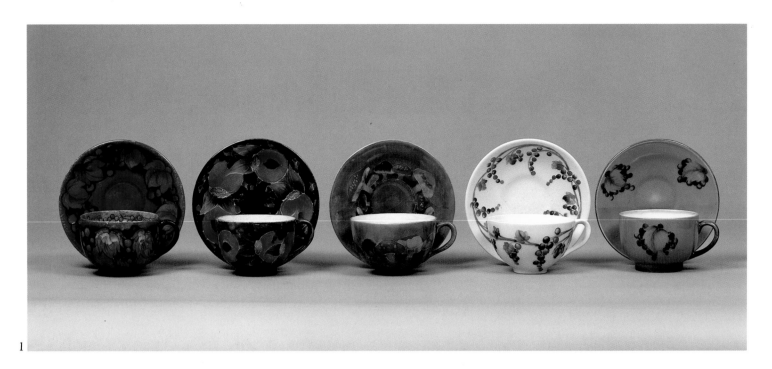

1

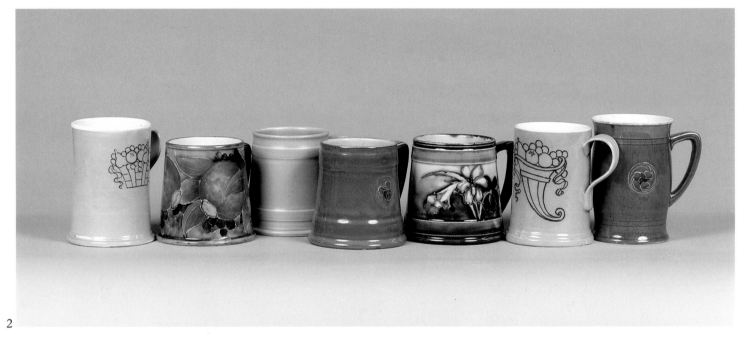

2

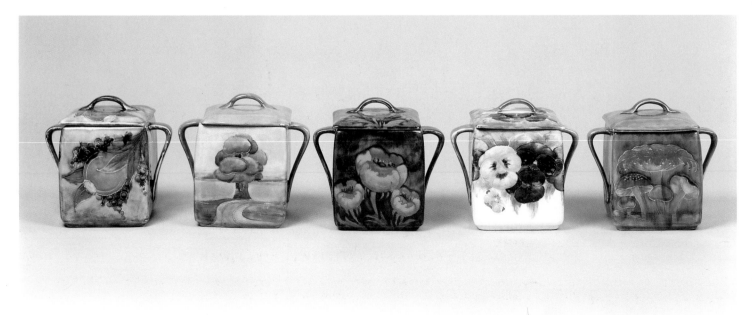

3

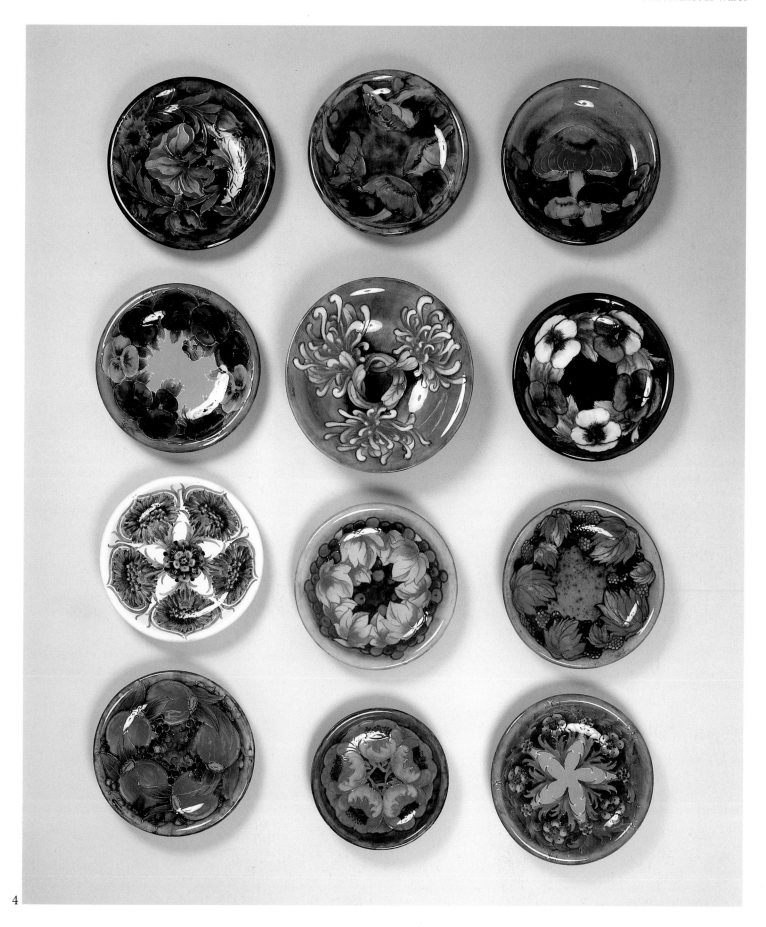

4

1 Group of cups and saucers decorated with various designs, including pomegranate, toadstool and leaf and fruit. The example on the far left has a flambé glaze, 1915-1930. Cup height 3 ins
2 Group of mugs, showing a range of shapes and decorative styles, including conventional patterns, saltglaze and slipwares, 1914-1935. Tallest height 4½ ins
3 Group of biscuit boxes decorated with pomegranate, Hazledene, poppy, pansy and Claremont designs, three dated 1914. Height 6 ins.
4 Group of plates decorated with a range of designs and glazes, 1914-1930. Largest diameter 7 ins

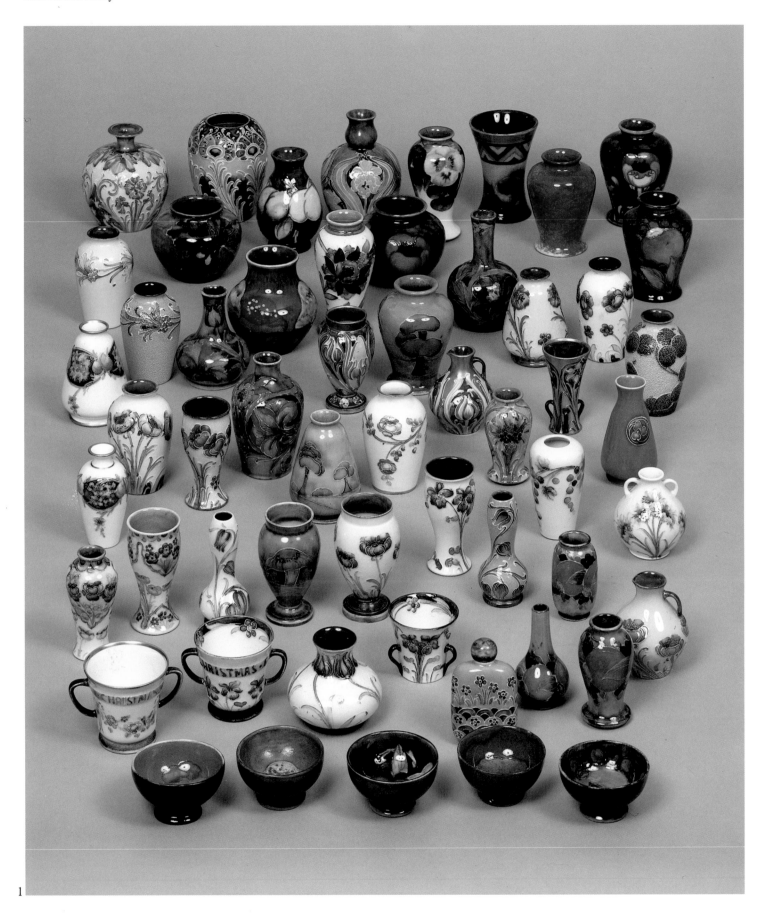

1

1 Selection of miniature vases, bowls, jugs and loving cups, and a scent bottle, decorated with a wide range of Moorcroft designs, including Aurelian, Florian, Flamminian, landscape, toadstool, Spanish, Persian, pomegranate, various floral patterns and flambé glazes, 1898-1935. Average height 2¼-4ins
2 Group of Moorcroft Blue, or Powder Blue, domestic and tablewares, showing some of the vast range of shapes produced between 1913 and 1963. Candlestick height 8ins
3 Traveller's fitted case containing examples of the Moorcroft Blue and Sunray tablewares, c1935
4 Plate decorated with chevrons and carrying the words MOORCROFT POTTERY one of a small number of designs made for exhibition and display purposes between 1913 and the mid 1920s and not offered for general sale. Diameter 10½ins
5 Selection of buttons, knobs, beads and metal mounted brooches, decorated with various Moorcroft designs and lustre glazes, 1914-1925

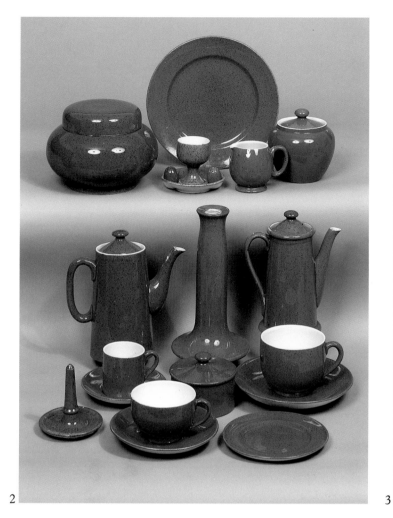

2

3

4

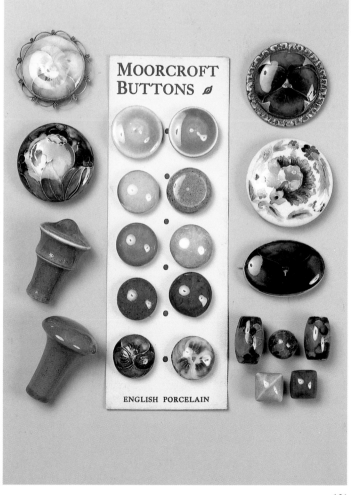

5

1930s Designs

The 1930s were a difficult time for Moorcroft, partly because of the international financial situation, and partly because of changing attitudes towards decorative pottery. The bright colours of the 1920s had been replaced by pale and sombre tones, and decorative patterns had given way to the plain, handcrafted styles of the studio potter. Moorcroft, always alert to changes in contemporary taste, responded in a number of ways. First, his export market was still strong and so he continued to develop his floral designs and flambé glazes. Second, he expanded tableware production, introducing the yellow Sunray and a plain green range. Third, he introduced new designs that reflected the taste for lighter and more subdued colour, matt glazes and abstract or geometric ornament. Some incorporated highly simplified versions of earlier motifs, such as peacock feather or honesty, while others were entirely new, for example yacht, orange and blossom or waving corn. It was a period of experiment and many other designs appeared on individual pieces but were not developed further.

By late 1930s Moorcroft was incresingly in competition with the studio potters and it must have been ironical for him, whose pottery had always been thrown, turned and decorated by hand, to have to produce wares whose finish emphasised the handcraft look. He developed what he called 'natural pottery' whose new and unsophisticated style was in stark contrast to the Moorcroft tradition for excellence in finish. The lathe was dispensed with, and the ware was finished on the wheel with ribbing and primitive banding. None of the shapes were standardised, some remaining as they left the wheel, while others were formed into eccentric shapes by squeezing or manipulation. Pale colours or the semi-matt magnolia glazes were used to finish the ware, sometimes over the simple slip designs. 'Natural pottery' was sold at home and abroad but it was not particularly successful. Pieces were generally regarded as 'not typically Moorcroft', but some were commended, in Canada and elsewhere, for their oriental simplicity and spontaneity.

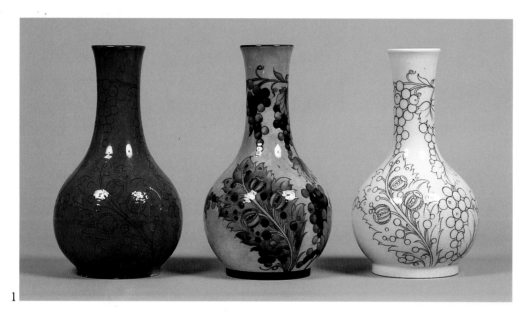

1

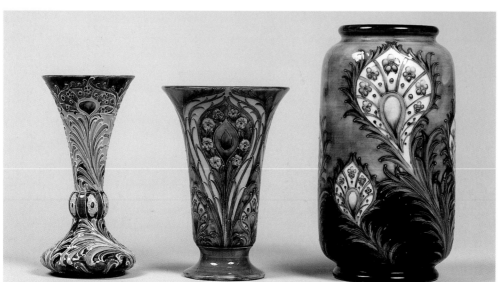

2

1 Three vases decorated with a leaves and fruit design, showing the simplification of the decoration during the 1930s. Left, a flambé glazed version, centre, a full coloured version under light flambé glaze, right, a plain version with the design drawn in outline, 1930-1938. Height 12½ ins
2 Three vases showing the development of the peacock feathers design, left, a Florian vase with the original design registered in 1899, centre, a revived Florian design of c1910, right, the simplified style of the late 1920s. Largest vase height 11¼ ins

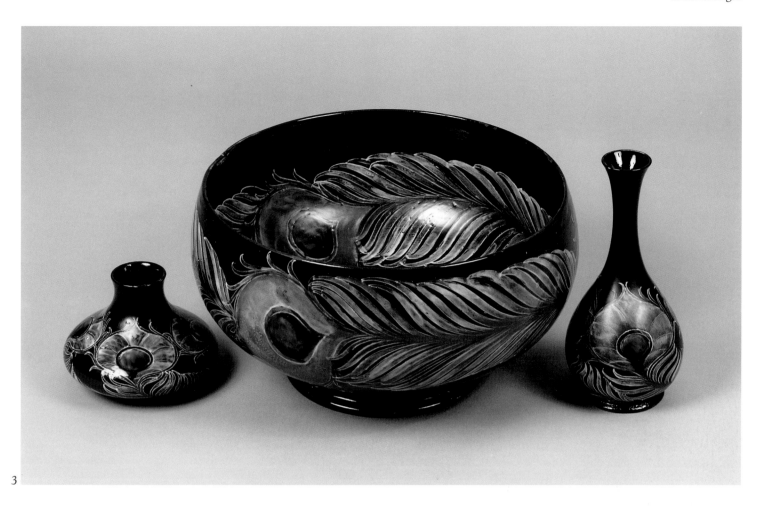

3

3 Group of wares decorated with the peacock feather design, showing the simplified drawing and dark blue grounds developed at Cobridge, c1918. Bowl diameter 12½ ins
4 Group of wares decorated with a late version of the peacock feathers, showing the stylised drawing and banding characteristic of the 1930s, c1934. Largest vase height 12½ ins

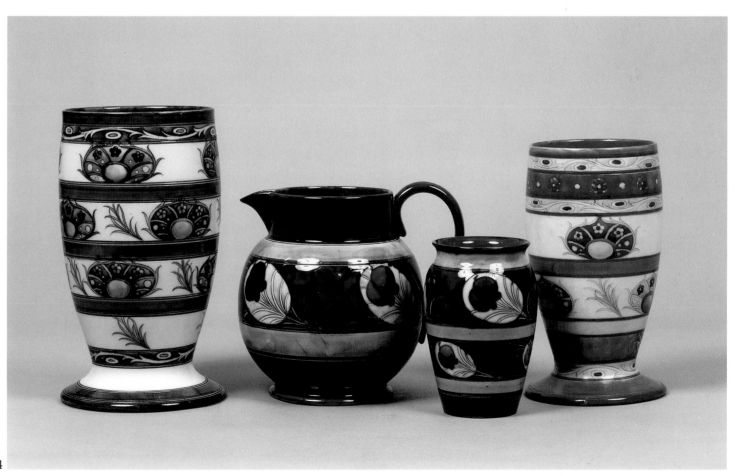

4

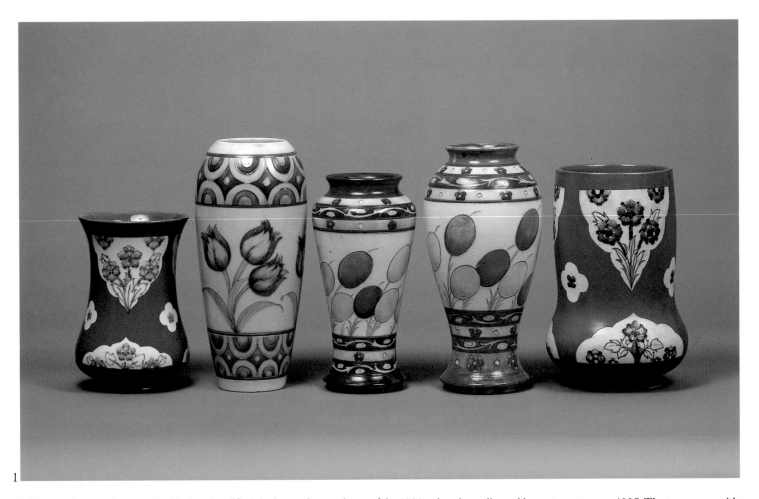

1

1 Group of wares decorated with the simplified design and matt glazes of the 1930s, showing tulip and honesty patterns, c1935. The two vases with monochrome designs in panels also show the continuity of styles during this period, for the smaller dates from c1916, and the larger is dated 1941. Largest vase height 10½ ins
2 Vase decorated with the late version of the honesty design, c1932. Height 13 ins
3 Vase decorated with the waving corn design, showing clearly its development from the landscape patterns, c1934. Height 13 ins

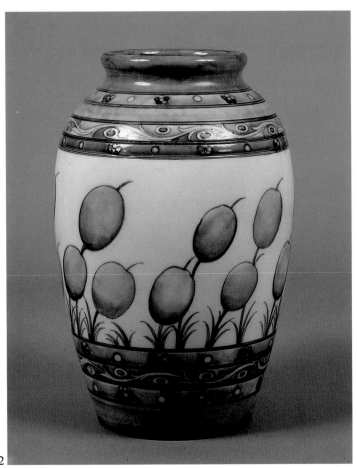

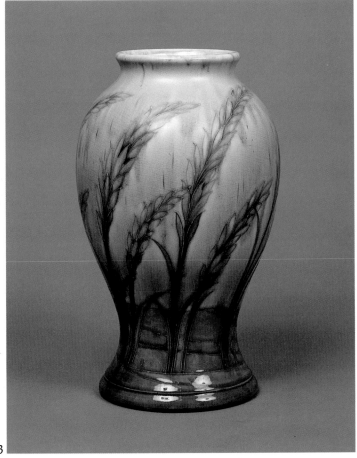

2

3

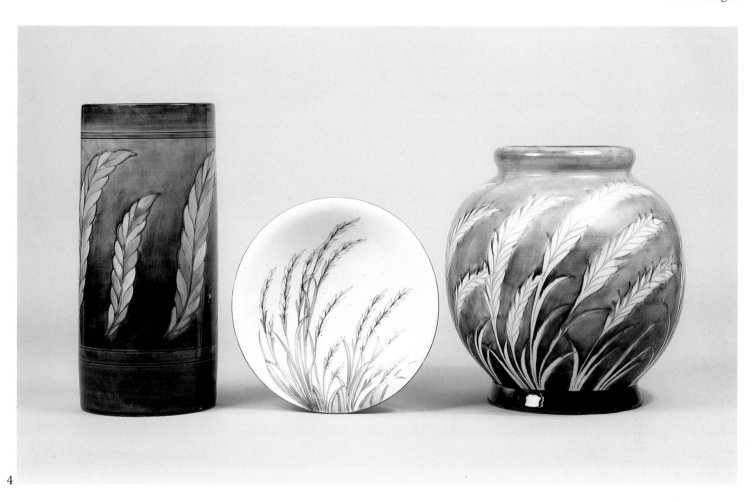

4

4 Group of wares decorated with the waving corn design, showing pale and mottled green grounds, ovoid vase dated 1937. Tallest vase height 14 ins
5 Group of wares decorated with simplified 1930s designs, the dish and jug with the orange and blossom pattern, the vase with flowers and fruit, all c1935. Jug height 8½ ins

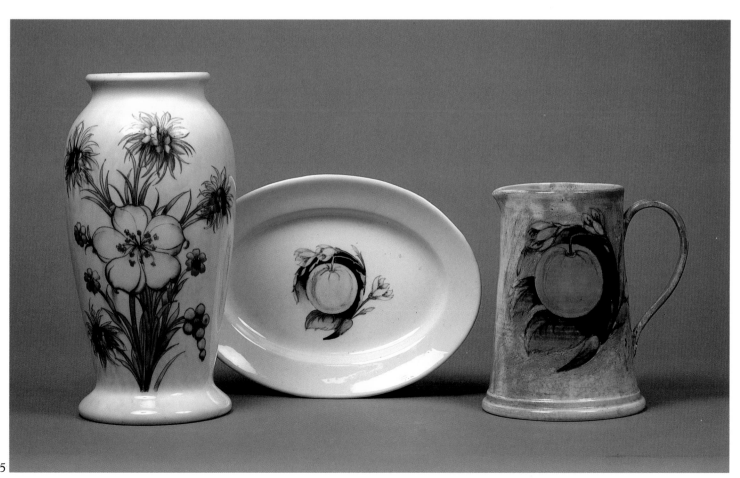

5

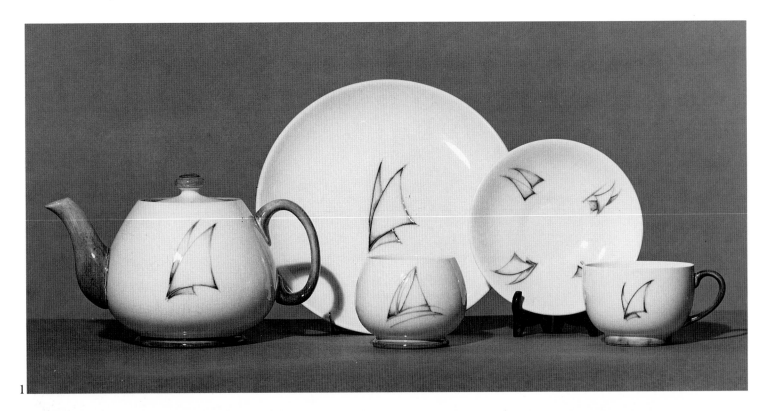

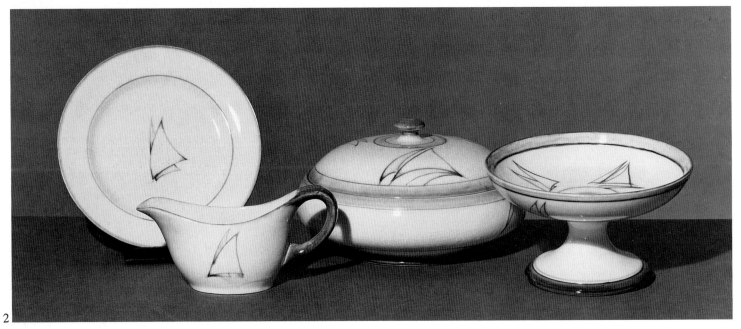

1 & 2 Selection of pieces from dinner and tea services decorated with the yacht design, all signed, c1935. Tureen diameter 8½ins
3 Group of wares decorated with the yacht design in various colour ways, and a plate with a duck design, 1934-1938. Larger vase height 10 ins
4 Group of wares decorated with the simplified Art Deco version of the peacock feathers design, with typical ribbing and matt finish, c1938. Jug height 10 ins

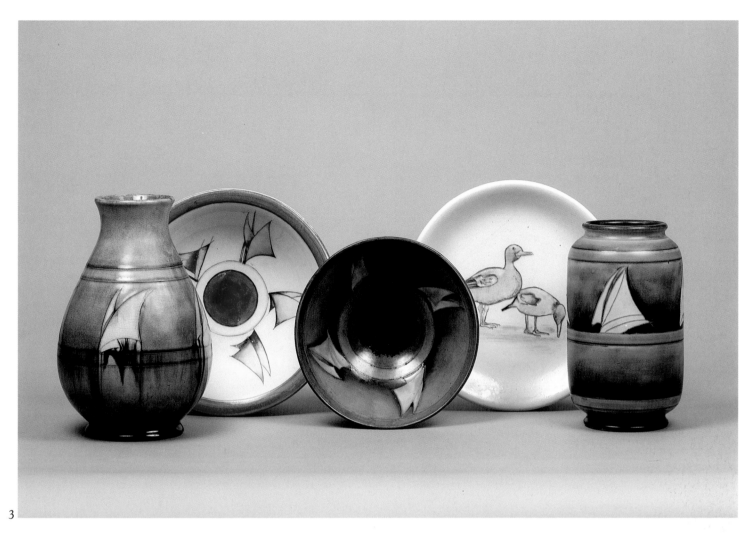

3

4

1 'Natural pottery' vase decorated with a pelican design in pale colours on a matt magnolia glaze, c1938. Height 4½ ins
2 Group of 'natural pottery' decorated with monochrome glazes, showing the characteristic handcrafted forms and simple ribbed surface patterns, c1935-1939. Tallest vase height 8 ins

Chapter Five
Walter Moorcroft at Cobridge, 1945-1986

Walter Moorcroft was born on 12 February 1917. After attending a preparatory school in Buxton, he went to Rugby, leaving at the age of 18. At that point his father gave him a choice; he could either continue his education at university, or he could come into the works. Walter did not hesitate in making his decision and started at Cobridge directly from school in 1935. The next four years were a vital period of development for him, giving him an insight into every aspect of pottery design, manufacture and selling. He became familiar with his father's working methods and the characteristic features of every design and so, although he received no formal design or art education, he was able to produce his own experimental designs during the late 1930s. The outbreak of the Second World War brought this period of apprenticeship to an end and Walter joined the army, serving with the Intelligence Corps. He did not return to Cobridge until early October 1945, shortly before his father's death, and he was then plunged straight into the deep end. That he was able to take the full responsibility for the factory directly onto his shoulders was due largely to his pre-war experience.

For the first four years Walter concentrated on keeping the factory alive. It was the period of austerity and the effects of a depressed home market and restrictions on the manufacture of decorative pottery made life difficult. At first he relied on the export markets and was able to maintain and develop a number of his father's designs, particularly the orchid and anemone patterns. Walter succeeded in keeping the factory going and gradually, as restrictions were lifted and his skilled craftsmen came back from war service, stability began to return.

While his father's designs had been vital during this difficult period of transition, Walter soon began to develop his own. His early patterns, such as, columbine and hibiscus, tended to follow in his father's footsteps, but a more distinctive personal style soon began to emerge during the 1950s. From the start, the exotic appealed more to Walter than to William, reflected both in

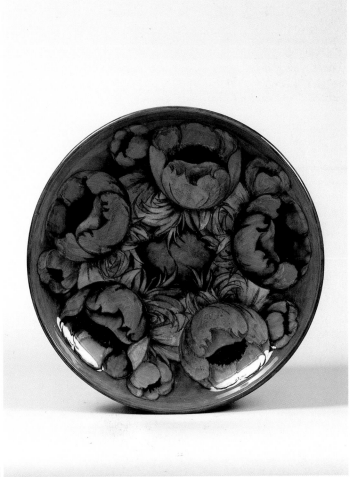

3 Large vase decorated with a fighting cock under a rich flambé glaze, designed by Walter Moorcroft in 1938. Based on a Chinese illustration, this was one of Walter's earliest identifiable designs and about 6 were made in different finishes. The vase carried William's signature. Height 12 ins
4 Charger decorated with a poppy design by Walter Moorcroft under a rich flambé glaze, c1939, and signed by William. Diameter 16¾ ins. Both these pieces date from the end of Walter Moorcroft's period of training at Cobridge, and show him starting to develop a distinctive personal style. Further progress in this direction was cut short by the outbreak of war in 1939.

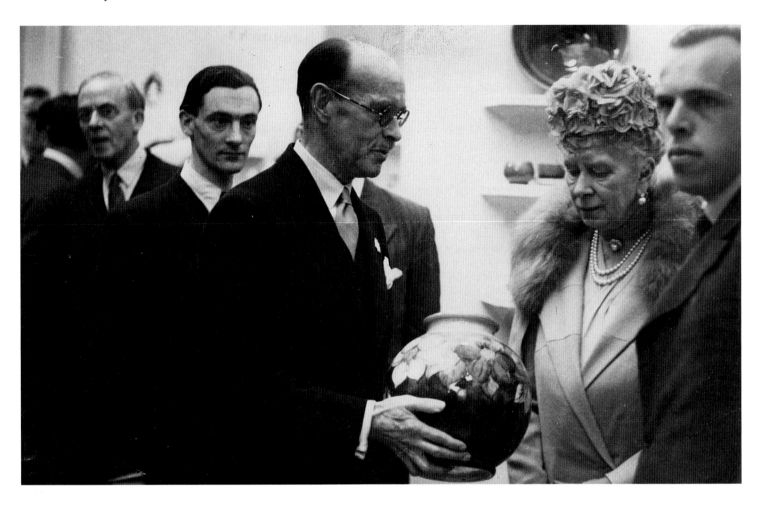

1 Queen Mary, a collector of Moorcroft pottery for over 20 years, was a regular visitor to the annual British Industries Fair. Here, she examines a pot with Walter Moorcroft in 1947
2 Using the technique developed by his father, Walter Moorcroft sketches a lily design directly onto the pot

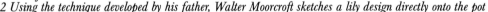

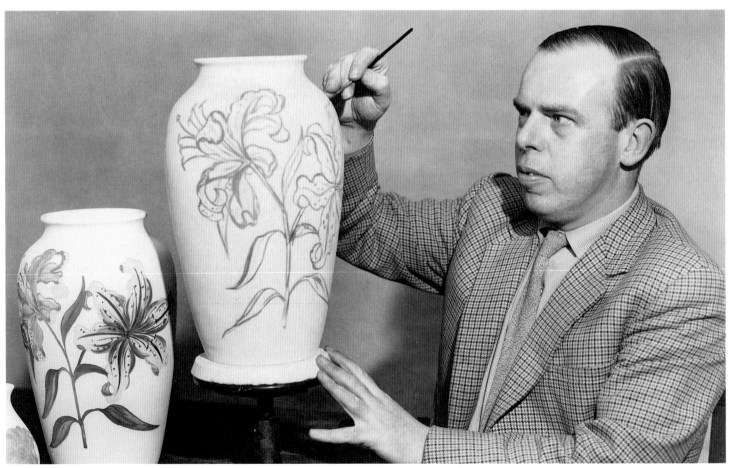

his more dramatic use of colour and in the choice of subjects such as arum lily, Bermuda lily, magnolia and, above all, the eccentric Caribbean and marine designs.

Walter's greatest inheritance from his father was his understanding of the transmutation process. Walter continued the experiments in flambé firing that he had started before the war. William had always kept the secrets of his flambé process to himself, preparing his own glazes and firing the kiln but, during the vital four year period before the war, he had transmitted these to Walter. During the late 1940s and early 1950s Walter was able to complete his mastery of this complex and dramatic technique, and he showed himself to be as dedicated to its harsh disciplines as his father had been before him. By expanding the use of silver in the firing alongside the more usual copper, he was able to increase the range of flambé colours, adding bright yellows to the reds, greens and browns, and control the application of the flambé colours to the details of the designs. Walter pushed the flambé process to its limits, making the most of its potential for unexpected accidental effects. It was a demanding and time consuming process. To achieve the rich colours sometimes required two glaze firings followed by up to three flambé firings, at intervals of three weeks. Firing too often could destroy the colours. The results were always unpredictable, and rarely repeatable. Even the weather was important: 'I always licked my finger to see which way the wind was blowing before firing', says Walter. Flambé firing continued at Cobridge until 1970, when the arrival of natural gas made it no longer practical and the oven was finally pulled down in 1973. At its peak flambé represented 10% of the output.

Walter Moorcroft has now been in charge at Cobridge for over forty years and throughout much of this time he has been entirely responsible for every aspect of the factory's production, from design to distribution. Under his control the factory has maintained its reputation as a small industrial studio pottery, relying largely on traditional skills and crafts. Certain technical changes have occured, for example casting has replaced throwing, and the old coal-fired bottle ovens have been replaced by a modern electric kiln, but essentially the factory is still one where William would feel at home. As a designer Walter has made his mark but, once again, the styles and methods developed by his father have been maintained. Slip-trailing and hand decoration have continued, ensuring that Moorcroft pottery has a distinctive quality that can be recognised anywhere in the world. While relying largely on natural inspiration for his designs, Walter has been wide-ranging in his use of sources. Some patterns were based on flowers he found in his garden, or leaves picked up on the golf course, while others have been inspired by plants he found during visits to the Caribbean and other exotic or distant countries. Perhaps the most adventurous period was the 1960s and early 1970s, a time when Walter's initial dependence upon his father's later designs came to end, and when his own skill as a designer reached maturity. This period also coincided with a great change in his personal life for in 1959 he married again, his first wife having died in tragic circumstances several years before. His new enthusiasm for life was reflected by the bright colours and dynamic styles that marked the 1960s. In the mid 1970s Walter brought about another change when he designed the magnolia range, a complete break with traditional Moorcroft colouring that established a pattern for the future.

For over seventy years the Moorcroft pottery remained a family business, controlled first by William from 1913 to 1945 and then by Walter from 1945 to 1984. In 1984, Walter's younger brother John became Managing Director and at the same time the Moorcroft family sold a controlling interest in the shares of W. Moorcroft Limited to three brothers, Michael, Stephen and Andrew Roper, whose extensive interests in ceramics included the Churchill Group. Under the shrewd eye of Roper management, production techniques were streamlined. A range of wares with moulded decoration was introduced to increase

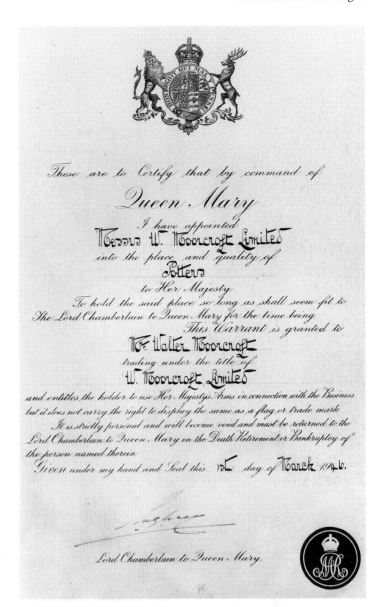

3 *William Moorcroft was awarded a Royal Warrant by Queen Mary in 1929. In March 1946 this Warrant was transferred to Walter, enabling him to use the title granted to his father, 'Potter to Her Majesty the Queen.' The Warrant expired in 1978, 25 years after the death of Queen Mary.*

production, featuring geranium and campanula designs by Walter. Sadly, the involvement of the Roper Brothers was short-lived. In September 1986, following John Moorcroft's wishes in the matter, they sold their shareholding in W. Moorcroft Limited to the Dennis and Edwards families.

Walter retires from the company in February 1987 after 52 years, an arrangement which Walter himself negotiated with the Roper Brothers in 1984. He continues to be actively involved in design. At the same time the new Board will shortly introduce fresh designs drawn, for the first time, by artists outside the Moorcroft family. Whilst on the one hand there will be a broad acknowledgement of the enthusiasm of collectors, there will also be pieces specifically designed for the contemporary market. The Moorcroft tradition of English excellence will continue in shape, in design, in colour and in quality.

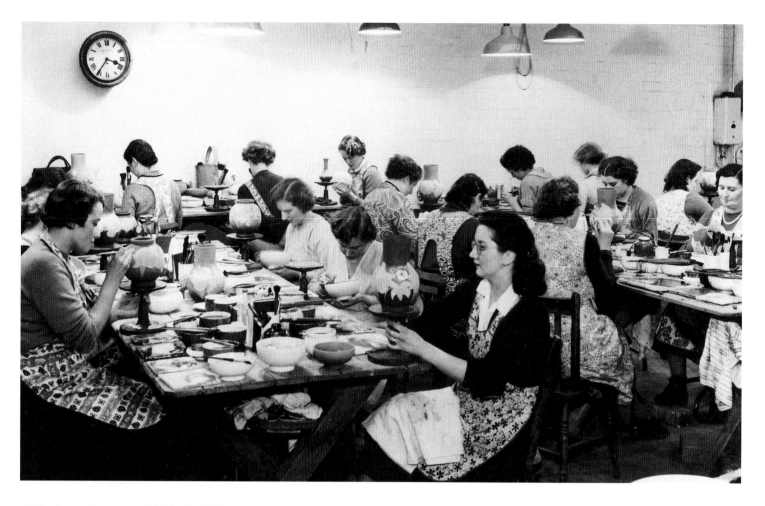

4 The decorating room at Cobridge in 1954

5 Adrienne Moss painting a lily design in 1954

Walter Moorcroft Designs 1946-1984

Spring Flowers

William Moorcroft's 1930s design continued in occasional production until the late 1950s, virtually unaltered

Orchids

Developed by William in c1937, and continued intermittently by Walter through the 1940s and 1950s on blue, green and flambé. Last used in 1972 for special vases made to celebrate the centenary of William's birth, with yellow and blue grounds. The anemone design was also used.

Clematis

Developed by William in 1938/9 from a flower he picked in his drive at home, and continued by Walter from 1946 to 1975. Production finally ceased in 1983, except for special orders. Made on dark blue, woodsmoke, green, yellow, ivory and with flambé, and experimentally on turquoise in 1959.

Anemone

William's pre-war design was used regularly by Walter from 1945 until 1975 when he redrew it. The new design was made first on blue and woodsmoke, on yellow from 1978 and green and ivory from 1984

Fuschia

William's design was used on lampbases for the American market and was a mainstay of production during the war. Production was continued by Walter until c1947, for the Crest Company of Chicago

Columbine

Walter's first independent design, drawn in 1947 from flowers picked in his garden. This was confined to a few pieces only until the early 1980s when he designed a complete range. It was used first on blue grounds, later on yellow, ivory, green and woodsmoke.

Hibiscus

Drawn c1949 from pressed flowers sent to Walter from Jamaica. Early versions of the design include buds, dropped in the early 1960s, and leaves shaded pink, later replaced by yellow. Coral hibiscus, with its one-colour flower, was introduced in 1968. In 1971 the design was redrawn in Bermuda, and this new range included coral on ivory from 1974, and pink on ivory, green, woodsmoke, yellow and blue. In 1979/80 pink and coral on brown were added, and in 1986 a pale blue and dark blue version was produced, influenced by contemporary furnishing styles.

Bourgainvillaea

Drawn in c1950 from pressed flowers sent to Walter from Jamaica, and used on ivory and green until the early 1960s

Lilies

The tiger lily was drawn when he was at school in c1935, but the design was not used until c1950 and then remained in occasional production. He redrew it in a different style in the early 1960s. His arum lily was the result of persistent searches in local hedgerows and was produced in greater numbers from 1959 to 1962.

Dianthus and Fresia

Drawn in 1955 and used in small quantities on small vases, trays and bowls, on pearl, ivory and green grounds, over the next couple of years. A turquoise was used experimentally.

Leaves in the Wind

Drawn in 1960 from leaves found by Walter in the lanes of Worcestershire, this restrained design was conceived with flower arranging in mind. It was well received but was withdrawn in 1962 as many retailers found it untypical.

Dahlia

Drawn in 1960 and used experimentally for a short period

Caribbean and Marine

Originally designed in 1961 to fulfil an order for tankards from a company in Bermuda, this colourful pattern was also used on vases and trays. It was withdrawn in c1963. Similar in style was the marine design, an underwater pattern featuring seahorses, fish and seaweed in bright colours, made between 1962 and 1964

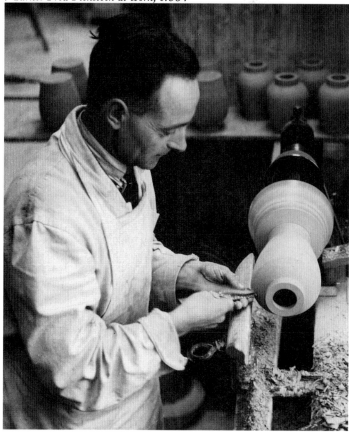

6 *Thrower Ted Burden at work, c1954*
7 *Turner Fred Pickstock at work, c1954*

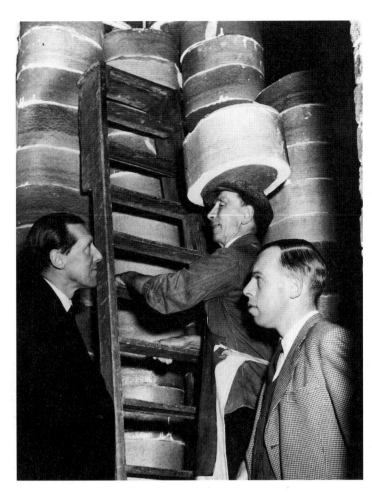

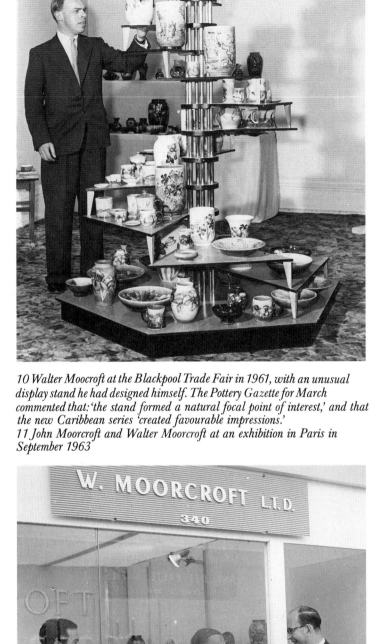

8 Placer W. Bowler loads a sagger into the oven in 1952, while Walter Moorcroft and Geoffrey Lloyd, Minister of Fuel and Power, look on
9 During the 1950s and 1960s Moorcroft's advertising was often both dramatic and ambitious

10 Walter Moorcroft at the Blackpool Trade Fair in 1961, with an unusual display stand he had designed himself. The Pottery Gazette for March commented that: 'the stand formed a natural focal point of interest,' and that the new Caribbean series 'created favourable impressions.'
11 John Moorcroft and Walter Moorcroft at an exhibition in Paris in September 1963

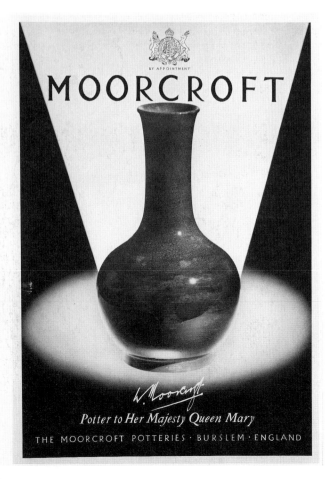

12 The Moorcroft stand for the British Industries Fair of 1953, designed by David Macaulay Advertising

Poplar Leaves
Drawn in 1962 from leaves collected by Walter at the local golf course, the design was used only on a large vase, with ivory, smoky blue and flambe autumn grounds. About 25/30 made in all

Poinsettia
The design was drawn in 1967 for a Christmas plate commissioned by Woodward of Vancouver but never went into production

Maize
Drawn in 1967, the design was produced experimentally to fulfil an order from T Eaton, a Canadian retailer, but never achieved full production

Bermuda Lily
Drawn by Walter in Bermuda in 1971. After an initial trial with a turquoise ground, he developed the design with a white flower on olive green. Later variations were a yellow flower on ivory (Eastern Lily) in 1975 and a yellow flower on brown (Jungle Brown Lily) in 1978

Alamander
Drawn by Walter in Bermuda in 1971, the design was used only on about 20/30 small boxes

Pansy Nouveau
Introduced in 1972 for the American market, the design was inspired by William's pansy design of 1911. The pale green ground and the style of drawing tried to capture the flavour of the Art Nouveau period. It was withdrawn in 1973.

Magnolia
Drawn in 1975 from magnolias seen by Walter in the grounds of Hodnet Hall, Shropshire, and first exhibited in February 1976. Pink flowers on blue were first used, but later ivory, yellow, and olive green grounds were added. This design was being sold in all five continents within 18 months of its inception.

Wild Rose
Drawn for Liberty to be part of a promotion to launch the Mini Metro in September 1980, the design was made experimentally

on woodsmoke and pale yellow but never went into production
Butterfly Bramble and Butterfly Bluebell
Designed in October 1984, these two new patterns were specially produced to appeal to the Moorcroft collector. The third design in the series featured an arum lily drawn with grasses.

Geranium and Campanula
Drawn in Crete in October 1984, these patterns were designed for relatively large scale production, using casting rather than slip trailing. The moulded range also included mugs decorated with a bottle oven, and with single sprays of rose, daffodil, bluebell, and thistle, as well as geranium and campanula.

13 The retirement of thrower Ted Burden in February 1966, left to right, E. Pickstock, Mary Williams, Majorie Kubanda, Winnie Hemmings, Ted Burden, Walter Deauville, Maria Forrester and Walter Moorcroft

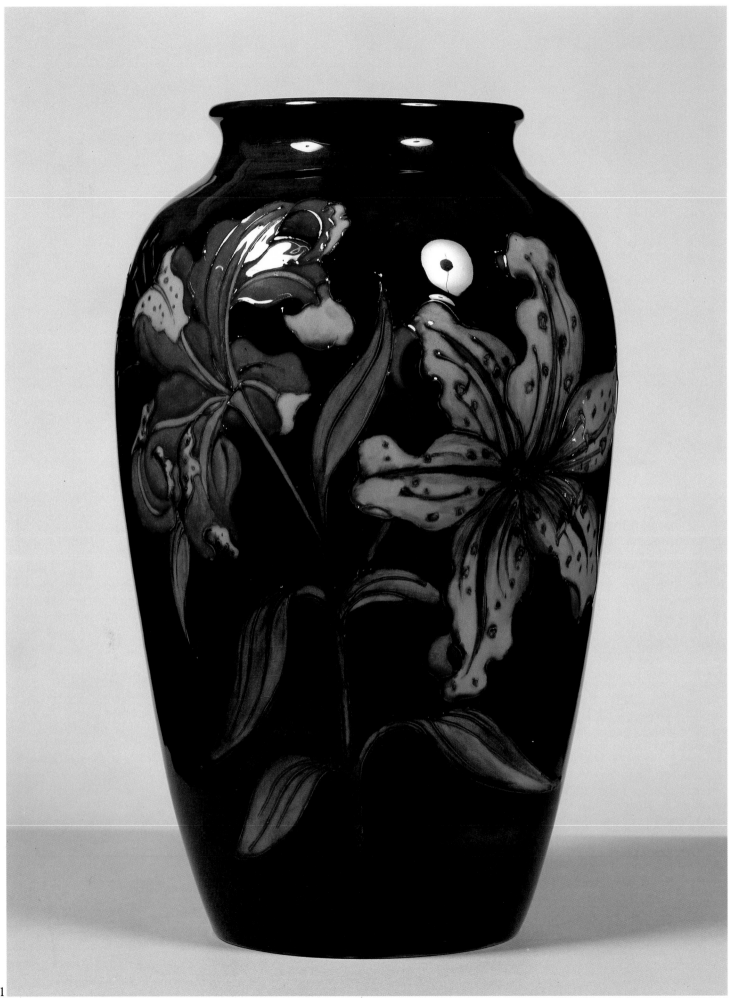

1

1 Vase decorated with a lily design, showing both sides of the flower, with a light flambé glaze. Drawn by Walter directly from the flower, and dated 1962. Height 14½ ins

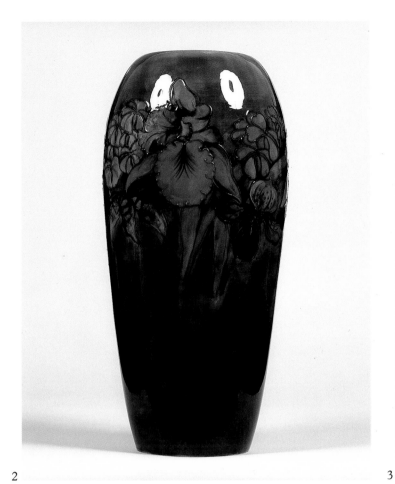

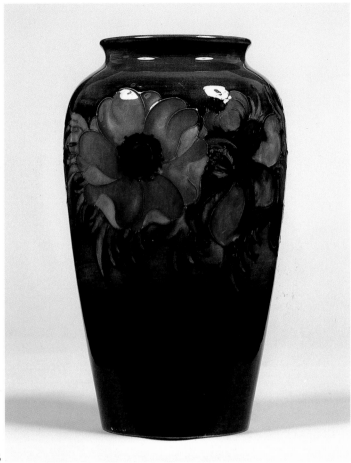

2

3

2 Lamp base decorated with an orchid design under a rich flambé glaze, c1954. Height 18½ ins
3 Vase decorated with an anemone design under a flambé glaze, c1954. Height 10½ ins
4 Lamp base decorated with a fuchsia design under a yellow flambé glaze, made for the Crest Company of Chicago, c1948. Height 12 ins
5 Vase decorated with the hibiscus design, the tropical colours emphasised by the flambé glazes, dated 1952. From a small group of about 25, some of which were made for a Cunard cruise liner. Height 10 ins

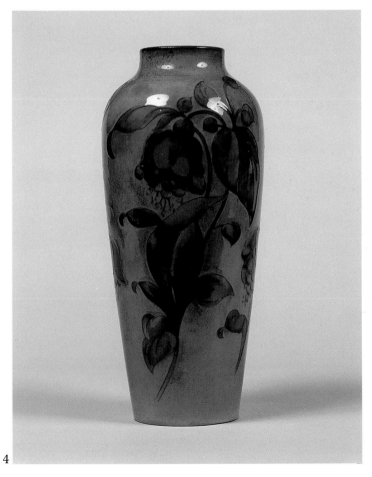

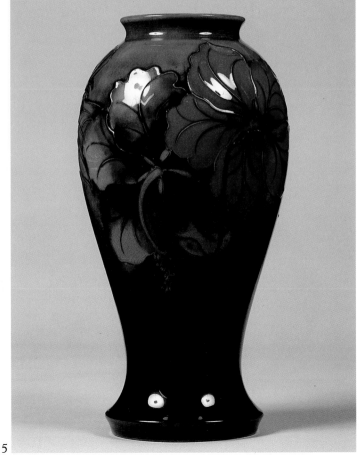

4

5

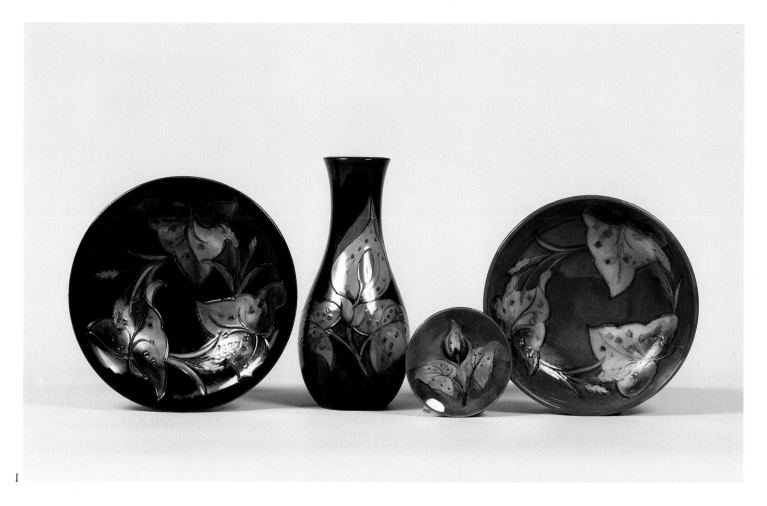

1 Group of wares decorated with an arum lily design, showing the development of the design into the darker colours of flambé firing, c1960. Black bowl diameter 10 ins

2 Group of wares decorated with various flower designs under flambé glazes, left to right, dahlia bowl 1960, clematis vase designed by William but executed by Walter c1948, clematis dish and small vase 1960, orchid *Laelia Autumnalis* dish 1960. Largest dish diameter 10 ins

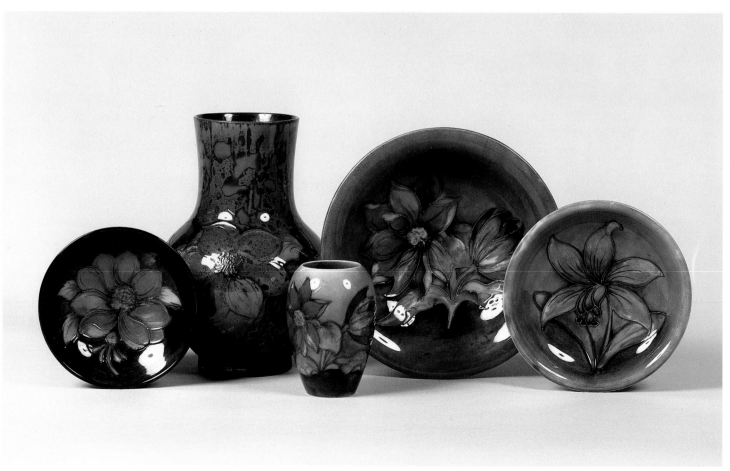

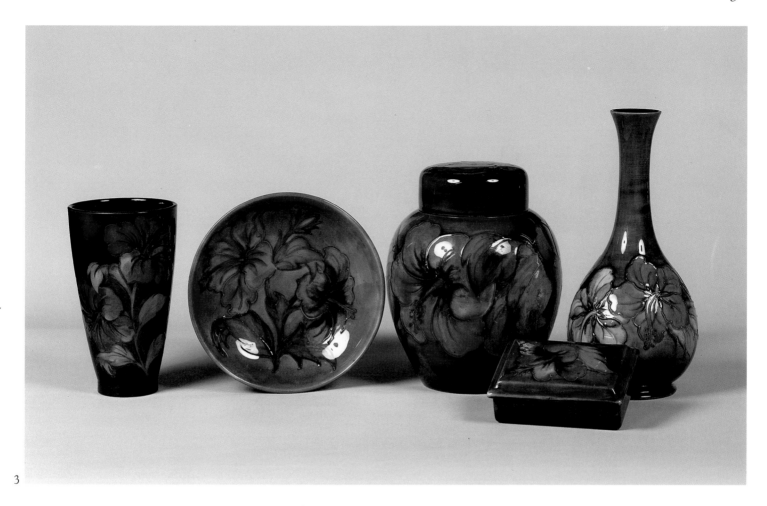

3

3 Group of wares decorated with the hibiscus design, showing the varied effects of the flambé firing including the turquoise and brandy flame affects achieved by firing close to the limit, 1954-1965. Taller vase height 10¼ ins
4 Group of wares decorated with various flower designs under flambé glazes, left to right, clematis dish 1963, poinsettia Christmas plate 1967, one of 12 trials for a Canadian order, anemone vase c1955, two columbine vases 1954 (taller) and 1948. Christmas plate diameter 10 ins

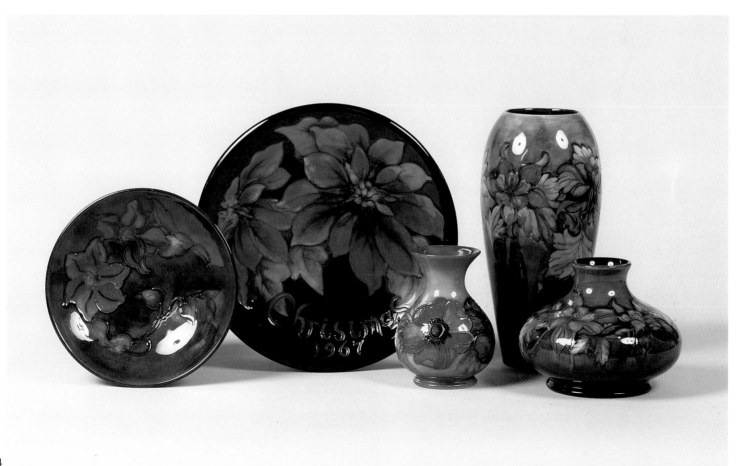

4

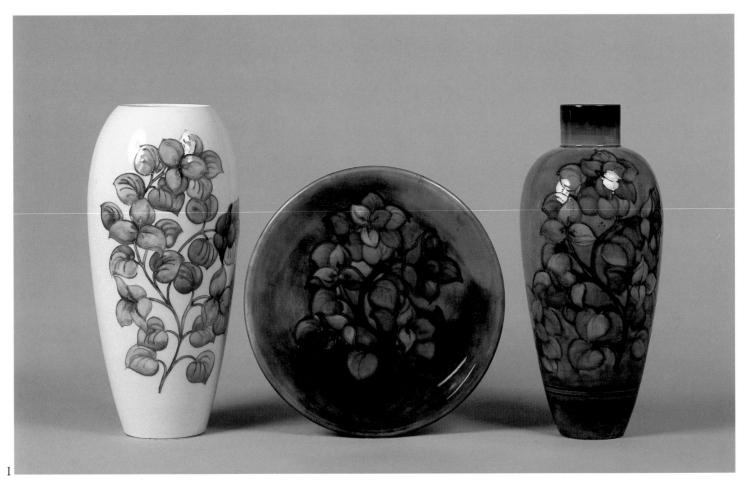

1 Group of wares decorated with a bourgainvillaea design, showing naturalistic colours c1955 and flambé effects 1950 (the vase) and 1960. Plate diameter 10ins
2 Group of wares decorated with marine and Caribbean designs under rich flambé glazes, 1960-1964. Tankard height 3½ins
3 Group of wares decorated with versions of the clematis design on different ground colours, drawn by William in c1938 and developed by Walter between 1946 and 1975. The jar and cover is dated 1948, the green and ivory ground vase 1956. Tallest vase height 8½ins
4 Group of wares decorated with an orchid design, drawn by William in 1937 and developed by Walter from c1947. Trumpet vase 1948, flambé dish 1959, yellow and blue ground vases made in 1972 to celebrate the centenary of William's birth, with special backstamp. Dish diameter 10ins
5 Group of wares decoratd with Walter's version of his father's spring flowers design, 1947-1957. Tallest vase height 12½ins

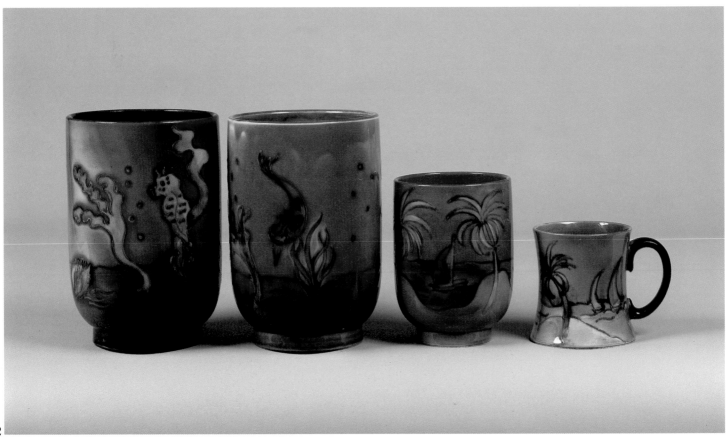

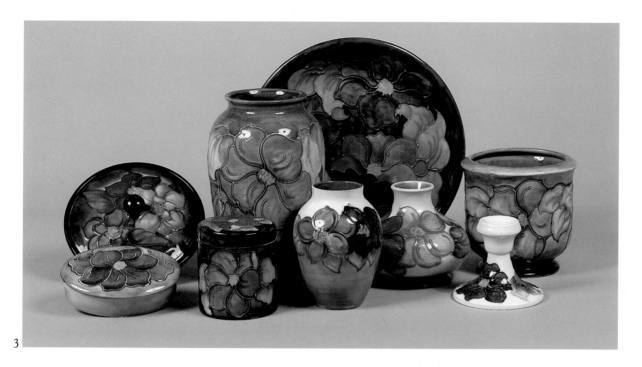

3

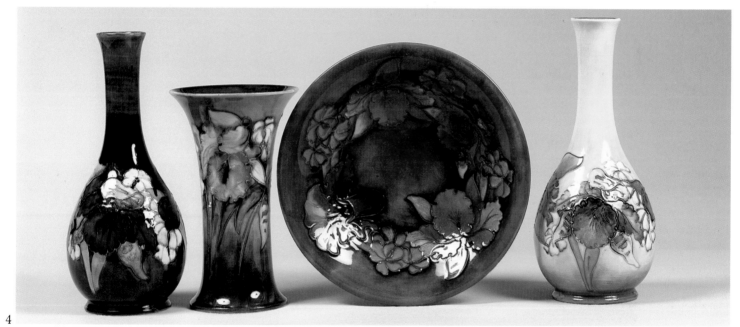

4

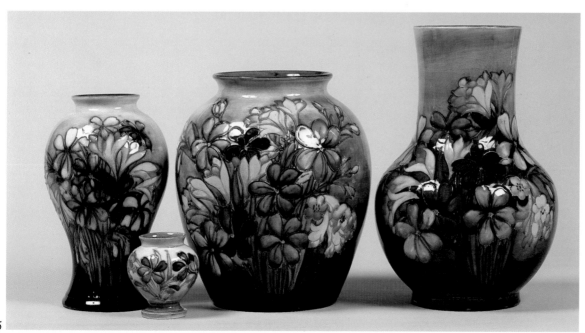

5

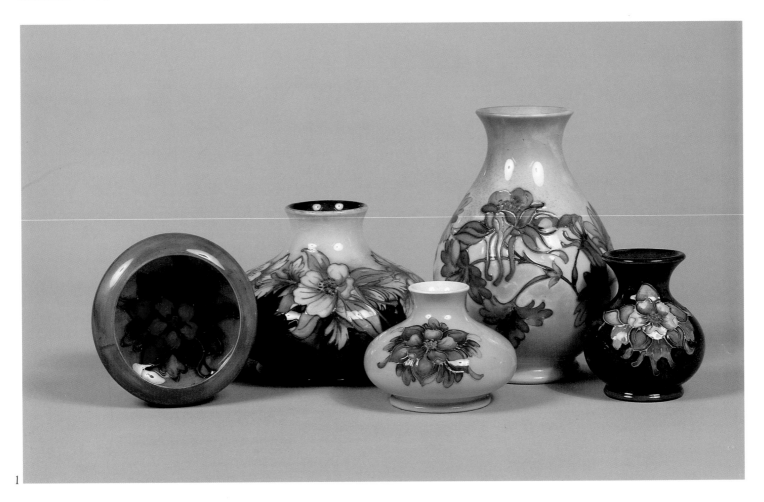

1 Group of wares decorated with a columbine design, the squat blue/green vase 1947, the pale flambé vase 1949, the others c1955. Tallest vase height 7½ ins

2 Group of wares decorated with a columbine design showing various ground colours, c1980-1985. The tall green ground vase is from a limited edition of 100, made in 1983. Ginger jar height 6½ ins

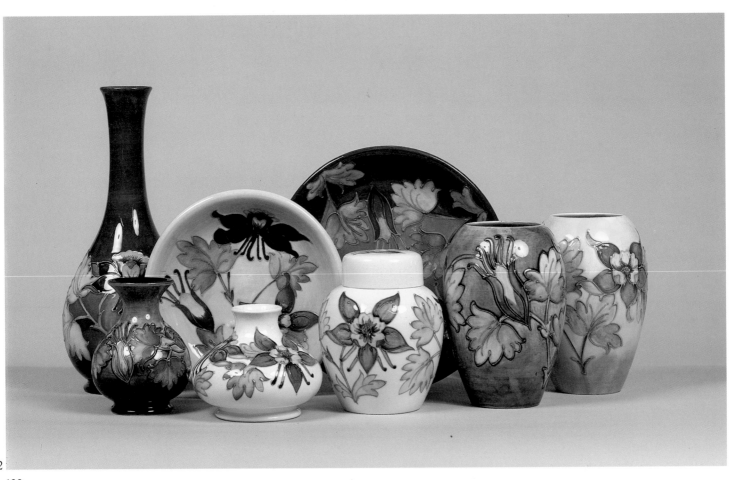

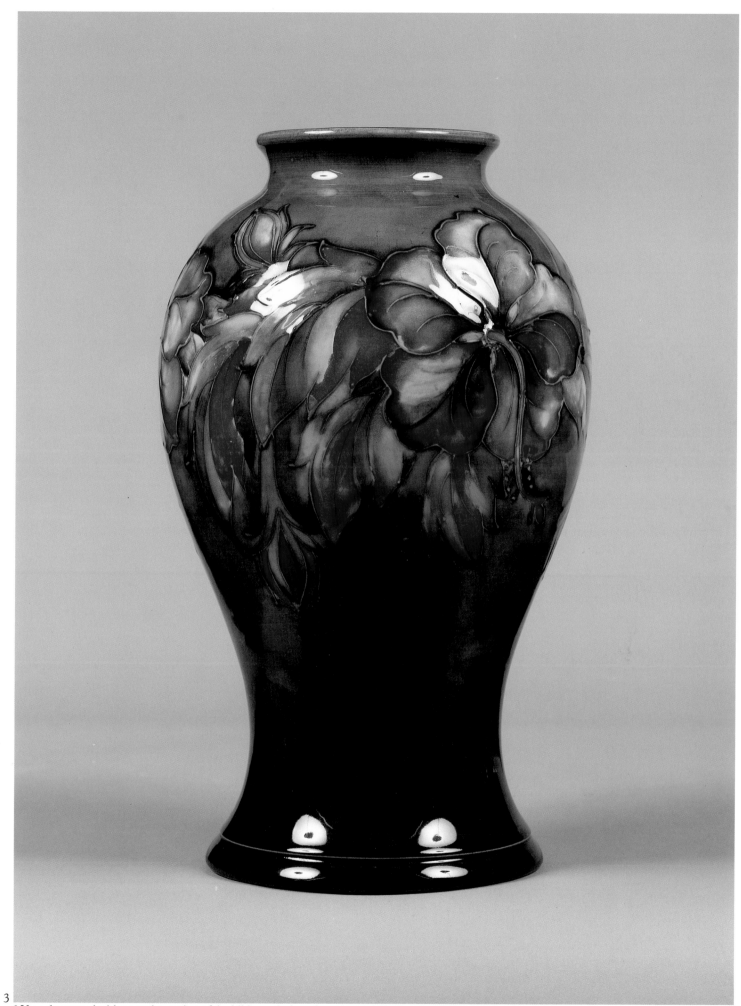

3

3 Vase decorated with an early version of the hibiscus design, showing the leaves shaded with pink and the bud which was dropped from the design in the early 1960s, c1950. Height 12 ins

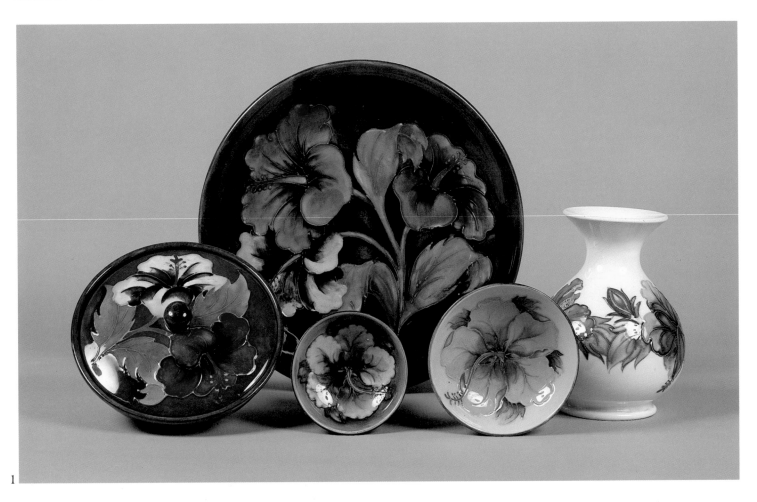

1

1 Group of wares decorated with early versions of the hibiscus design, showing different colour ways, left to right, box and cover 1960, plate 1965, small bowl 1949, larger bowl 1955, vase 1962. Box and cover diameter 6ins
2 Group of wares decorated with the hibiscus design on brown and yellow grounds, 1975-1985. Plate diameter 10ins

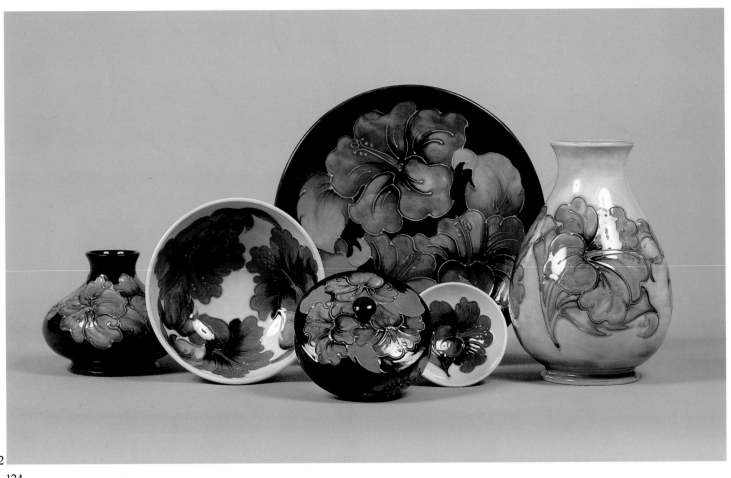

2

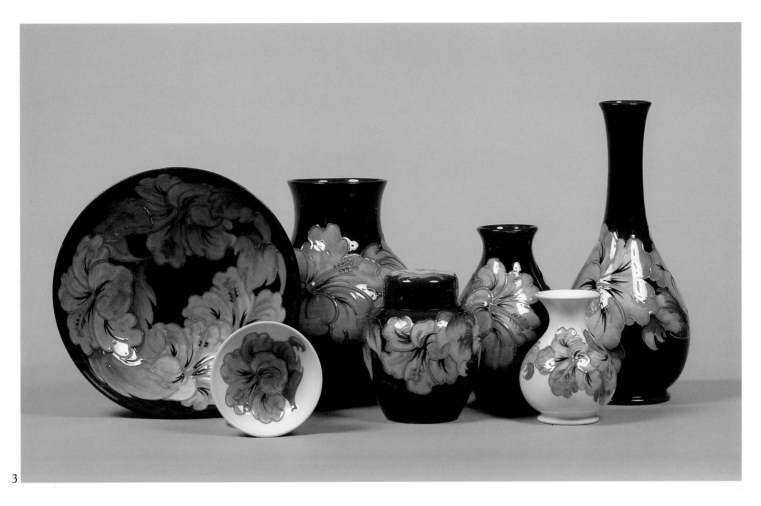

3

3 Group of wares decorated with the coral hibiscus design, showing green, brown and ivory grounds, 1968-1980. The dish and the adjacent vase were made in limited editions of 200 in 1973. Dish diameter 10½ins
4 Group of wares decorated with the hibiscus design on green, woodsmoke, ivory and dark blue grounds, c1974. Tallest vase height 8½ins

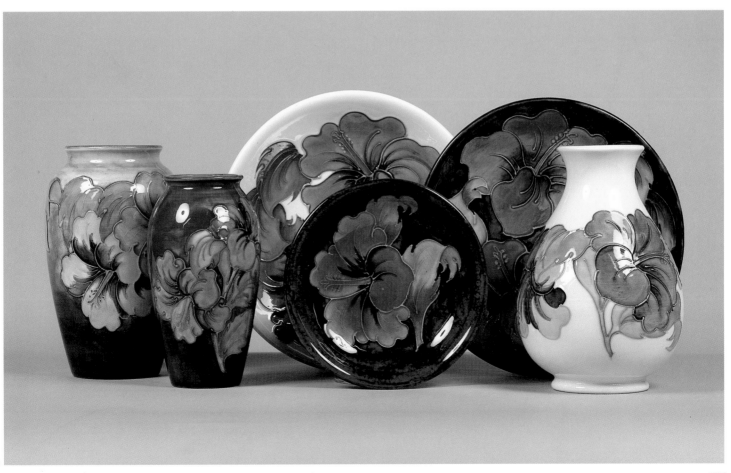

4

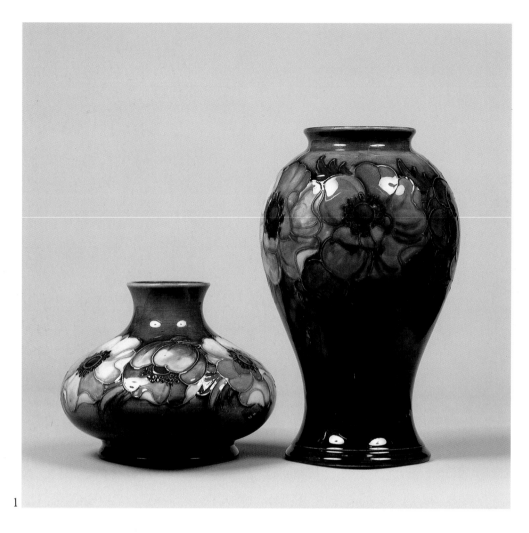

1

1 Two vases decorated with an anemone design, showing the continuation by Walter of his father's pre-war design, c1949. Larger vase height 9½ ins
2 Group of wares decorated with the new version of the anemone design developed by Walter from 1975, showing green and ivory grounds, c1984. Largest vase height 8 ins

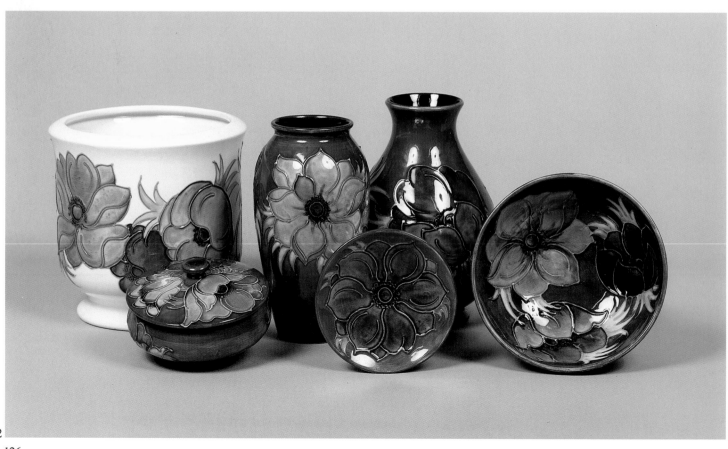

2

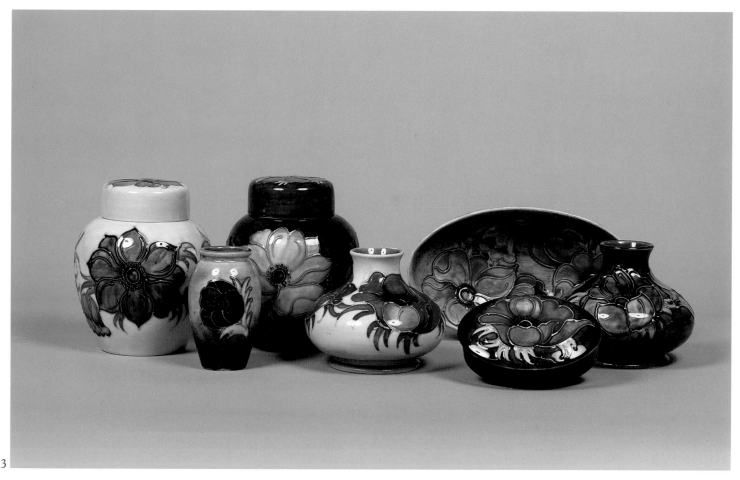

3

3 Group of wares decorated with Walter's version of the anemone design, showing blue, woodsmoke and yellow grounds, c1975-1980. Ginger jar height 6½ ins

4 Group of wares decorated with various flower designs, left to right, clematis on green, one of about 50 produced in 1959, dianthus on pearl, one of about 100 made on various pale grounds c1955, African lily on box and cover c1953, fresia c1955, clematis on an experimental turquoise 1959. Turquoise vase height 5 ins

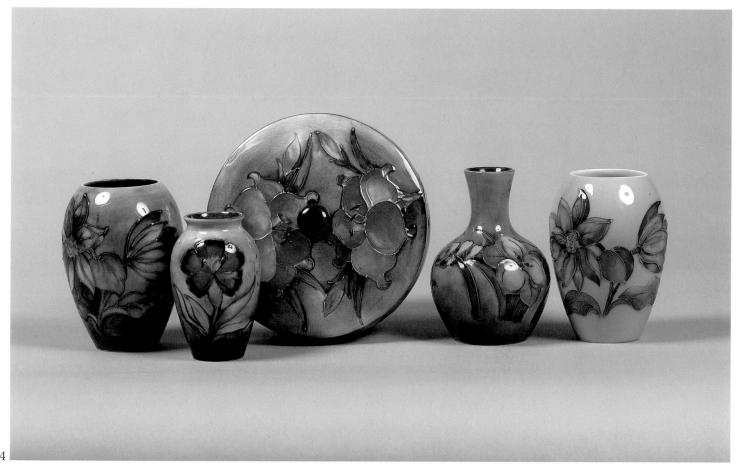

4

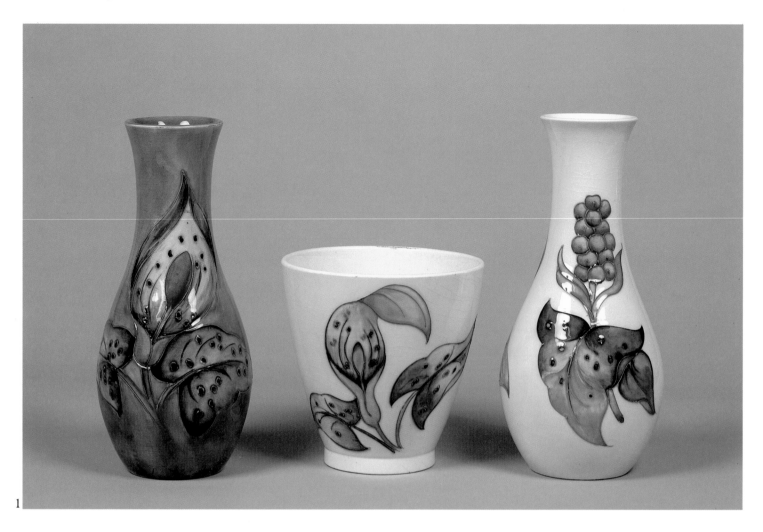

1

1 Group of wares decorated with the arum lily design, showing green and ivory grounds, 1959-1962. Vase height 11 ins
2 Group of wares decorated with the arum lily design, showing yellow and blue grounds, and a small planter with a flambé glaze, 1959-1962. Larger dish diameter 8½ ins

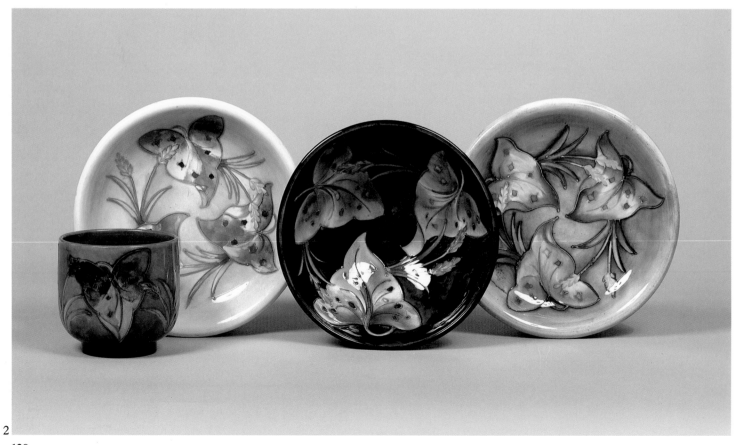

2

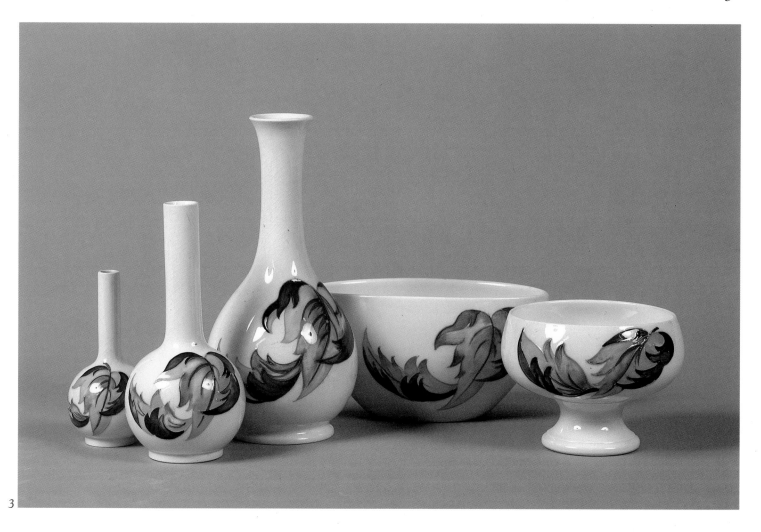

3

3 Group of wares decorated with the Leaves in the Wind design, showing the slight decoration and subdued colours chosen with flower arranging in mind, 1960-1962. Largest vase height 8½ ins
4 Group of wares decorated with the Caribbean and marine designs, showing the characteristic bright colours and the exotic fish, 1960-1965. Vase height 9½ ins

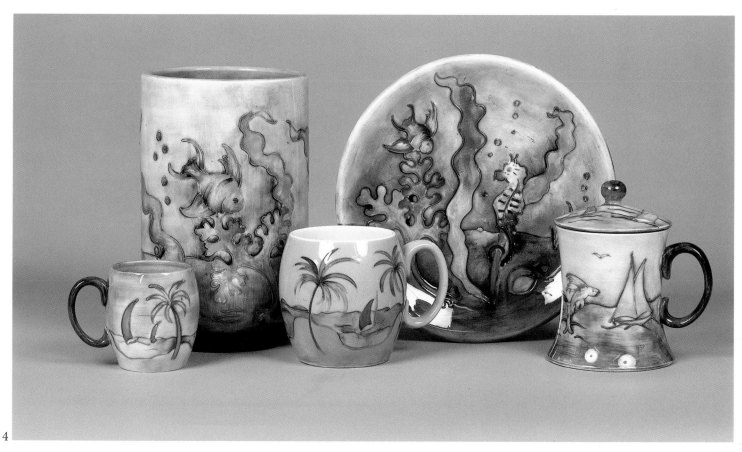

4

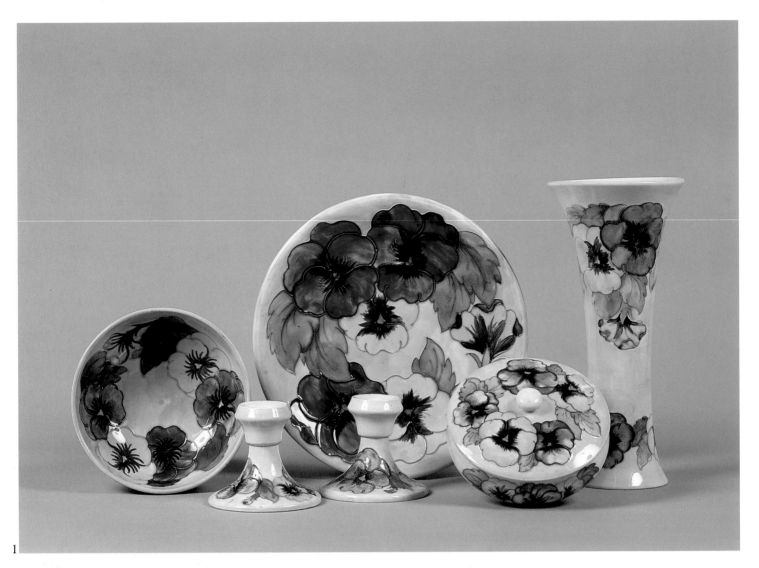

1

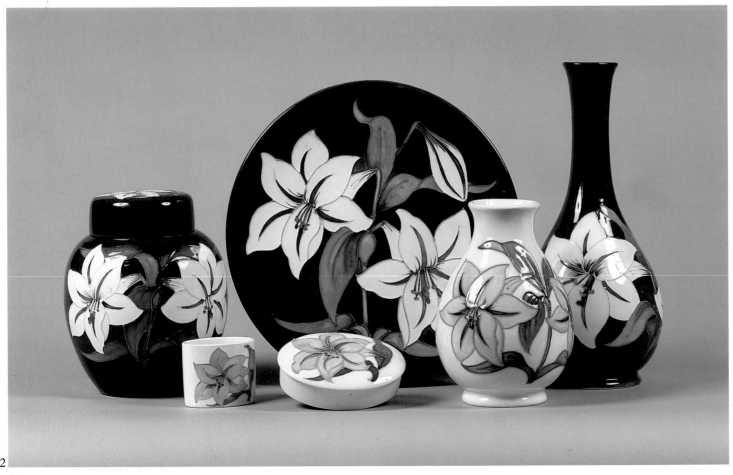

2

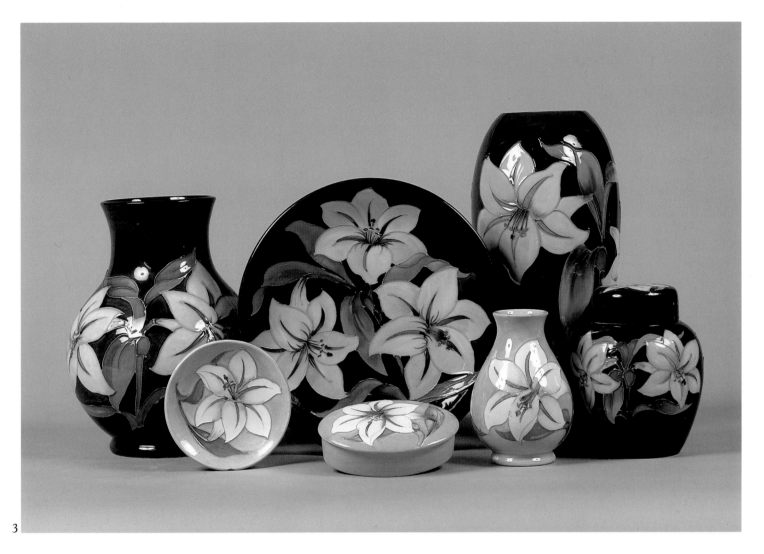

3

1 Group of wares decorated with the Pansy Nouveau design, drawn by
Walter for the American market in 1972 and inspired by his father's
pansy design of 1911, 1972-1973. Vase height 11 ins
2 Group of wares decorated with the Bermuda lily design, showing the
green and ivory grounds, introduced in 1973 and 1975. Tallest vase
height 12½ ins
3 Group of wares decorated with the Bermuda lily design, showing the
yellow flower on a brown ground introduced in 1978, and the turquoise
ground produced experimentally in 1971. The vase on the left is from a
limited edition of 200 produced in 1983. Plate diameter 10 ins
4 Vase decorated with a poplar leaves design in autumnal colours,
showing the ivory ground. Small numbers were also made with smoky
blue grounds and with flambe glazes. Dated 1962. Height 12¾ ins

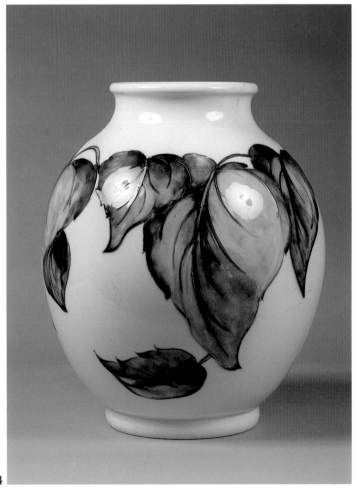

4

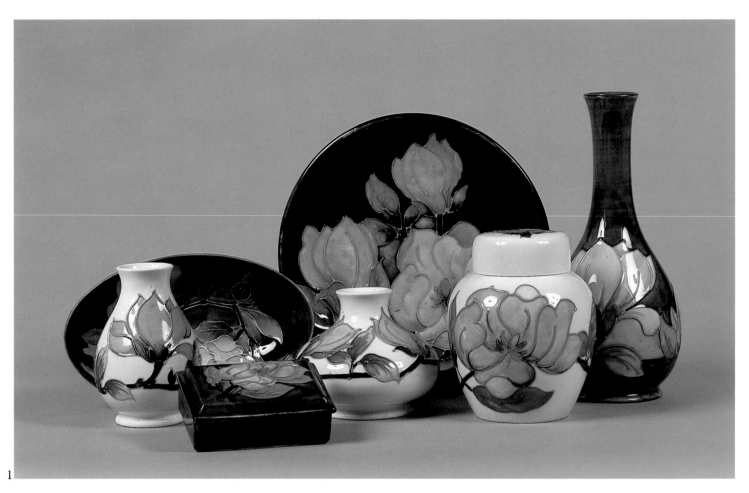

1

1 Group of wares decorated with the magnolia design, showing the dark blue and ivory grounds, c1976. Plate diameter 10½ ins
2 Group of wares decorated with unusual colour versions of the magnolia design, showing its development from 1975. The box and cover with a pale flower on woodsmoke was one of the first trials and is dated 12/5/75. The regular ground colours were dark blue, ivory, lemon yellow and, occasionally, olive green. Planter height 9 ins

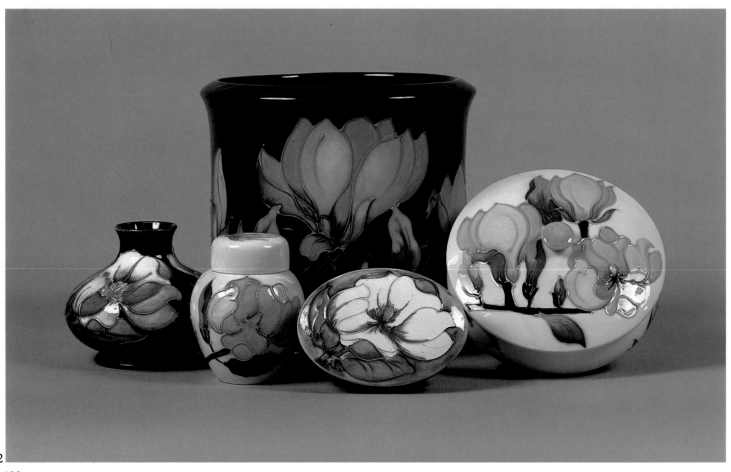

2

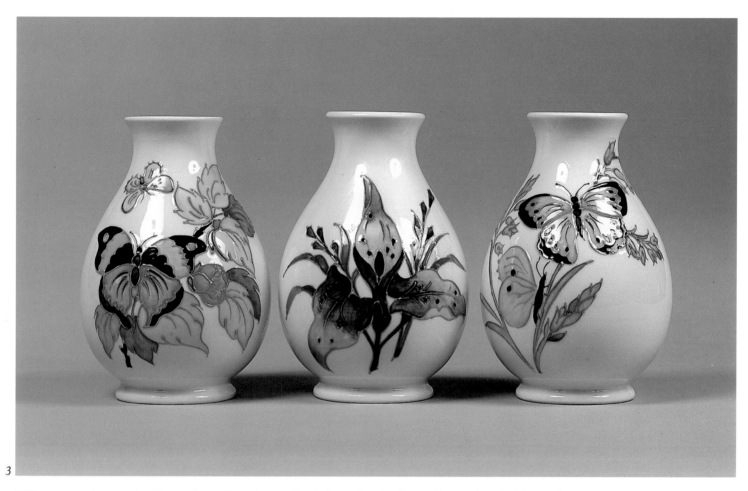

3

3 Three vases decorated with new butterfly and arum lily designs, showing butterflies combined with brambles and bluebells and the lily with grasses, produced in small quantities with collectors in mind from 1984. Height 8 ins
4 Group of wares decorated with experimental designs, left to right, maize vase made in 1967 for T. Eaton of Canada but never fully produced, wild rose plate made on yellow and woodsmoke in 1980 but never produced, tiger lily bowl and plate c1965 and alamander box and cover made in 1971. Vase height 12 ins

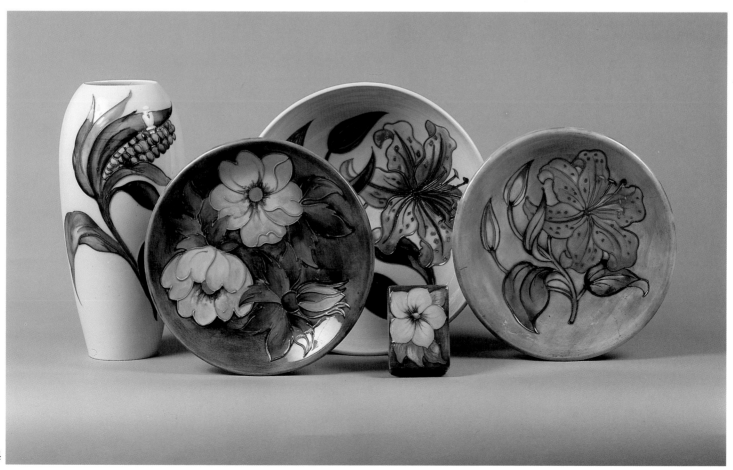

4

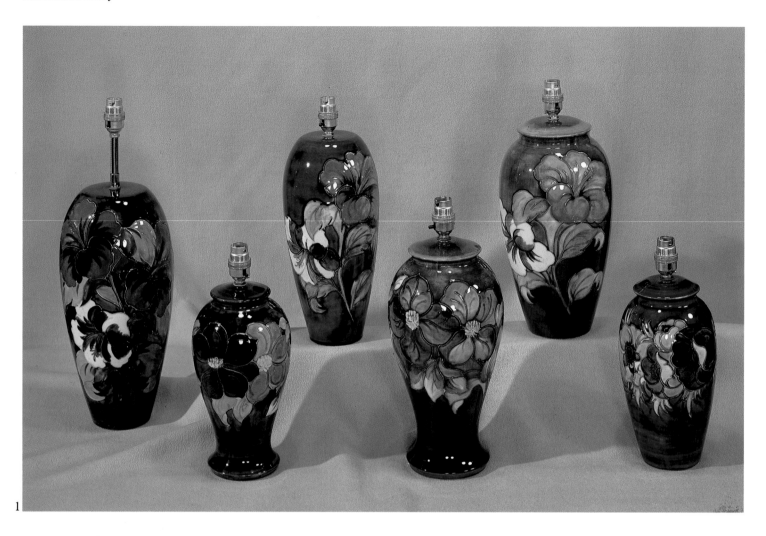

1

1 Group of lamp bases decorated with hibiscus, anemone and clematis designs on dark grounds, c1978. Largest height 12 ins (without light fitting)
2 Publicity photograph showing a range of pendants, brooches and a ring decorated with hibiscus and clematis designs, c1978. The teardrop pendant was also made with lily and magnolia designs. Round pendant diameter 3 ins
3 Group of wares showing blue campanula and pink geranium designs introduced in 1985. These wares featured moulded raised designs rather than hand drawn slip-trailing, but with hand-painting. Yellow and coral campanula were added to the range in 1986. All moulded wares are unsigned. Lamp base height 9½ ins

2

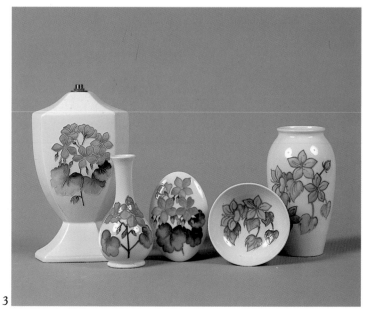

3

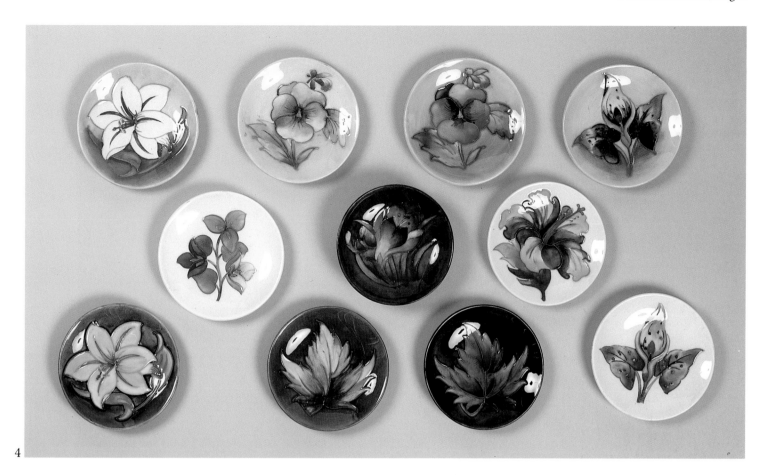

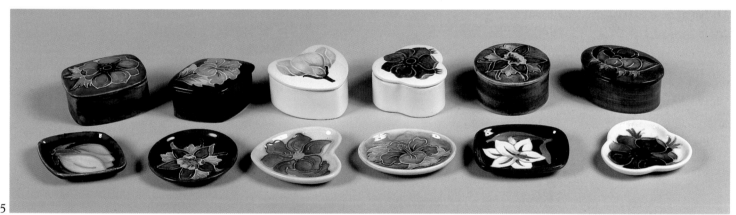

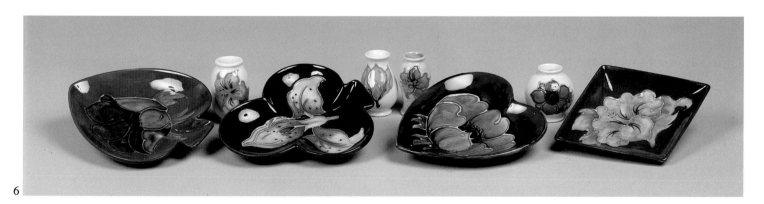

4 Group of small coasters decorated with a range of designs showing familiar patterns in unusual colours, including Bermuda lily, arum lily and hibiscus, as well as experimental patterns such as maple leaf, 1955-1975. Diameter 5 ins

5 Group of small shaped boxes and covers decorated with standard designs in a range of colour ways, originally inspired by papier mâché boxes from Kashmir. Introduced in 1981/2, the range included 110 items. The diamond and clover shapes were dropped in 1984/5. Average diameter 3 ins

6 Set of card trays decorated with standard patterns, designed for bridge players in 1972, and now out of regular production, and four miniature vases which continued the tradition established by Walter's father. Now out of regular production, these miniatures were made from the early 1970s with a range of standard designs on blue, green, ivory, woodsmoke and yellow grounds. Average height 2 ins

Chapter Six
Commemorative Wares

Commemorative wares were made by William Moorcroft at Macintyre's and at Cobridge, and the tradition has been continued by Walter. Moorcroft commemoratives were either adaptions of existing patterns, with inscriptions added, or were specially designed to celebrate a range of public and private events. Their most characteristic feature is a distinctive style of lettering, hand-drawn in slip, perhaps seen at its best on the wide range of mugs produced for occasions such as the coronations of Edward VII and Queen Alexandra, George V and Queen Mary, Edward VIII, and George VI and Queen Elizabeth. The ending of the First World War was also commemorated in this way. Commemorative vases, bowls, jugs, pipe trays and complete tea services were also made. The earliest commemorative piece may have been a two-handled mug inscribed 'Christmas & New Year Greetings' and made in about 1902, one of a number of private commissions, several of which came from Mr & Mrs Lasenby Liberty. Heraldic decoration was also popular, notably on a range

of match holders made for various Oxford and Cambridge colleges.

Walter Moorcroft has produced his own range of commemoratives, celebrating the coronation and jubilee of Queen Elizabeth II. He has also made Year plates in limited editions from 1982, and Year bells from 1983

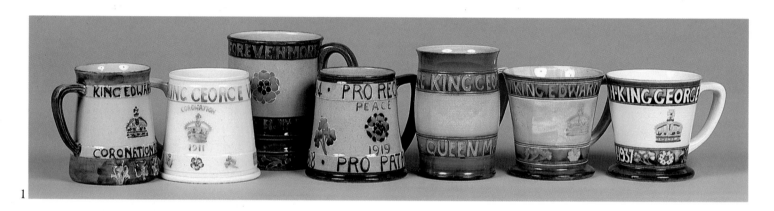

1

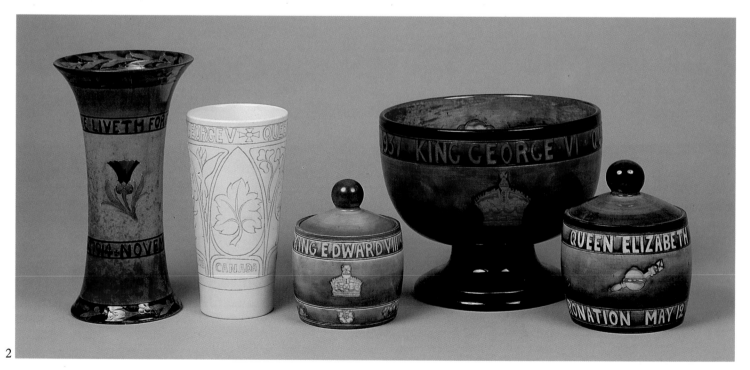

2

1 Group of commemorative mugs, left to right, coronation of Edward VII, 1902, designed by Lasenby Liberty and made for Mr and Mrs Liberty, coronation of George V 1911, made for Mr and Mrs Liberty, First World War, 1919, inscribed 'Their name liveth for evermore', First World War 1919, made for Lady Liberty, George V silver jubilee 1935, coronation Edward VIII 1937, coronation George VI 1937. Height 3½- 4½ ins
2 Group of commemorative wares, left to right, First World War vase 1919 with flambé glaze, George V silver jubilee vase 1935, Edward VIII coronation box and cover 1937, George VI coronation bowl 1937 with flambé glaze, George VI coronation box and cover 1937. White vase height 8 ins

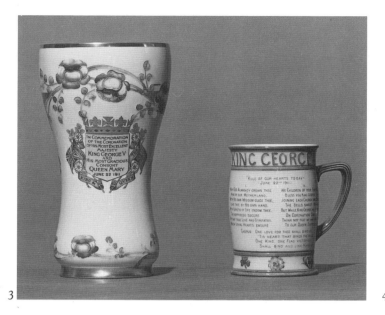

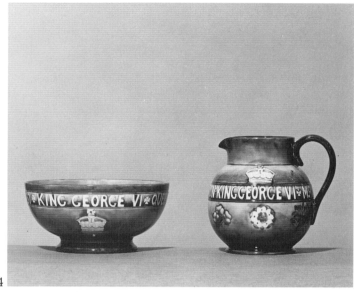

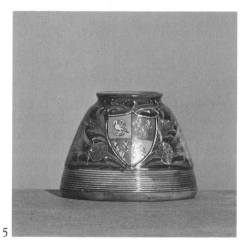

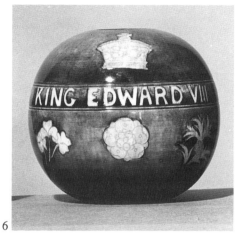

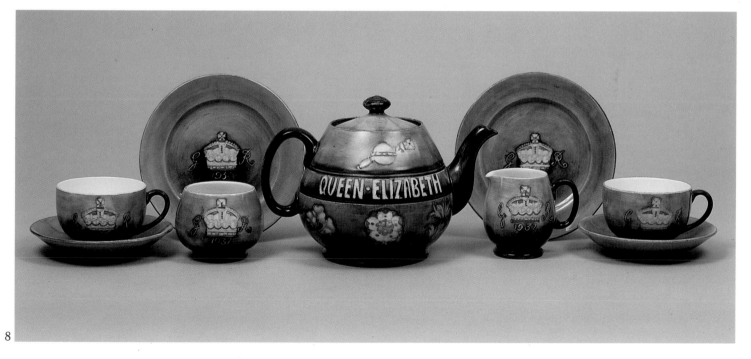

3 Vase decorated with rose garlands, gilding and a printed panel celebrating the coronation of George V, and the Norton Mug, decorated with a printed patriotic hymn and made for Lord Norton to celebrate the coronation of George V, both 1911. Vase height 8 ins
4 Bowl and jug made to celebrate the coronation of George VI, 1937. Jug height 6½ ins
5 Match holder decorated with a flower design and printed with the arms of Corpus Christi College, c1910. Height 2½ ins
6 Round pipe tray made to celebrate the coronation of Edward VIII, 1937. Height 5 ins
7 Two-handled vase decorated with an heraldic lion, other devices and a Latin inscription, c1911. Height 4½ ins
8 Tea service made to commemorate the coronation of George VI and Queen Elizabeth, 1937. Teapot height 5½ ins

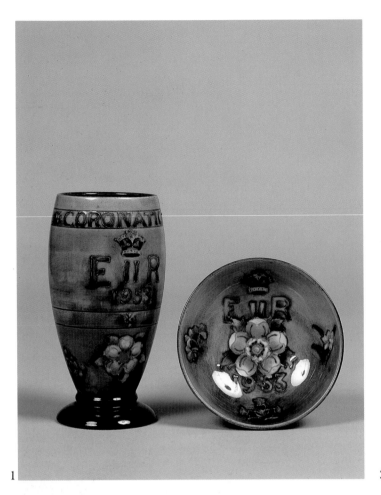

1

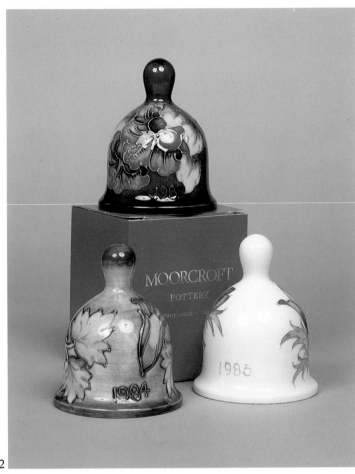

2

1 Vase and bowl made to celebrate the coronation of Queen Elizabeth ll, 1953, both made in small limited editions. Vase height 6 ins
2 Year bells made in 1983, 1984 and 1985 in limited editions of 250. The year bell for 1986 is decorated with coral hibiscus. Height 4½ ins
3 Year plates for 1982, 1983, 1984 and 1985, made in limited editions of 250, and plate made to celebrate the silver jubilee of Queen Elizabeth ll in 1977 in a limited edition of 125. The year plate for 1986 is decorated with coral hibiscus. Diameter 8½ ins

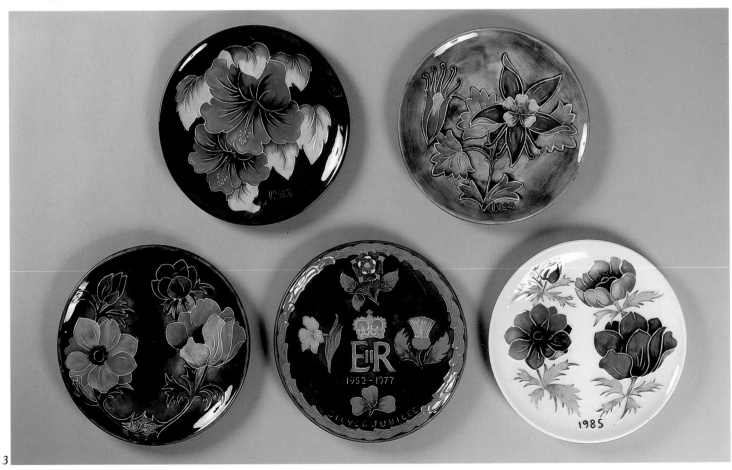

3

Addenda: New 1986 Designs

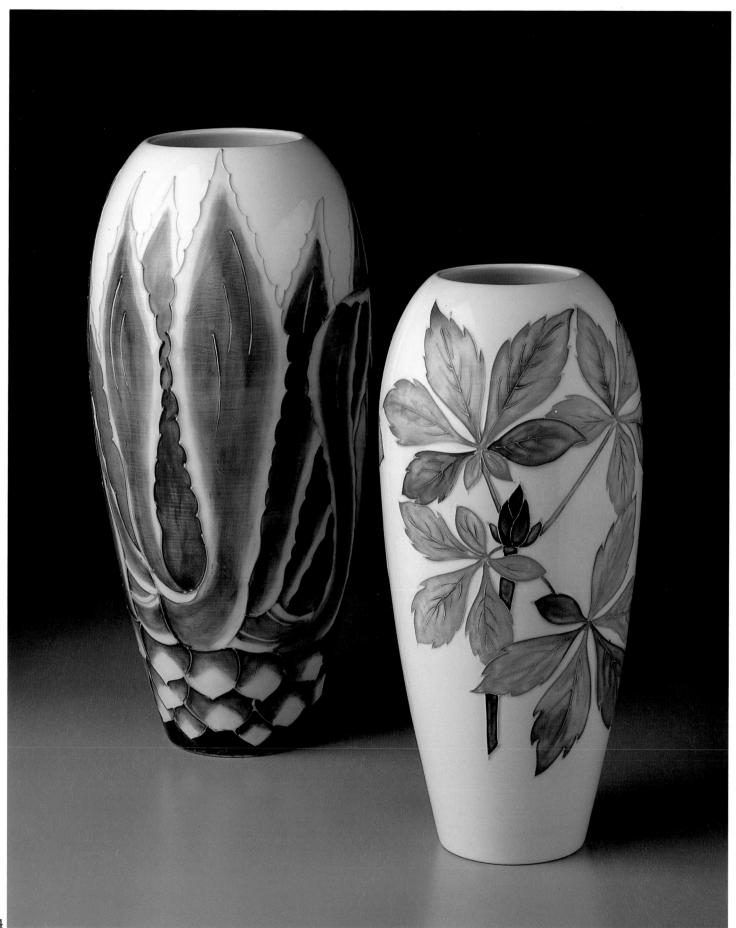

4

4 Vases decorated with pineapple plant and chestnut designs, drawn by Walter Moorcroft during the autumn of 1986 and produced in limited editions.

Signatures and Backstamps

Moorcroft pottery can be marked in a number of ways, all of which can be a help with identification and dating. These can include the Moorcroft signature or initials, printed or impressed factory marks, retailers' marks, design registration numbers, and pattern or shape marks. Paper labels with printed factory marks were also widely used. Precise dating is generally quite difficult, and the details of the design and decoration can often provide more clues than the marks. Important pieces sometimes carry dates, and many wares produced during the period of transition from the Washington works to the new Cobridge factory, 1912-1914, are dated. Otherwise, it is a matter of relying on familiarity with style and marks to select the likely period of manufacture.

Signatures and Initials

From the start, William Moorcroft established the habit of signing or initialling wares made under his control in his department at Macintyre's, as a mark of quality. A signature never meant that he had made or decorated the piece himself. Several styles were used during the Macintyre period, the full painted signature, *W Moorcroft des.* (designer), painted initials, *WM des.* or an incised signature or initials. Later Macintyre wares were signed without the des. Signatures during this period are generally in green, but other colours can be found. Pieces from the Cobridge period are generally in blue but this is not a firm rule. The colour of signature was determined more by the brush that came to hand than by any planned system of dating. Wares made to Moorcroft's designs but not in his department, such as the printed Aurelian Wares and the Dura tablewares, were rarely signed. At Cobridge the signature or initials became bolder, larger and more stylised.

When he took control of Cobridge in 1945, Walter Moorcroft established the tradition of initialling all wares over about 5 inches in height or diameter. Although his style of initials is similar to his father's, they can be distinguished from each other, particularly by association with the design used. Until the early 1980s Walter only signed new designs or important pieces in full, but recently the full signature has been used more frequently, particularly on wares made with collectors in mind. Before 1959 Walter used a blue/grey colour which changed to green after that date. From 1978 brown was generally used, reverting to green in about 1981.

Unless stated otherwise in the captions, all the wares illustrated in this book carry some form of painted or incised Moorcroft signature or initials.

Factory Marks

Macintyre art wares carry some form of printed factory mark. The pre-Moorcroft wares, Washington Faience, Taluf Ware and Gesso Faience all had individual printed backstamps, and this pattern was followed by Moorcroft's Florian Ware, Butterfly Ware and Hesperian Ware. When the Florian Ware mark was given up in about 1905, it was replaced by a standard printed Macintyre monogram backstamp, used on its own, or combined with a retailer's mark. At the Cobridge factory, Moorcroft began to use impressed marks and this pattern has been continued to the present day. There have been two main styles, the simple factory name, and the facsimile signature and Royal mark used from 1928. Marks printed with a rubber stamp have been used on small pieces, and printed marks have also be used on recent limited editions.

Retailers' Marks

Moorcroft wares often carry printed retailers' marks as this was a service available at the Macintyre factory at a small extra cost. About twenty retailers have been noted, the most important of which was Liberty. From the early 1900s Florian and other wares were made for Liberty and marked accordingly. From about 1906 many pieces carried only the Liberty mark and the Moorcroft signature. The other distinctive backstamp was the Hesperian Ware made for Osler's. Some retailer's marks were painted, for example those on wares made for Shreve of San Francisco. Retailers' marks were rarely used during the Cobridge period.

Design Registration Numbers

It was common practice at the Macintyre factory to register both shapes and designs at the Patent Office and many Moorcroft-designed shapes and patterns were registered between 1898 and about 1905 in the Macintyre name. Printed registration numbers were often included with the backstamp, giving an indication of the date of introduction of the pattern or shape, but not the date of manufacture.

Pattern and Shape marks

Impressed or painted numbers with an M prefix can often be found on many Macintyre wares, a continuation of a shape and pattern identification system in use at the factory before Moorcroft's arrival. The working of the system is not entirely clear. At Cobridge impressed shape numbers were regularly used. Decorators' and gilders' marks can also be found.

Paper Labels

A rectangular paper label was used from the early 1920s. The circular paper label was introduced after the award of the Royal Warrant in 1928 and continued in use in various forms until the Warrant lapsed in 1978. A label printed in red was used on seconds.

1 Gesso Faience mark, printed in brown on wares designed by Harry Barnard from c1897. Continued in occasional, or accidental, use until the early 1900s and so can be found on Moorcroft designs

2 Florian Ware mark printed in brown, 1898-c1905 and early painted Moorcroft signature

3 Florian Ware mark printed in brown, 1898-c1905, printed design registration mark, early incised Moorcroft initials and painted pattern or shape number

4 Butterfly Ware mark printed in brown, c1900 and incised Moorcroft initials

5 Osler's Hesperian Ware mark printed in brown, c1901-3 and painted Moorcroft signature

6 Standard Macintyre factory mark printed in brown, c1904-1913, printed design registration mark, painted initials and painted pattern or shape number

7 Standard Macintyre factory mark printed in brown, c1904-1913, printed retailer's mark, painted signature and impressed shape number

8 Liberty mark printed in green, c1903-1913, Liberty paper label, painted signature, and impressed shape number. Painted Liberty marks can also be found

9 Stamped Tudric mark, used on Moorcroft wares made for Liberty and mounted with hammered pewter, c1916-1923

10 Impressed Cobridge factory mark, 1913-1916, impressed date, painted signature and date, impressed shape number

11 Impressed Cobridge factory mark, c1916 and painted signature. England was added to comply with international tariff regulations

12 Impressed Cobridge factory mark, c1918-1929 and painted initials. Made in England was added to comply with USA import regulations

13 Impressed Cobridge factory mark, c1918-1929, painted signature, printed Moorcroft paper label, printed Liberty paper label

14 Impressed factory mark with facsimile signature, 1928-1949, painted signature and printed paper Royal Warrant label, in use 1928-1953

15 Impressed factory mark with facsimile signature, painted Walter Moorcroft signature 1945-1949 and printed paper Royal Warrant label

16 Impressed factory mark, c1949-1986, painted Walter Moorcroft initials and later printed paper Royal Warrant label, in use 1953-1978

17 Impressed factory mark, c1949-1986 and painted Walter Moorcroft signature

18 Recent painted Walter Moorcroft signature and date

19 Printed mark used in 1972 on wares made to commemorate the centenary of William Moorcroft's birth

20 Printed limited edition mark, 1983, on wares made to commemorate the 90th anniversary of Tasmanian retailers, E.A. Joyce and Son, impressed factory marks and Walter Moorcroft painted initials

Index

William Moorcroft Designs

Walter Moorcroft Designs

Footnote: William Moorcroft relaxing on the beach at Borth, c1929.